P9-CRF-026

NANCY GRAVES: EXCAVATIONS IN PRINT

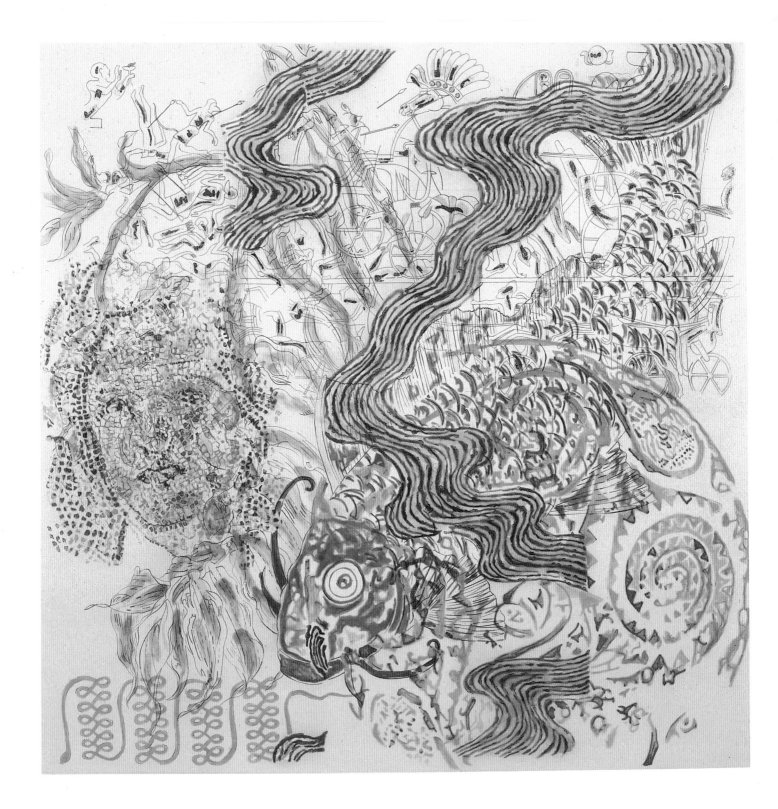

NANCY GRAVES
EXCAVATIONS IN PRINT

A CATALOGUE RAISONNÉ

Thomas Padon

With a Foreword by J. Carter Brown

HARRY N. ABRAMS, INC., PUBLISHERS, IN ASSOCIATION WITH THE AMERICAN FEDERATION OF ARTS

For Harry N. Abrams, Inc.:
Project Director: Margaret L. Kaplan
Editors: Diana Murphy, Lory Frankel
Designer: Dana Sloan

For The American Federation of Arts:
Publication Coordinator: Michaelyn Mitchell

Library of Congress Cataloging-in-Publication Data

Padon, Thomas.
Nancy Graves: excavations in print: a catalogue raisonné/
Thomas Padon; with a foreword by J. Carter Brown.
p. cm.
Exhibition tour: Nelson-Atkins Museum of Art, Kansas City, Mo.,
Jan. 26–Apr. 7, 1996 . . . [et al.].
Includes bibliographical references and index.
ISBN 0–8109–3391–8 (Abrams hc)
ISBN 1–885444–00–1 (AFA pb)
1. Graves, Nancy Stevenson, 1940– —Catalogues raisonnés.
I. Graves, Nancy Stevenson, 1940– .
II. Nelson-Atkins Museum of Art. III. Title.
NE539.G695A4 1996
769.92—dc20 95-23940

Copyright © 1996 The American Federation of Arts

Published in 1996 by Harry N. Abrams, Incorporated, New York,
A Times Mirror Company, in association with The American Federation of
Arts, New York. All rights reserved. No part of the contents of this book
may be reproduced without the written permission of the publisher

Printed and bound in Japan

CONTENTS

This catalogue has been published in conjunction with "Nancy Graves: Excavations in Print," an exhibition organized by The American Federation of Arts. It is a project of ART ACCESS, a program of the AFA with major support from the Lila Wallace–Reader's Digest Fund. Additional support has been provided by the National Patrons of the AFA.

EXHIBITION TOUR

Nelson-Atkins Museum of Art
Kansas City, Missouri
January 26–April 7, 1996

Frances Lehman Loeb Art Center,
Vassar College
Poughkeepsie, New York
May 3–July 14, 1996

The Butler Institute of American Art
Youngstown, Ohio
August 9–October 20, 1996

Cornell Fine Arts Museum,
Rollins College
Winter Park, Florida
November 9, 1996–January 12, 1997

Mitchell Art Gallery,
St. John's College
Annapolis, Maryland
September 5–November 16, 1997

Middlebury College Museum of Art
Middlebury, Vermont
December 12, 1997–February 22, 1998

Memphis Brooks Museum of Art
Memphis, Tennessee
June 26–September 7, 1998

The American Federation of Arts is a nonprofit art museum service organization that provides traveling art exhibitions and educational, professional, and technical support programs developed in collaboration with the museum community. Through these programs, the AFA seeks to strengthen the ability of museums to enrich the public's experience and understanding of art.

FOREWORD

The American Federation of Arts is to be congratulated on making available to the public this distinguished body of work by Nancy Graves. Since 1969, when the young artist's work was presented at the Whitney Museum of American Art, her painting and sculpture have been documented in numerous exhibitions and publications. Yet, familiar as her work in these two mediums may be, her printmaking is to date largely unknown. Nevertheless, it is only when we examine this body of prints that we can fully grasp the highly charged imagination of the artist. We therefore applaud the AFA for organizing this retrospective and producing the first catalogue devoted to her graphic work. Those unacquainted with the artist's prints will doubtless be impressed by the number and range of works assembled for the first time in this catalogue raisonné.

Graves made her first print in 1972 and since that time has worked with a variety of master printers in virtually every printmaking technique. Looking carefully at these prints reminds us that there are no boundaries in Graves's work; inspiration flows freely between her mediums. Just as sculptural elements routinely protrude from her paintings and her sculpture bears a brilliant palette of colors, so, too, her prints explore two- and three-dimensional space and color. The unceasing experimentation that characterizes the artist's work in other mediums is evident in her prints as well. Graves frequently combines processes to create a single work of vast technical complexity. When confronted with the limitations of a particular printmaking technique, Graves modifies it or abandons it altogether and develops her own, as she did when she printed organic material directly on paper at the Pilchuck Glass School. Enlivening Graves's prints is a gallery of figures and icons selected from the annals of history, religion, and mythology—humanist references that are fed by her extensive travels and study of history. The artist uses these images in provocative juxtapositions that obliquely comment on our own multicultural society. Graves's lyrical mix of abstract and representational form has made her work as easily identifiable as it is difficult to relegate to any existing category of contemporary art.

I am delighted to introduce Thomas Padon, whose essay and interview with the artist in these pages bring new insight to the exceptional work of Nancy Graves. His thorough documentation of the artist's prints will no doubt invite further study.

Those familiar with Nancy Graves's work in other mediums have experienced her unique blend of daring and delight. My hope is that viewers of this exhibition and its catalogue will find these qualities abundant in her graphic oeuvre and will share my own enthusiasm for the imaginative creativity of this extraordinarily gifted artist.

J. Carter Brown
Director Emeritus,
National Gallery of Art, Washington, D.C.
Chairman, United States Commission of Fine Arts

ACKNOWLEDGMENTS

This catalogue and the traveling exhibition it accompanies could not have been realized without Nancy Graves's continuous cooperation and her generous contribution of time and guidance: she has our deepest gratitude. Nancy is an artist of great intelligence, inventiveness, and depth, and we are proud to have played a part in exploring and documenting the sustained quality of her printmaking.

Our special thanks go to J. Carter Brown, director emeritus of the National Gallery of Art, for contributing the foreword to this publication.

This publication and exhibition would not have been possible without the efforts of many individuals at the American Federation of Arts. Thomas Padon, director of exhibitions, both curated and coordinated the project and authored the publication—and he did so with thoroughness and insight. Others whose contributions have been crucial to the development and realization of the project include Sarah Fogel, registrar; Melanie Franklin, exhibitions assistant; Rachel Granholm, curator of education; Evie Klein, scheduler; Alexandra Mairs, exhibitions/publications assistant; Michaelyn Mitchell, head of publications; Jillian Slonim, director of public information; and Robert Workman, former director of exhibitions.

Special recognition is due the staff at Harry N. Abrams, Inc., our copublisher—in particular, Margaret Kaplan, senior vice president and executive editor; Diana Murphy, senior editor; and Dana Sloan, designer.

We are pleased to acknowledge the participation of the museums on the national tour: the Nelson-Atkins Museum of Art, Kansas City, Missouri; the Frances Lehman Loeb Art Center, Vassar College, Poughkeepsie; the Butler Institute of American Art, Youngstown, Ohio; the Cornell Fine Arts Museum, Rollins College, Winter Park, Florida; the Memphis Brooks Museum of Art, Memphis; the Mitchell Art Gallery, St. John's College, Annapolis; Middlebury College Museum of Art, Middlebury, Vermont.

Finally, our thanks go to the Lila Wallace–Reader's Digest Fund for their support of this exhibition through the AFA's ART ACCESS program, and to the National Patrons of the AFA, whose contributions helped to make this project possible.

Serena Rattazzi
Director
The American Federation of Arts

POSTSCRIPT:
As this book was going to press, Nancy Graves succumbed to an illness she had fought with extraordinary strength and dignity. Nancy will be very deeply missed, and always remembered.

There are many people whose help was instrumental in bringing both this catalogue raisonné and its accompanying exhibition to fruition. At the American Federation of Arts I would first like to express my gratitude to Serena Rattazzi, director, for her unwavering support of this project. I was also fortunate to have the expertise and encouragement offered by Robert Workman, former AFA director of exhibitions. Michaelyn Mitchell, head of publications, skillfully orchestrated every phase of the catalogue and made many astute recommendations. Special recognition is due Donna Gustafson, curator of exhibitions, who was uncommonly generous with her time and provided valuable suggestions for the manuscript. I would also like to thank Melanie Franklin, exhibitions assistant, for her thoroughness and dedication. Others at the AFA who provided much appreciated assistance to this project are Sarah Fogel, registrar; Sarah Higby, exhibitions coordinator; Evie Klein, exhibitions scheduler; Alexandra Mairs, exhibitions/publications assistant; and Sybil Young, summer intern in the Exhibitions Department.

I would also like to acknowledge those people with whom Nancy Graves collaborated to make the prints represented in this catalogue. They have been extremely cooperative in responding to my numerous questions regarding documentation, particularly Deli Sacilotto and Rebecca Litowich-Sacilotto at Iris Editions, Marabeth Cohen-Tyler and Barbara Delano at Tyler Graphics Ltd., and Giovanna Zamboni-Paulis at 2RC Edizioni d'Arte. The assistance of Mary Noel Black at the Lunar and Planetary Institute, Houston, and David Aldera at New York Central is also greatly appreciated.

At Harry N. Abrams, my thanks go to Margaret Kaplan, Dana Sloan, and my good friend Diana Murphy, for their cooperation and professionalism.

Janie Samuels at Nancy Graves's studio helped enormously with this publication and coordinated myriad tasks with unfailing kindness and humor. My friends and colleagues Claudia Defendi and Karyn Zieve deserve special thanks for their insightful advice for this catalogue. Finally, I would like to thank Jim Wheelock for his inexhaustible patience and support in this—as in all—endeavors.

I am grateful for having the opportunity to work with Nancy Graves. My preparation of this catalogue would not have been possible without the countless hours she spent with me tirelessly speaking about her work or the access to her archives that she generously provided for my research. I am indebted to Nancy Graves for her cooperation and deeply appreciative of her energy and warmth.

Thomas Padon

INTRODUCTION

Nancy Graves made her first prints in 1972, a suite of ten lithographs inspired by maps of the lunar surface. At first glance these prints look like brightly colored abstract matrices. However, the individual titles Graves assigned—referring to specific lunar regions—suggest otherwise. The works in this series, Lithographs Based on Geologic Maps of Lunar Orbiter and Apollo Landing Sites (cat. nos. 1–10), like virtually all of the artist's prints, can be read on more than one level. Only when we realize that the images are based on lunar maps produced from satellite imagery and that Graves methodically transposed the topographic detail do we begin to understand the artist's intention, for these prints give some of the earliest signs of her interest in the natural sciences, visual perception, and the play between abstract and representational imagery. In the Lunar series the artist signaled her preoccupation with strategies of communication: how information is visualized, transmitted, and processed. Though cartography is only one means of communicating visual information, it is one that holds great interest for Graves, who has said that "mapping encompasses all our significant efforts."[1] It is in the very exercise of making a map that we seek to locate ourselves and begin to come to terms with the abstract spatial and philosophical relationships implied in the activity.

To date Graves has made 174 prints at thirteen printmaking workshops. In comparison with her painting and sculpture—which have been documented in numerous publications and exhibitions for more than two decades—the artist's prints have received little attention. Yet it can easily be said that in her prints one finds represented the sum of

Graves's artistic interests and investigations, her ceaseless experimentation with materials, and her goal of breaking down traditional boundaries within and between artistic mediums. The prints assembled in this catalogue illuminate the artist's exacting concern for matters of form, material, and process. It would be difficult to discuss Graves's printmaking without regard to her artistic investigations as a whole. Thus, while my principal focus is on the artist's prints, the essay considers her printmaking in the context of developments in other mediums.

Graves is unusually attuned to the phenomena of nature. A passionate interest in science led her to introduce unorthodox forms drawn from archaeology, astronomy, botany, cartography, paleontology, and zoology into her sculpture, painting, prints, and films. In the last decade the artist's intellectual pursuits have taken a more humanist course, as she has fashioned an enigmatic pictorial idiom from elements of world history. Graves has spoken of her desire to make art out of what she terms the "shards of art."[2] Like an archaeologist, she sifts through the layers of cultural and geological history to assemble a cache of images drawn from various disciplines, eras, and civilizations. Fragmented by the artist and inserted in layers of her own abstract form, these images endow her work with a complex range of references that become her personal language of sign and symbol. In her provocative juxtaposition of historical and organic images, Graves alludes to the common ties between cultures and disciplines, the relationship of past to present, and the continuum of history.

1. Nancy Graves, quoted in Roberta Smith, *Four Artists and the Map Image/Process/Data/Place,* exh. cat. (Lawrence, Kans.: Spencer Museum of Art, University of Kansas, 1981), 11.
2. This and all other quotes by Nancy Graves that are not footnoted have been taken from conversations held with the artist in New York between May 1991 and March 1995.

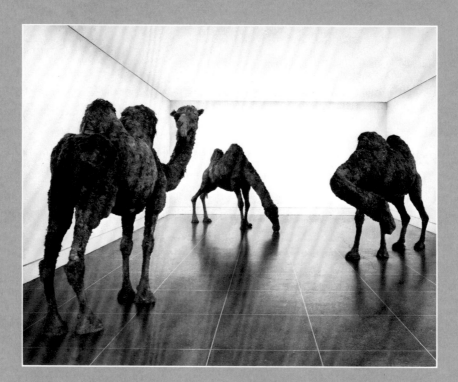

FIG. 1
Nancy Graves
Camel VI, VII, and VIII, 1968–69.
Wood, steel, burlap, polyurethane,
hide, wax, arcylic, oil paint, and
fiberglass: *Camel VI*. 90 × 144 ×
48″. National Gallery of Canada,
Ottawa; *Camel VII*. 96 × 108 ×
48″. National Gallery of Canada,
Ottawa. Gift of Allan Bronfman;
Camel VIII. 90 × 120 × 48″.
National Gallery of Canada,
Ottawa. Gift of Allan Bronfman

EXCAVATIONS IN PRINT

All art is at once surface and symbol.
Those who go beneath the surface do so at their own peril.

—OSCAR WILDE
The Picture of Dorian Gray

Nancy Graves's career was launched in 1969, when the Whitney Museum of American Art, New York, exhibited her *Camels* (fig. 1), a sculpture group on which she had begun work in Italy two years prior. It was remarkable that Graves, then a virtually unknown artist (it was only her third exhibition), was given an exhibition at a major museum; it was equally remarkable that the presentation became such a high-profile event, garnering reviews in publications such as *Arts, The New York Times, The Village Voice,* and *Time.* But then Graves's *Camels* were anything but ordinary.

The *Camels* shared in the provocative spirit of the age. Their overt physicality, repetition of form, and emphasis on process tie them philosophically most closely with Minimalist sculpture. Yet, these startlingly realistic beasts with their scraggly appearance—painstakingly constructed by the artist from wood, steel, burlap, hide, wax, and oil paint—were far from the reductive and purified forms of Minimalism. The fact that they were recognizable creatures placed them even further from Minimalist sculpture, with its antireferential tenet. The associations conjured up by Graves's literal evocation of the camel, however, were part of her agenda: to engage the viewer in a dialogue regarding reality and abstraction and to explore the nature of the aesthetic experience. By placing these objects—seemingly more at home in a natural-history museum—in a fine-arts context, Graves invited a debate on no less than the meaning and function of art. As Linda Nochlin has noted, a large measure of the *Camels'* subversive power extends from the viewer's inability to assign them satisfactorily to the category of either representation or abstraction.[1]

Much has been made of Graves's childhood association with the Berkshire Museum in Pittsfield, Massachusetts (see fig. 2), where her father worked as assistant to the director. The exigencies of space dictated that the Berkshire Museum display fine arts and natural history under the same roof. Thus, as has often been noted, the artist grew up without the traditional demarcation between the fine arts and natural history, as equally well versed in the iconography of Western art as in the vast range of plant and animal forms. Graves's intimacy with both art historical and organic form gave her a unique perspective that has informed her work for over two decades. In 1968 the *Camels* served as, so to speak, her declaration of independence.

In the years after she completed the *Camels,* Graves made sculpture that proclaimed her interest in primitive forms and cultures, evidenced by a partial list of their titles: *Evolutionary Graph*; *Fossils* (fig. 3); *Mummy*; *Pleistocene Skeleton*; *Shaman*; and *Totem*. Graves, like many artists of the 1970s, aspired to transcend Western rationality by presenting sculpture conceived, as described by Kirk Varnedoe, "on ideas about the structures of Primitive thought and belief."[2] In a 1970 interview, Graves noted that an artist "who keeps to that [Western] form is going to be trapped by it" and explained that she wanted "to find another structure, another way of thinking, which doesn't allow for Western rationality."[3] Investigating many of the alternatives to traditional modes of presentation prevalent at that time, she had

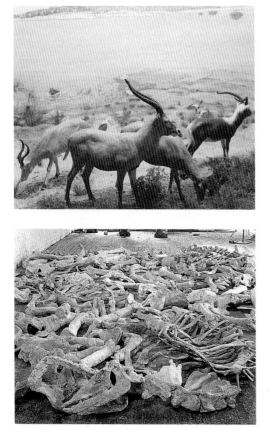

FIG. 2
Detail of Nile River group,
diorama from Animals of the
World in Miniature Room, The
Berkshire Museum, Pittsfield,
Massachusetts. 1956

FIG. 3
Nancy Graves
Fossils. 1969–70. Plaster, gauze,
marble dust, acrylic, and steel, 3
× 25 × 25′. Collection the artist

her new sculptures scattered across the floor, hung from the ceiling, propped against the wall, or supported by armatures that became a highly visible and integral component of her work. The strength of her early sculpture often obscures the fact that it was painting that Graves studied as a graduate student at Yale University, New Haven, from 1961 to 1964 and that she was completely self-taught as a sculptor. Yet, despite her early success, Graves suddenly stopped making sculpture in 1972 in favor of painting. The artist recalls that at that time she once again wanted to feel the sensation of brush to canvas. Rather than give up the inquiries she had begun in sculpture, however, Graves translated them to other mediums.

The Camouflage Series was Graves's first group of paintings. Her choice of camouflage in nature as her subject was in keeping with her interest in natural history and visual perception. It also provided Graves a formal model through which to continue the exploration into the dichotomies of abstraction and representation that began with the *Camels*. Graves adopted a pointillist style for these scenes of sea animals, reptiles, and insects. Throughout the series, brightly colored, stippled strokes reverberate on white grounds, lending a shimmering, atmospheric quality to the large canvases. In works such as *Camouflage Series No. 4* (fig. 4), Graves's apparently nonrepresentational field of dots suddenly shifts, revealing an underwater scene of fish. Acting just as camouflage does in nature, the artist's stippled marine forms dissolve suddenly back under their Neo-Impressionist protective cover. Brenda Richardson observed that in the Camouflage Series Graves translated many of her recent investigations in sculpture to a two-dimensional format.[4] Marking the beginning of the artist's interest in shifting figure-ground relationships, the Camouflage paintings share a dense, allover pattern similar to that

found in such sculptures as *Variability and Repetition of Variable Forms* (fig. 5). From this point on, Graves would frequently explore the figure-ground relationship in all the mediums in which she worked, often by placing whole and fragmented forms in layers so that they are revealed to the viewer simultaneously.

The artist again explored spatial depth and patterns as they occurred in nature in her three films shot on location in Morocco and Florida between 1970 and 1973.[5] Graves remembers being inspired at that point by Eadweard Muybridge's late-nineteenth-century photographic studies of animal locomotion.[6] In her films she similarly analyzed form and sequential animal motion, focusing the camera at close range on herds of camels in *Izy Boukir* (1971) or flocks of frigate birds and flamingos in *Aves* (1973) and cropping them into deeply layered compositions of abstract form.

In 1971 Graves began an extensive series of drawings and paintings that related to the mapping of diverse geologic regions. Appropriating map imagery was yet another means by which artists of the period freed themselves from traditional art constructs. As Roberta Smith noted, by the early 1970s it was "probably difficult to find an artist working in the Conceptualist or Earthwork mode who had not used a map at least once in some way."[7] While other artists explored systems of mapping, none did so with Graves's tenacity. Cartography would, in fact, prove to be her principal focus for the next two years and continue to inform her art until the close of the decade. The artist recalls being drawn to mapping because it is "one of the most complete abstractions . . . because it can relate to any kind of abstract thought."[8] Thus, unlike other artists, such as Jasper Johns, who were drawn to the map as a visual icon, Graves was attracted to the conceptual nature of a map as an abstract system of organizing space.

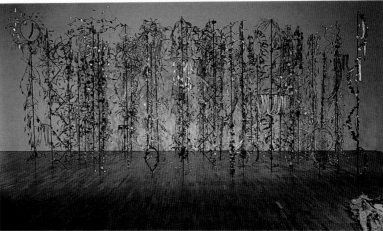

FIG. 4
Nancy Graves
Camouflage Series No. 4. 1971.
Oil on canvas, 96 × 72″. Collection the artist

FIG. 5
Nancy Graves
Variability and Repetition of Variable Forms. 1971. Steel, latex, gauze, wax, oil, and acrylic, 10 × 26 × 15′. National Gallery of Canada, Ottawa

From 1971 to 1972 the artist created a series of drawings, paintings, and prints inspired by maps, charts, and satellite imagery of Antarctica, the ocean floor, the Moon, and Mars. Even to those familiar with her work, Graves's new focus on such geologic regions appeared to have little in common with her earlier fossil sculptures. Yet, Graves explained, she was interested in the ocean floor *because* it was a source of fossils, and the Moon because *it was itself* considered to be a fossil of Earth.[9] At the same time the artist was no doubt also amused by the intellectual exercise of making abstractions of maps, which are themselves already two-dimensional abstractions of three-dimensional space. Over the next year Graves created series of works closely based on scientific materials she extensively researched.[10] She frequently added or deleted detail, changed the orientation, or combined portions of separate maps, charts, or photographs to strengthen their compositions. Additionally, the artist often altered the original colorations of the charts or maps, or in the case of black-and-white primary material, added her own coloration. Though she used the same pointillist technique she had developed for the Camouflage Series, Graves employed a limited palette and a tighter matrix of strokes, which largely account for the cool, pseudoscientific aura of these geographically inspired works.

Graves's use of lunar imagery recalls the appropriation of media imagery, one of the legacies of American Pop art of the 1960s. Television coverage of the Apollo lunar missions from 1968 to 1972 was extensive, especially of the 1969 flight of *Apollo 11,* when the fantasy of a man on the Moon became a reality. Because of the media attention, the image of the Moon was firmly imprinted in the American consciousness by the early 1970s. Notably, it also appeared in varying guises in the work of many of Graves's contemporaries, including Vija Celmins, Robert Morris, Robert Rauschenberg, and James Rosenquist. In contrast to these artists, Graves turned to the process by which the language of scientific data on the Moon had been gathered and codified into maps.

When she accepted an invitation in 1972 to work at Landfall Press in Chicago on her first prints to be issued in an edition,[11] Graves decided to create a series related to her drawings of the lunar surface, which also served as the basis for eight large-scale paintings she completed later that year. Graves had been unhappy with her previous experiences in printmaking—in graduate school and at the Atelier Mourlot in Paris the year following her graduation[12] —but now felt prepared for the challenge. During the 1960s, printmaking had been transformed from a medium seldom used by more than a few American artists to one that painters and sculptors turned to with increasing frequency as an alternative means of expression. The two figures largely responsible for the so-called print renaissance in America are Tatyana Grosman, who founded Universal Limited Art Editions in 1957 in West Islip, New York, and invited a number of artists—including Jim Dine, Helen Frankenthaler, Jasper Johns, Robert Motherwell, and Rauschenberg—to make their first prints; and June Wayne, founder of the Tamarind Lithography Workshop in Los Angeles in 1960 (since relocated to Albuquerque). Tamarind's primary mission was to revive lithography by training a new group of master printers, but the workshop also initiated a visiting artist program, which introduced dozens of artists to lithography and helped to establish the European tradition of the master printer–artist relationship in America. By the early 1970s a number of new printmaking workshops had been founded, and the print renaissance expanded beyond its original focus on

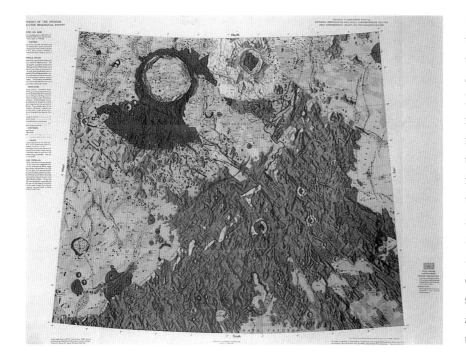

FIG. 6
R. J. Hackman
Detail from Geologic Map of
the Montes Apenninus Region
of the Moon. 1966. 32 × 47".
Courtesy Lunar and Planetary
Institute, Houston

lithography. With growing frequency master printers induced artists to work in intaglio and to try experimental processes, as well as to combine an increasing number of processes in a single work. In 1972 Graves entered a remarkably vibrant and technically sophisticated printmaking arena.

In consultation with Jack Lemon, master printer at Landfall (who had trained at Tamarind), Graves decided to translate her Lunar drawings, which had been based with varying degrees of literalism on original maps, into a suite of ten lithographs (cat. nos. 1–10). Lithography[13] is closely related to drawing, and the artist had had prior experience with the process. Graves drew her seemingly exact system of dots directly on sheets of Mylar, which were then transferred to light-sensitive aluminum plates.[14] As in her drawings, Graves retained much of the coloration of the original maps (fig. 6 shows the map on which

V Montes Apenninus Region of the Moon, cat. no. 5, was based), indicating geologic characteristics, and transposed their array of black lines representing craters, faults, rilles, and ridges on the lunar surface. However, Graves removed the legend from the map, making such colors and marks meaningless and calling into question the informative nature and function of a map. In the absence of recognizable imagery in the series, color equals structure. In some works, such as *VII Sabine D Region of the Moon, Lunar Orbiter Site IIP-6 Southwest Mare Tranquilitatis* (cat. no. 7) and *I Part of Sabine D Region, Southwest Mare Tranquilitatis* (cat. no. 1), Graves's colors coalesce into rudimentary horizontal bands, suggesting geologic stratification, while others, such as *II Fra Mauro Region of the Moon* (cat. no. 2), feature less regular color patterns and thus appear totally abstract. In contrast with her Camouflage Series, the Lunar prints have no natural form hiding beneath their surfaces to provide scale or reference. Spatial ambiguity abounds. Only the artist's pointedly specific geographic titles provide orientation and serve to remind us that these prints, though abstract in appearance, are rooted in precise scientific data.

Graves has stated that mapping is "by system and concept . . . allied with narrative or sequential time,"[15] suggesting that her preoccupation with maps was related to her study of Muybridge's sequential photographic studies of motion. Using a serial format in these Lunar prints, Graves declared her interest in narrative time. In addition, Graves printed her hand-drawn strokes off register to emphasize the sequential nature not only of the printing process itself but also of the accumulation of geographical data by the lunar satellite. Just as Muybridge's sequences of exposures reveal the fluidity of motion, so, too, the ten lithographs in the Lunar suite immerse the viewer in a spatial and temporal rhythm.[16]

Interest in the interplay between spatial perception and the planographic nature of lithography led Graves to experiment with *chine collé* and printing on Japanese papers and sheets of Mylar, which were laminated to the paper, creating layers of varying translucency. Though referring to her map paintings, the artist's comment that "emphasis on layering is an exposure of 'process' as a formal ingredient of the *making* of the painting" applies equally to this print series.[17] Conceptually and formally, Graves introduced the dimension of time into the print series, emphasizing the *process* of mapping over the composition of the completed maps themselves.

But just as we might question why Graves did not simply present stuffed camels at the Whitney in 1969, thereby extending the Duchampian tradition of the readymade, we could ask why she did not simply transfer actual lunar maps—legends and all—directly into print for this series. After all, to have done so would have been to comment obliquely on the saturation of visual information in contemporary society. Perhaps Graves realized that screenprinted versions of the lunar maps would have been read in the same way as the originals, which is to say, hardly at all. One result of the assault of visual information today is that we spend increasingly less time with each new stimulus. In order to restore acuity to viewers whose senses had been dulled by the onslaught of visual stimuli, Graves began, as Linda Cathcart has noted, "to remove images from their naturalistic context in order to allow the viewer to form a deeper relationship with the underlying information they offered."[18] In the Lunar series, Graves reinterpreted form in an attempt to have the viewer focus on the mental processes involved in constructing and reading a map and visualize the vast three-dimensional spatial coordinates represented. Though her maps, like her *Camels* before them,

do not for a minute feign to be the real thing, they are somehow more accessible for being made by hand. In the Lunar series the artist made landscapes of geologic time, rife with references and spatial complexity.

After the Lunar series of prints and the eight paintings that immediately followed them, Graves began to move away from the controlled approach that characterizes these works. While she nevertheless continued to explore various processes of scientific observation—in addition to lunar maps, Graves now introduced imagery drawn from satellite views of Mars and various charts relating to astronomy, meteorological data, and ocean currents—she changed her formal approach. The regularized, allover patterning of the Camouflage and Lunar series gave way to more open compositions.

In 1975 Nancy Graves was commissioned by the National Air and Space Museum in Washington, D.C., to make a print to benefit the museum. Graves was specifically interested in printmaking's facility to produce complex layers, and in *National Air and Space Museum Silkscreen* (cat. no. 12) the artist exploited the ease with which screenprinting can create distinct, flat planes within a shallow space by means of overlapping form. In the print, as in such contemporary paintings as *Rheo* (fig. 7), the artist juxtaposed a number of images of Earth, with abrupt changes in scale and orientation to underscore their origins as data from multiple infrared and weather satellites. Thus, a broad view of the Atlantic coastline of the United States from Virginia to Maine is represented by the large white form that descends diagonally from the top left, while a closer view, resembling patchworklike farmland, dominates the lower half of the print. Graves created a lively composition through use of emphatic diagonals, bold contrasts of primary and secondary colors, and

the visual pun of a "brushstroke" appearing to break through the plate mark at top, partially obscuring the museum's name. This print signals Graves's first combination of abstract (in her overlay of discrete rectangles and expressionistic line) and representational (in the images of Earth abstracted from satellite photographs) form. The following year the artist used the same screens to create *Ertsne* (cat. no. 13), but she replaced the high-key colors and concomitant jangly rhythm of *National Air and Space Museum Silkscreen* by what is almost a ghost image. The artist's limited tonal range in *Ertsne* dissolves the previously discrete forms and pushes the composition to the edge of total abstraction.

In 1977 Kenneth Tyler invited Graves to make a series of intaglio prints at his workshop outside New York, initiating the first of their many collaborations.[19] Given Tyler's reputation for encouraging artists to explore new techniques and combine several processes in a single work,[20] it is not surprising that in the Synecdoche series (cat. nos. 14–19) Graves—

who had previously worked only with lithography and screenprinting—now created six prints combining etching with aquatint, engraving, drypoint, and pochoir. Intaglio processes would open up a new range of expressive and formal possibilities in her printmaking.

Graves felt that there was still much to be explored in her abstractions of the lunar surface. Rather than return to original source material, the artist decided to use her own Lunar lithographs as a basis for the Synecdoche series, just as she had reinterpreted her lunar drawings in a series of gestural watercolors and paintings completed in 1976. In comparison with her earlier lithographs and screenprints, the Synecdoche series is startling in its simplicity. Graves moved away from the literalism and precise patterning of her first print series and exalted in the sensuousness of line, which she laid down in spare, calligraphic strokes. The apparent spontaneity of her line belies the artist's circumspect reflection on each print's composition, which included extensive proofing and the fabrication of a mock-up on which cutouts of her strokes could be precisely arranged and studied. Each of the six works in the series relates directly to a print from the Lunar series.[21] In *Saille* (cat. no. 14), for example, Graves reinterpreted *VIII Geologic Map of the Sinus Iridum Quadrangle of the Moon* (cat. no. 8), reducing the composition to its elemental structure. Employing etching, aquatint, and pochoir, she transposed her earlier dense matrix of pink, gray, green, yellow, blue, and violet dots into the spare lines and transparent color washes of *Saille*. Finally, the artist distilled the external outline of *Sinus Iridum* to a single L-shaped stroke of pastel that echoes part of the faceted contour of the earlier composition (albeit in inverted fashion). Just as she had reduced these compositions to a basic structure, Graves assigned titles

FIG. 7
Nancy Graves
Rheo. 1975. Acrylic, oil, and gold leaf on canvas, 64 × 64″. The National Museum of Women in the Arts, Washington, D.C. Gift of Wallace and Wilhelmina Holladay

within the series that have no specific meaning but refer, in the artist's words, to the "roots of language."

In the Synecdoche series Graves experimented with the full expressive potential of each intaglio process. The artist recalls that it was this series that marked her realization of the degree to which each technique could be read as a separate planar entity, thus providing her the means to expand beyond the compressed spatial confines of the 1972 Lunar series. Fluctuating color and form are further enlivened by hand-colored pastel strokes, though the impressive range of tonal gradations and exquisite textures achieved by Graves and Tyler in the series make it difficult to determine which lines are pastel and which are made by an intaglio process. Like many artists, Graves was interested in hand coloring as a way to counter the mechanical quality of printmaking. Yet she used pochoir, applying the pastel by hand through a stencil, ironically ensuring that the marks drawn "by hand" were as uniform as those etched into the plates—another instance of her playing with the perception of images and the limitations of the print medium. Since completing the Synecdoche series, Graves consistently has favored intaglio processes, etching in particular. In addition, her prints continue to grow increasingly complex in formal and technical terms.

Graves had studied archaeology in the late 1960s while making her fossil sculptures, and in 1977 she intensified her research in that field, coincidental with the completion of a large canvas, *Scaux* (fig. 8). Two years later Graves was awarded a residency at the American Academy in Rome, where she studied preclassical and classical cultures for a new group of sculpture. She also began preliminary work with Valter and Eleonora Rossi of 2RC Edizioni d'Arte in Rome on an intaglio print project, *Paleolinea* (cat. no. 58).[22] Graves made many visits to ancient sites

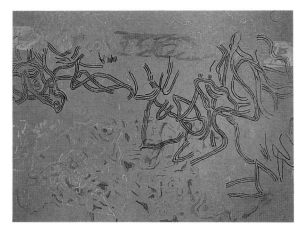

FIG. 8
Nancy Graves
Scaux. 1977. Acrylic on canvas, 64 × 88″. Collection the artist

throughout the Mediterranean in 1979. This intense period of research and travel had exciting consequences for her career that even Graves may have not foreseen, for in addition to confirming her interest in archaeology, the artist began to analyze the physical overlay of cultures she now observed first-hand at archaeological sites. Graves witnessed in these excavations the palimpsest of history—how vestiges of one culture are subsumed and overwritten by the next—and began to formulate a parallel formal structure for her paintings and prints in which diverse images would be fragmented and laid down in distinct yet overlapping layers. The beginnings of Graves's formal investigation appear in *Paleolinea.*

Paleolinea and the painting on which it was based, *Scaux,* also illuminate the extent to which Graves contemplates the evolution of her own work. The artist frequently returns to a composition when the passage of time, or adoption of another process or medium, allows her to make a stronger statement. In *Scaux,* Graves created a vaporous ground on which she scored an array of parallel lines that gradually reveals the outlines of two bull heads—a motif

that, despite the title of the painting, was actually taken from an Upper Paleolithic cave drawing from Altamira (fig. 9) rather than Lascaux. *Paleolinea,* a large print begun in 1979 combining etching, aquatint, and drypoint, is closely related to *Scaux* but more complex. Graves retained the animal outlines as the substructure of the composition but used drypoint to give them greater emphasis in the print. Likewise, the enigmatic form that extends horizontally from the upper right edge, almost transparent in the canvas, is given more dramatic presence in *Paleolinea.* Based on a type of carved bone or horn often found in Upper Paleolithic sites (fig. 10), this form is cloaked in a chiaroscuro that suggests carved recesses along its irregular surface. Graves also introduced motifs appropriated from other Upper Paleolithic sites: a group of horses reminiscent of those found in the cave of Les Trois Frères (in Languedoc, near the southern border of France), etched in the inky haze just below the bone form, and a pattern of dots resembling animal hide that is found in several Upper Paleolithic cave paintings. Guided by Valter Rossi, a master printer known for his expertise in aquatint, the artist produced exquisite surface effects and an extraordinary range of tenebrous tones more evocative of the primal imagery depicted than was the comparatively unmodulated field in *Scaux.* By constructing *Paleolinea* in distinct layers, Graves evoked the often feverish overlapping of the images in the cave paintings themselves. Resembling cellular activity at microscopic level, Graves's protean forms and spirochete lines in *Paleolinea* refer to the roots of life, just as the chalky outline of the artist's hand clearly visible at right refers to the ritual aspect of Upper Paleolithic painting, the very roots of Western art and culture.

Graves moved closer to complete abstraction in her ambitious Monoprint series, completed at Tyler

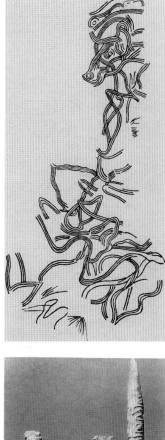

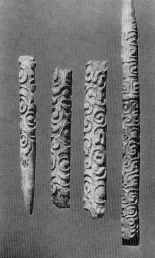

FIG. 9
Detail of Paleolithic-period meanders from the cave of Altamira, Spain

FIG. 10
Upper Paleolithic-period carved reindeer horns

Graphics in early 1981 (cat. nos. 27–57), a series that closely parallels her highly gestural contemporary paintings and watercolors. The monoprint process appealed to Graves, as it allowed her to investigate painterly concerns in a mechanical medium but without all the technical encumbrances of printmaking. Monoprints, as well as monotypes, enjoyed a resurgence in the early 1980s as a means by which artists could work in printmaking without producing uniform editions.[23] Graves created this suite of thirty-one monoprints at Tyler Graphics using one polished magnesium plate and two etched copperplates in various combinations. Quotations from *Paleolinea* are recognizable throughout the series: the artist's handprint, the spirochete lines, and the animal hide pattern of dots. With form thus largely established, Graves focused on color, which she mixed directly on the plate with uncharacteristic vigor, often heightening tonal contrasts by printing on paper colored with printing inks thinned with varnish. Though at times her expressionistic color is almost impenetrable, virtually overpowering the figure-ground relationship, Graves generally achieved a balance between luminous color and abstract form in the series, as seen in *Chala* (cat. no. 33). Individual works in the series carry the artist's typically enigmatic titles. Like those of the 1977 print series, they are nonreferential, but Graves finds them allusive of the root sounds of languages.

The importance of the artist's experimentations in sculpture during the late 1970s and early 1980s to her work in other mediums cannot be overstated. Prior to 1977 Graves had alternated between periods of making either sculpture *or* painting and prints. In the late 1970s, however, she began working in all three mediums more or less simultaneously. It was a remarkably active period, one that included the completion of the artist's first bronze, *Ceridwen,*

out of Fossils (1978), employing the lost-wax process; *Quipu* (fig. 11), a large sculpture based on an ancient Andean counting device made of knotted string; and the Synecdoche series and the related group of watercolors and paintings previously discussed. *Quipu,* completed at the Tallix Foundry in 1978, marked a turning point for Graves; for this piece she worked in direct casting for the first time. Direct casting involves encasing an object (in the case of *Quipu,* nautical ropes and string) in a ceramic shell, which is then baked in a furnace until the heat incinerates the object, leaving behind a mold of its form. Molten bronze is poured into the mold, and, after cooling, the mold is broken away to expose a minutely detailed replica of the original object in bronze. The direct-cast process profoundly affected Graves's approach, for it allowed her to indulge her interest in organic form and introduce a virtually limitless variety of found and natural objects into her sculpture without what she called "the tedium of modeling."[24] The principal drawback to the direct-cast process—it does not allow for sculpture to be produced in editions, as the mold creates only one cast before it is destroyed—was inconsequential to Graves in comparison with the spontaneity that the process brought to her work.

When Graves shifted to the direct-cast process in 1978, she stopped making preliminary drawings for her sculpture. Instead, the artist has amassed a large inventory of direct-cast bronze forms—from scissors to pea pods, sardines to farm tools—which she assembles to create an individual work, welding them into implausible compositions that appear to defy gravity. Describing this sculpture, Graves remarked, "I try to subvert what is logical, what the eye would expect."[25] Indeed, the artist creates compositions in which wild juxtapositions of scale (any object can be scaled up or down after being direct

cast according to her preference) and form abound. As cast and arranged by Graves, objects contradict their original nature: a delicate lamp shade becomes the base of a sculpture weighing several hundred pounds, or a string bean is transformed into a giant tentacle. Color, which had appeared unimportant to the artist in her earth-toned sculpture of the 1970s, gained new emphasis in her direct-cast sculpture. Graves applied rainbow-hued patinas and enamel paints directly and copiously to her sculpture after welding in a process developed for her at the Tallix Foundry in which the artist fuses the pigments to the treated bronze surfaces with a blowtorch. Describing the palette of her direct-cast sculpture, Robert Storr aptly termed it "Oriental, even Indian in cast. Organized around saturated and slightly 'off' primaries, with supplementary contrasts of secondary colors—purple, red-orange, cobalt green."[26] Since the early 1980s Graves's almost surrealist juxtaposition of form and multicolor surfaces have made her direct-cast sculpture as distinctive as her *Camels* had been over a decade before.

From the early 1980s to the present Graves has displayed a remarkable fluidity between mediums. Experiments in one arena are often repeated in another. Not surprisingly, the same gutsy juxtapositions of form—and, concomitantly, of metaphor—that characterized her new sculpture appear in her painting and prints. Just as she amassed an inventory of direct-cast objects for her sculpture, Graves began to collect a cache of images for her graphic work taken from nature, science, religion, icons of art history that the artist saw on her extensive travels, and, of course, her own work. Fragmented and removed from their original context, these images become a vocabulary of signs that Graves uses ideographically to refer to various disciplines, cultures, and eras.

Calibrate (cat. no. 24), one of two composite

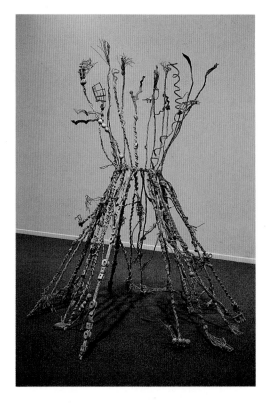

FIG. 11
Nancy Graves
Quipu. 1978. Bronze with polychrome patina, 70 × 60 × 58″. Collection Helen Elizabeth Hill Trust, Houston

prints Graves completed at Tyler Graphics in 1981, is the first example of the artist's formal strategy of juxtaposing fragments of disparate objects. In *Calibrate* the artist again reexamined her earlier work, first by basing the print on a 1979 painting of the same name, and second by visually referring in the composition to no less than three of her sculptures from the 1970s. Depicted in the central red and black geometric form are *Calipers* (fig. 12), a sculpture consisting of bent segments of hot-rolled steel, represented in the print by the network of white, yellow, and red V-shaped lines, and *Variability and Repetition of Variable Forms* (fig. 5), represented by the diverse organic forms impaled on vertical spikes rising from the bottom. A group of skeletal camel legs drawn from *Variability of Similar Forms* (1970)

FIG. 12
Nancy Graves
Calipers. 1970. Quarter-inch hot-rolled steel, 1 × 10 × 15'. Collection the artist

appears twice, to the left of the geometric form and rising behind it on the right. *Calibrate* displays a color palette equal in intensity to that of the artist's bronze sculpture. Graves presaged a new assertive energy in her prints in the strident color contrasts, the wiry black lines that dart nervously in and around the contours of the bones on the left, and the vigorous strokes that push against the confines of the printing plate.

By introducing fragments of three key early sculptures in *Calibrate,* Graves essentially recapped the first phase of her sculptural career. Like many of her prints, this one can be read on more than one level. Joan Simon has suggested that those unfamiliar with the sculptures depicted may find the composition an enigmatic study of abstract and representational form; while those acquainted with these works may not only savor the memory of the individual sculpture's previous incarnation but also search to find meaning in Graves's new juxtaposition.[27] In *Calibrate,* as in her direct-cast sculpture, the artist found unanimity in disparate form.

Graves refined her practice of combining art historical and organic form in deeply layered compositions during the mid-1980s. Particularly revealing of her process is the Simca series (cat. nos. 60–62), three screenprints the artist made over a period of six months at Simca Print Artists, Inc., in New York. The first, *5745* (cat. no. 60), was commissioned by the Jewish Museum in New York and completed in late 1984. As weightless as her direct-cast sculpture, the composition features a similarly unlikely assemblage—bean pods, a frog, fragments of a classical head, a Byzantine mosaic, and meandering parallel lines, recalling those in *Paleolinea,* radiating out from a central pentagon containing a stylized palmetto leaf and orchids. The remarkably free exchange occurring between Graves's prints and

her work in other mediums can be seen by comparing *5745* with *Discoid* (fig. 13), a direct-cast bronze that includes the same palmetto leaf and flowers, or with such paintings as *Sceadu* (fig. 14), which also features the compositional device of abstract and representational imagery revolving around a similar geometric form.

Graves returned to Simca Print Artists twice in the following months to create *75 x 75* (cat. no. 61) and *Six Frogs* (cat. no. 62). For both of these prints the artist reused the screens from *5745*. In order to create a new density of form, she supplemented the composition with thirteen new screens, adding images of leaves, small squares recalling tesserae, more bean pods, and small bundles of parallel lines resembling vertebrae. The print reveals Graves's continued interest in visual perception and repetition and fragmentation of form. She added five frogs, one of them cut off at the top, one cropped by the pentagon at the bottom, and one of the three at the left virtually transparent, and a second classical head, cropped in half at the right margin. Finally, she subtly inverted the orientation of the pentagon form as seen in *5745*. In fact, finding the often-obscure but abundant differences between the three prints recalls those childhood visual games in which pictures that at first glance appear identical actually contain numerous disparities. Graves replaced the bold contrast of unmodulated color in *5745* with a combination of opaque inks, which absorb the light, and iridescent inks, which reflect it, demonstrating a new concern for transparency and effects of light. Divisions between layers are less distinct, causing objects in *75 x 75* and *Six Frogs* to alternately recede and project. The spatial structure is further obscured by Graves's decision to print selective forms slightly off register (most notably the frogs), self-consciously belying the technical sophis-

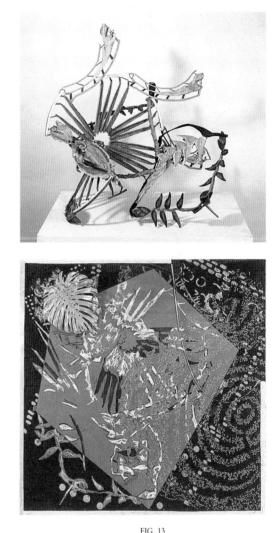

FIG. 13
Nancy Graves
Discoid. 1982. Bronze
with polychrome patina, 37¾ ×
45 × 37½". Private collection

FIG. 14
Nancy Graves
Sceadu. 1983. Oil on canvas
with aluminum sculpture and
tape, 96 × 96 × 21¾". Collection
the artist

tication of these complex screenprints.

What determines the rapidity with which the eye moves through any of Graves's recent compositions is the degree of recognizable form. With these three works completed at Simca the artist began to use the sequential process of screenprinting—numerous screens to layer and overlap color and form—to manipulate the ease with which the viewer is able to discern the fragmented images buried in her prints. She could selectively place her ideograms, as Jean Feinberg has aptly termed the artist's private visual vocabulary,[28] at the topmost, or last, layer, where they are easily read, or near the bottom, that is, among the first screens printed, where they become almost unrecognizable. In this way, the artist establishes the varied rhythm of her prints. Graves anticipates that each viewer will mentally reconstruct her fragmented images, and as each new form is recognized, individual associations will reverberate and be transmuted into a new composite. In this regard Graves ascribes no set meaning to her prints, realizing that the personal experience of each viewer largely determines what associations he or she will project onto the composition. As for her idiosyncratic attraction to the frog, Graves states that the frog, like the camel before it, was of interest specifically because it had been little explored in Western art.[29]

Graves began work in 1984 on the Black Ground series (cat. nos. 65–67), a group of intaglio prints published by 2RC Edizioni d'Arte, distinct within the artist's graphic work as it is the only one in which black predominates. The series has much to do with the paintings the artist completed between 1981 and 1983 and the costumes and set she designed in 1985 for Trisha Brown's dance *Lateral Pass,* in all of which she explored the effect of brilliant colors on black grounds. *Anifoglie* (cat. no. 65),

the first in the series, features the artist's eclectic grouping. Plant forms float weightlessly through the composition, balanced by a scrim of multicolor curving lines based (as the artist related) on the foundations of specific archaeological sites whose excavation records she had reviewed in the library of the American Academy in Rome. Graves recalls that she began the series as she was reassessing the theories of color perception espoused in "Interaction of Color," the noted course (later published in a book of the same name) developed by Josef Albers for the Yale School of Art and Architecture, where he was chairman of the Department of Design from 1950 to 1958.[30] She had taken the course as a graduate student, and in 1984, almost twenty years later, she renewed her interest in the optical effects of color in this series through the use of intense, neon-like inks. In place of the ethereal washes and marks of the 1977 Tyler Graphics series, or the chaotic overlapping of form and transparent color of the Simca series, Graves exhibited a new solidity and clarity of form in *Anifoglie*—individual objects were now legible.

Neferchidea (cat. no. 66) perhaps best demonstrates the affinities and disparities between the Black Ground series, begun in 1984, and the paintings Graves executed earlier, such as *Nefer* (fig. 15). The image of Nefertiti, taken from the celebrated limestone bust of about 1360 B.C. in the Staatliche Museen, Berlin, dominates the canvas in red pointillist dots at the left.[31] Passages of highly gestural strokes, pink tessera-like shards, and angular white lines struggle for dominance above a murky ground. The disparate elements, however, remain just that; Graves did not achieve here the same synthesis of form as she has in her prints or sculpture. As do most of the black-ground paintings, *Nefer* lacks the tension between figure and ground that had become so palpable in the prints. Printmaking allowed

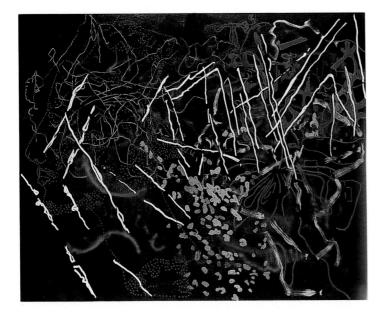

FIG. 15
Nancy Graves
Nefer. February 1982. Oil on
canvas, 64 × 80″. Collection
United Missouri Bank N.A.,
Kansas City

Graves to create discrete planes. In *Neferchidea,* the
eye is drawn quickly to the center of the composi-
tion and to the stylized palmetto leaf, behind which
a long blue snake unfurls. Graves used aquatint to
create the richly modulated fields of the black
ground and the saturated colors on which they
reverberate. Color contrasts incite forms alternately
to recede and advance. The artist further manipulat-
ed spatial equilibrium through selective use of
embossing: the large curving lines and spikes of the
palmetto leaves physically project toward the viewer,
as do select areas of the black ground, creating forms
that are perceived almost subliminally.

In the artist's New York studio is a large box in
which lie photocopies, photographs, and pages torn
from magazines and newspapers. This nondescript
container offers great insight into Graves's recent
work, for not only does it constitute a compendium
of her interests, it also serves as a metaphor for her
formal approach. Removed from their original con-
text, the illustrations contained within—of Greek

and Roman sculpture, Pompeian frescoes, insects,
Theban tomb paintings, molecular diagrams, Japan-
ese *ukiyo-e* prints, snakes, Byzantine mosaics, astro-
nomical phenomena, textile designs, Etruscan tomb
paintings, classical music scores, architectural details,
botanical prints, Flemish altarpieces, and medieval
manuscripts, among others—have little in common
except that they all caught the artist's voracious eye
and lie in a collective jumble. To Graves, each pre-
sents a pictorial embodiment of the culture or disci-
pline from which it was drawn—the very definition
of an ideogram. By combining fragments of one
archetype with another within a single composition,
Graves has created visual and metaphorical juxtapo-
sitions as unexpected as the stratified grouping of
illustrations themselves. The artist explained that by
visually quoting from the past, her own work would
be brought "back into the art historical context." By
means of this personal visual vocabulary Graves has,
since the late 1980s, added the weight of history to
her combination of disparate forms.

The Clash of Cultures (cat. no. 68) is the first
instance of the artist's appropriation and juxtaposi-
tion of diverse historical motifs. Graves had previ-
ously introduced historical figures in two print
series: Nefertiti in *Approaches the Limit of I* and
Approaches the Limit of II (cat. nos. 25 and 26) and
the Roman head that appears in the Simca series of
1984–85 (cat. nos. 60–62), though in each the figu-
rative elements are partially obscured. Graves
evinced a new comfort with the human figure; as
the artist pointed out, at that time she began to give
"equal meaning" to both figurative elements and
ground. Assembling visual fragments in this large
intaglio print much like a collage, Graves introduced
a figure based on a twelfth-century mosaic from the
church of San Marco in Venice on the right, while
on the left a female head in profile drawn from a

fourth-century B.C. Etruscan tomb painting extends into the margin. Alongside is a dragon, which, Graves recalls, alludes to "medieval art history." Between the female figures is a field of colorful patterns and forceful diagonals. It visually echoes the centuries separating the cultures that produced their original images and gives visual form to what the artist referred to as "the clash of history."[32] Despite the spirited patterning, a new clarity and physicality emerge; gone is the insistent overlapping of form seen in earlier prints such as *Six Frogs* (cat. no. 62).

Of course, such formal schemas are only the means of entry to Graves's private universe of ambiguous juxtapositions. Referring to the drawing on which the print was closely based, Graves explained that the composition was about "the reverberation of different points of view due to the proximity of cultures that were formerly distant from each other,"[33] by which she indicated that the relationships *among* the objects or figures, that is to say, their affinities *or* disparities, are her focus, not any individual figure or motif itself. To this end, Graves selects historical figures or motifs that she feels the viewer can associate—if not specifically identify—with a culture. Once recognized, each image evokes a set of associations according to the viewer's experience. Thus, as suggested by the quote from Oscar Wilde that opens this essay, Graves's prints can be examined on several levels. The enigmatic titles Graves has drawn from fragments of literary text since the late 1980s encourage such cognitive flux. When looking at Graves's prints, the viewer may choose to focus only on the formal qualities of their surfaces or contemplate the extended range of the artist's metaphorical associations, running through their sequences of meaning again and again in various permutations. The artist has said that she selects any given historical image "ten

percent for its history, ninety percent for its form."[34] Yet it is that historical component that grounds her recent work and initiates an open-ended discourse between Graves and the viewer.

In 1989 Graves moved away from the flat, collagelike approach of *The Clash of Cultures* toward a formal strategy relating to her contemporary drawings in which she constructed complex compositions of layer after layer of historical and organic imagery laid down in translucent strata. For example, in *Canoptic Prestidigitation* (cat. no. 74; see note on spelling), completed in 1990 with Donald Saff at Graphicstudio in Tampa, Florida, Graves assembled on a nonhierarchical plane from left to right ducks and canopic jars from a Theban tomb painting; an enlargement of drapery (in black over silver) from a Hellenistic sculpture; the hand of God (in purple) and the head of Eve (in red, fig. 16), both from Michelangelo's late Renaissance Sistine Chapel ceiling fresco; snakes (in green and yellow); mourning women from another Theban tomb painting; and, finally, a *chine collé* cast relief of the Egyptian falcon god, Horus. The clash of disparate imagery of varying scale and orientation is initially somewhat dizzying; one image bleeds into the next. Graves requires the viewer to search through the interlocking layers of this enigmatic narrative to seek out individual figures.

It is interesting to note that Graves has never directly introduced photographic reproductions into her work, as have many artists working with strategies of appropriation. Graves has said, "What I enjoy about objects of the past is the process of their fabrication and the diverse reasons for which they have been made."[35] The cultural context of each historical image the artist selects is as important to her as the image itself. In *Canoptic Prestidigitation,* for example, while a photograph of Michelangelo's fresco would reproduce his painting as precisely as direct

casting rendered forms for the artist's sculpture, Graves feels it would do little to convey the spirit in which the painting was made. Photographic reproductions are too literal, too jarring for Graves. Instead, the artist makes drawings of projected images and then transfers the drawings into her prints, in effect digesting them before incorporating them into her work. In choosing to present fragments of figures or objects, Graves encourages a new examination, especially of images that have become visual clichés, such as the hand of God in Michelangelo's *Creation of Adam* fresco. By breaking down and reassembling images and placing them in new contexts, she challenges us to reconsider their inherent meanings.

Graves has, since the mid-1980s, continued to transpose the results of experiments in one medium to another; consequently, she has achieved a remarkable synthesis in her work. Just as the artist cloaks her direct-cast sculpture in a painterly coat of brilliant patinas and enamel paints, Graves has, since 1983, further confounded the boundaries between painting and sculpture—and two- and three-dimensional space in general—by often adding brightly painted aluminum reliefs to her paintings and drawings. Not surprisingly, she found a way to employ this formal device in her printmaking, beginning with two large-scale prints completed at 2RC Edizioni d'Arte in Rome. These prints feature embossed reliefs that, like the relief-bearing paintings and drawings before them, boldly contest the supposed two-dimensional nature of their medium. In *Stuck, the Flies Buzzed* (cat. no. 73), Graves translated *Footscray,* a painting from her 1985 Australia series, into an intaglio print. Rather than add an aluminum relief to the print, as she had done in the canvas, however, Graves added a screenprinted and embossed paper relief made from leaves

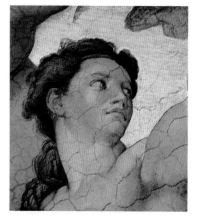

FIG. 16
Michelangelo
Head of Eve. Detail from *The Temptation and the Expulsion.* 1508–12. Fresco. Sistine Chapel, the Vatican, Rome

she gathered in Valter and Eleonora Rossi's garden in Rome.

Iconostasis of Water (cat. no. 85) likewise incorporates a three-dimensional relief into a composition well stocked with Graves's diverse cast of personages. In the translucent style of her current intaglio printmaking, the work features a pattern of blue stars and a group of ducks inspired by Theban tomb paintings; a depiction of Cleopatra at the left based on a drawing by Michelangelo; the head of a girl from a Greek stela; and the artist's ever-present overlay of abstract scrawling. Surmounting the composition is an embossing Graves made spontaneously from three fish after an outing to a Roman food market. The embossed relief is humorous and poignant—the paper fish rise buoyantly over figures that lie submerged in history. Through transparent layers, fragmented images, and shifts in scale and orientation, Graves alludes here, as in many of her recent prints, to nature, history, and printmaking as dynamic processes.

FIG. 17
Nancy Graves
Canoptic Legerdemain. 1990.
1 of an edition of 7. Brushed
stainless steel, aluminum mesh,
cast resin, cast paper, aluminum
(Hexcel) panels, cast epoxy with
sand and marble dust, and a litho-
graph on Arches Cover white
paper with *chine collé* and cast-
paper collage from Arches pulp,
85 × 95 × 37″. Collection the artist

Perhaps most indicative of the interaction
between her two- and three-dimensional work is
Canoptic Legerdemain (fig. 17), a large sculpture pro-
duced in an edition and completed in collaboration
with Donald Saff at Graphicstudio, in which Graves
incorporated the lithograph *Canoptic Prestidigitation*
(cat. no. 74) as a background element. The image of
Michelangelo's hand of God and the figure of Horus
now project toward the viewer, while recurring
motifs in many of Graves's prints—a hunting scene
based on a painting in a Theban tomb, translated
into laser-cut steel; a snake, translated into alu-
minum mesh; and a waterfall, translated into a
sinewy curve of cast epoxy—now protrude deep
into the viewer's space.

In 1991 the artist collaborated with the writer
Pedro Cuperman on *Tango,* a large folio published
by Iris Editions in New York with eight intaglio
prints by Graves (cat. nos. 77–84) and thirteen pages
of text by Cuperman that celebrate the social and
physical intricacies of the Latin American dance that
gives the folio its name. With master printer Deli
Sacilotto, Graves worked for the first time with the
technique of direct gravure. The artist drew images
of a snake, praying mantises, lice, a lyrebird, fossils of
prehistoric birds, a carp, orchids, and beetles on
sheets of frosted acetate. These were transferred to
a copperplate using sensitized carbon tissues and
then etched to reproduce the tones of the original
drawings. Graves subsequently worked on the plates
directly with aquatint and drypoint, selectively bur-
nishing them with a power tool and/or employing
spit biting to modulate the tones.

Graves conceived of the prints in the folio as a
continued exploration of pattern in nature and as a
tonal study of black and white. The artist calls *Logic
of Neon Signs* (cat. no. 80) the "white print," and in
it Graves worked to bring out as much of the off-

white ground of the paper as possible between the articulated frames of the two praying mantises that cut diagonally across the sheet. On the opposite end of the tonal scale is *Tracing Its Own Footsteps* (cat. no. 77), in which a feathery border resembling graphite powder, produced by means of etching and aquatinting rice on the copperplate, surrounds the image of a flea that Graves repeated four times (again recalling Muybridge) and echoed in the collagelike photogravure laminated to the support at the upper right. If the rich, vaporous shades of black and gray are reminiscent of *Paleolinea* (cat. no. 58), it is no coincidence. Graves even commented that with *Tango* she had come "full circle" from that earlier print. More than once the artist has asserted, "There is nothing more challenging and meaningful than to make prints in black and white." For an admitted colorist, it is ironic that the nine prints Graves has made in black and white are among her most powerful. The cryptic titles of the prints in the folio were selected by Graves from Cuperman's text for *Tango*. The poet speaks of the dance as a gradually unfolding ritual, stating near the conclusion, "Tango helps you find your own levels of proximity." The human figure is conspicuously absent in Graves's illustrations for *Tango,* but her choice of plants and animals, combined with her anthropomorphic titles, speaks of humanity's interrelationship with other forms of nature.

Graves was invited to make prints as an artist in residence at the Pilchuck Glass School near Stanwood, Washington, in the summer of 1992. The Pilchuck series (cat. nos. 87–113) of monotypes again reveals the artist's sense of experimentation and instinctive feel for her materials. Graves remembers being astonished by the lush flora of the Northwest Coast in the summer and was inspired to choose embossing as a means of introducing the natural beauty of the

plant material into these prints. The artist picked a wide variety of native flora (including leaves and berries) and garden perennials from the extensive grounds of the school. Then, working with printer Cate Brigden, she placed the organic material on a glass printing plate, covered it with moistened paper, and ran it through an etching press. The pressure not only embossed the image of the plants themselves but also transferred much of their natural juices, staining the paper with unpredictable colors and patterns. Welcoming the variables of chance into the composition, Graves affixed any organic material that adhered to the paper after printing; the artist later added watercolor to selected monotypes whose natural colors she felt did not sufficiently augment the embossed plant forms. The print *VII-6-92* (cat. no. 90) illustrates the immediacy of her material and the extraordinary beauty and variety of form and color Graves captured in the series.

Inspired by the results of her Pilchuck series, Graves embarked on her most recent print series, a group of monotypes of embossed food completed at Iris Editions shortly after her return from Washington in August 1992. Though the artist would be the first to see the humor in making art out of food, it would be a mistake to ascribe wit as the principal motivation of the Full Plate series (cat. nos. 114–74).[36] With an eye toward form and color, she selected a cornucopia of vegetables, fruits, beans, pasta, rice, and even sardines and dried squid for the Full Plate series. The vegetables and fruits were sliced and placed on a Plexiglas sheet along with the other organic material and spices. To regularize somewhat the uneven coloration Graves encountered in her previous series, she applied a watercolor mixture to the material before it was run through the etching press to be embossed. The artist still found it necessary, however, to add hand coloring to selected

prints. Direct casting had allowed Graves to include organic form directly in her sculpture; embossing organic materials now enabled her to bring natural form directly into her prints. With the simplest of means Graves paid homage in the Pilchuck series and Full Plate series to the multiformity of nature.

Since her Lunar series, completed in 1972, Graves has displayed a canny sense of how each new print will relate to her existing body of work. Thus, for all the evident experimentation and growth in her printmaking, certain constants remain throughout: an interest in visual perception, patterns in nature, fragmentation, motion, shifting figure-ground relationships, and multiple readings. Above all, it is the artist's predilection to quote from her own work—recycling images and exploring them in endless permutations—that is most responsible for the remarkable coherence of this group of prints. In these pages Graves's work can be viewed as an ensemble in which each work informs the next, and the artist's continuous evolution is apparent.

When Graves began to introduce historical figures into her prints in the mid-1980s, she initiated an ever-expanding narrative with a wide breadth of metaphorical references. Like the ancient archaeological sites Graves often studied, these complexly layered prints contain fragments from a succession of cultures, constituting a vertical recording of history. In her subjective tour of history, a Paleolithic carved bone or a fragment of a Byzantine mosaic can serve as a guidepost to an entire culture or era. The artist does not, however, invoke the weight of history nostalgically. Rather, she looks to the past to contextualize the present. Graves's prints contain a poetic resonance that far exceeds the sum of the individual figures contained within. In her recent prints, startling visual contradictions, abrupt shifts in scale and orientation, and nonhierarchical juxtapositions of historical figures, organic form, and abstract gesture all celebrate, in the artist's own words, "the clash of cultures." The bewildering array of disparate forms embraced within her idiosyncratic formal structure is intended to mirror the chaos of modern life. Yet even though most of her ideograms are based on ancient sources, her compositions speak to life in the late twentieth century with an optimism uncommon in contemporary art. In a society in which technology expands communication exponentially, Graves embraces cross-cultural exchange among previously insular cultures.

When talking to the artist, the word *palimpsest* is often heard. As she continues to take historical figures, organic form, and her own art as the foundation on which her new work will be built, Graves edges ever closer to closing the gap between humanism and science in her still unfolding narrative.

NOTES

1. Linda Nochlin, "Nancy Graves: The Subversiveness of Sculpture," in *Nancy Graves: Painting, Sculpture, Drawing, 1980–1985,* by Debra Bricker Balken, exh. cat. (Poughkeepsie, N.Y.: Vassar College Art Gallery, 1986), 16.

2. Kirk Varnedoe, "Contemporary Explorations," in *Primitivism in 20th Century Art: Affinity of the Tribal and the Modern,* edited by William Rubin, vol. 2, exh. cat. (New York: Museum of Modern Art, 1984), 661.

3. Nancy Graves, quoted in Emily Wasserman, "A Conversation with Nancy Graves," *Artforum* 9 (October 1970): 45.

4. Brenda Richardson, "Nancy Graves: A New Way of Seeing," *Arts Magazine* 46 (April 1972): 61.

5. In addition to *Izy Boukir* (1971), Graves made two other films focusing on camels, which the artist now considers study projects: *200 Stills at 60 Frames* (1970) and *Goulimine* (1970). For an excellent discussion of the artist's films, see Lucy Lippard, "Distancing: The Films of Nancy Graves," *Art in America* 63 (November–December 1975): 78–82.

6. Graves completed a series of drawings based on Muybridge's photographs, such as *Camel Walking (.057 Sec.) after Muybridge* (1971), illustrated in Linda L. Cathcart, *Nancy Graves: A Survey 1969/1980,* exh. cat. (Buffalo, N.Y.: Albright-Knox Art Gallery, 1980), 23.

7. Roberta Smith, *Four Artists and the Map Image/Process/Data/Place,* exh. cat. (Lawrence, Kans.: Spencer Museum of Art, University of Kansas, 1981), 7.

8. Nancy Graves, quoted in Mario Amaya, "Artist's Dialogue: A Conversation with Nancy Graves," *Architectural Digest* 39 (February 1982): 154.

9. See Joan Seeman, unpublished interview with Nancy Graves, June 6, 1979, in Cathcart, *Nancy Graves: A Survey,* 22.

10. Graves examined most of the primary source material at the Map Room of the New York Public Library. She studied satellite images and maps of Mars at the Jet Propulsion Laboratory, Pasadena, California.

11. Carl Solway, owner of Carl Solway Gallery, Cincinnati, invited Graves to work at Landfall Press and was publisher of the Lunar series.

12. Neither project produced a print in an edition.

13. See glossary for a description of all print terminology mentioned in this text.

14. For information on the Mylar method, see Mauro Giuffreda, *The New Lithography: The Mylar Method Manifesto* (Grafton, Vt.: Atelier North Star, 1979).

15. Nancy Graves, quoted in Max Kozloff, "Pat Adams, Nancy Graves, Budd Hopkins, Irving Petlin," *Artforum* 14 (September 1975): 57.

16. Graves similarly sought to envelop the viewer in the presence of the Moon in her related film, *Reflections on the Moon* (1974), in which the camera slowly panned over hundreds of photographic stills of the lunar surface.

17. Nancy Graves, quoted in "Nancy Graves: Excerpts from Notebooks," *Artscribe* 17 (April 1979): 40.

18. Linda L. Cathcart, "Nancy Graves: Sculpture for the Eye and Mind," in *The Sculpture of Nancy Graves: A Catalogue Raisonné,* by E. A. Carmean, Jr., et al., exh. cat. (New York: Hudson Hills Press in association with the Fort Worth Art Museum, 1987), 39.

19. Tyler is a master printer known for his remarkably expansive knowledge of print processes. In a career now spanning over three decades, Tyler has successively been technical director of the Tamarind Lithography Workshop; one of the founders of Gemini G.E.L., a print workshop in Los Angeles; and founder of Tyler Graphics Ltd., which he established in Bedford Village, New York, in 1973 (since relocated to nearby Mount Kisco).

20. See Elizabeth Armstrong, "Kenneth Tyler and the American Print Renaissance," in *Prints from Tyler Graphics,* exh. cat. (Minneapolis: Walker Art Center, 1984), 10.

21. See Catalogue Raisonné, nos. 14–19, for the specific references.

22. Though work on the plate was completed in 1979, *Paleolinea* was not printed in an edition until 1982.

23. See Barry Walker, *Public and Private: American Prints Today, the 24th National Print Exhibition,* exh. cat. (Brooklyn: Brooklyn Museum, 1986), 13.

24. Nancy Graves, quoted in Michael Edward Shapiro, "Four Sculptors on Bronze Casting: Nancy Graves, Bryan Hunt, Joel Shapiro, Herk Van Tongeren," *Arts Magazine* 58 (December 1983): 111.

25. Nancy Graves, quoted ibid., 112.

26. Robert Storr, "Natural Forms," *Art in America* 71 (March 1983): 120.

27. From an unpublished 1991 essay by Joan Simon.

28. From an unpublished 1992 essay by Jean Feinberg.

29. Graves first depicted a frog in a gouache drawing, *Photographs of Jumping Frog at 1/40 Second* (1971), illustrated in Cathcart, *Nancy Graves: A Survey,* 49.

30. Josef Albers, *Interaction of Color* (New Haven: Yale University Press, 1963).

31. The motif of the Egyptian queen had appeared in two earlier prints, *Approaches the Limit of I* and *Approaches the Limit of II* (cat. nos. 25 and 26) and in several of Graves's contemporary paintings. The image of Nefertiti subsequently materialized in three dimensions in her sculpture as well.

32. Nancy Graves, quoted in David Yager, "Conversation with Nancy Graves," in *Nancy Graves: Recent Works,* by David Yager et al., exh. cat. (Catonsville, Md.: Fine Arts Gallery, University of Maryland, 1993), 31.

33. Nancy Graves, quoted ibid.

34. Nancy Graves, quoted ibid., 35.

35. Nancy Graves, quoted in Kozloff, "Pat Adams, Nancy Graves," 58.

36. Daniel Spoerri's Tableaux-Pièges (Snare-Pictures), beginning in 1960, could be considered a precedent in using food as an art medium. Spoerri created the series by permanently affixing the remains of food from meals or meetings to the tabletops where the events occurred. Next, he would tip such a tableau on its side for wall display—as a sort of readymade still life, arranged by chance.

CONDUCTED BY THOMAS PADON,

NEW YORK CITY, FEBRUARY–JUNE 1992

Nancy Graves, 1995, photographed by Timothy Greenfield-Sanders

THOMAS PADON: *The period of the early 1960s was an exciting moment of artistic freedom and experimentation. You studied painting as a graduate student at the School of Art and Architecture at Yale from 1961 to 1964, a time when there were many talented artists among the faculty and students. Was the atmosphere at Yale pervaded by a similar sense of experimentation?*

NANCY GRAVES: Not really. Actually, we did very traditional painting. It may seem humorous now, but for all the developments going on outside the school—such as the end of Abstract Expressionism and the beginnings of Pop—our diet was Cubism and Matisse. But having a remarkable group of teachers—like William Bailey, Neil Welliver, Alex Katz, and Jack Tworkov on the faculty and artists like [Philip] Guston, [Esteban] Vicente, [Robert] Rauschenberg, and [Frank] Stella giving critiques as part of the visiting artists program—certainly provided a rare opportunity for a student. The atmosphere was collegial and fostered a lively dialogue between students and faculty.

TP: *Were there any critiques that made a particular impression?*

NG: Well, I can remember the critique I had from Philip Guston. I was doing some tablescapes after [André] Derain. They were definitely student work, but Guston appreciated their composition, paint quality, and color.

TP: *As a student of art at Yale you probably took the "Interaction of Color" course developed by Josef*

Albers, who was chairman of the Department of Design at the school from 1950 to 1958. How important was that class to you?

NG: I did take the course, which at that time was taught by Sewel Sillmann. I think the class was invaluable in fine-tuning the eye to aspects of color. I also took Albers's basic design course, then being taught by Neil Welliver. There was a tremendous amount of energy in that class. We worked largely in black and white, often in magazine collage, and abstracted sections of images and recombined them through variation and repetition into something totally unexpected.

TP: *When you attended Yale, there were very few female graduate students and no female undergraduates. Did you feel the Art Department faculty or visiting artists treated female students differently from male students?*

NG: Yes, I don't think women were taken seriously at Yale, but it had to do with the cultural mores of the time. Remember the number of successful women artists in the early 1960s could be counted on one hand: Joan Mitchell, Grace Hartigan, Lee Bontecou, and Helen Frankenthaler. Consequently, there were no female visiting artists or teachers at Yale, and women were never considered for teaching assistantships and traveling fellowships. I can still remember Jack Tworkov, the dean of the school, coming up to my studio on Crown Street, which I shared with nine men [Chuck Close, Rackstraw Downes, Michael Economos, Kent Floeter, Daniel

Gorski, William Hochhausen, Donald Nice, Stephen Posen, Richard Serra] during my final year, and trying to dissuade me from becoming an artist. His wife and daughter were artists, so obviously he knew how difficult it was for women. With good intentions, he was trying to save me from the same fate. However, things have changed: the school honored me with the Yale Arts Award for Distinguished Artistic Achievement in 1989 and with an honorary Doctorate of Fine Arts in 1992.

TP: *What prompted you to go from the study of liberal arts at Vassar to studio art at Yale?*

NG: I was interested in painting in high school. During my senior year I began looking at studio art programs and was led to believe that Vassar and Sarah Lawrence had similar curricula. I chose Vassar thinking that I could have a painting major but quickly discovered that painting and sculpture were considered by the faculty—mostly made up of notable individuals from the Institute of Fine Arts in New York—to be tools for understanding art history. Thus, I was only allowed a couple of years' credit of what they called studio or "applied art." Fortunately I spent a great deal of time painting during those two years and had some very good guidance from people like Alton Pickens and Rosemary Beck. They suggested that I apply to the Yale Summer School of Music and Art [in Norfolk, Connecticut] between my sophomore and junior years; I applied and was accepted for the six-week program, which taught painting, drawing, and photography. For the first time in my life I was in the company of students

who had had a great deal more experience painting in undergraduate school. I was asked to compete with these people, and while obviously I had a lot of growing to do, it was very exciting to me.

TP: *Did you paint outside of your classes at Vassar after your return from Yale Summer School?*

NG: No, I no longer had a studio space, so I settled down to an English major—it was quite a conflict for me. Painting was really what I wanted to do, and I remember thinking, "I've got to just hang in here and get through the English and French and go on afterward," which is what I did. In my senior year at Vassar I applied to the M.F.A. program at Yale and was admitted. Had I gone to Sarah Lawrence, the evolution would have been more logical, but I didn't get in there; it was just a stroke of fate.

TP: *You studied painting at Yale, but were you interested in other mediums?*

NG: Of course, but with my B.A. in English I felt that I had some catching up to do to be able to work at the level of some of my classmates who had a B.F.A. I did complete required courses in drawing and printmaking; the latter was an investigation of the rudiments of woodcut, lithography, and etching. I detested it! At the time, printmaking seemed very tedious to me. I was impatient with the indirectness of a process where the image is made in reverse and the colors are mixed optically by layering on separate plates. I really just wanted to devote more time to painting.

TP: *You spent a year in Paris after graduation and continued to paint. Then, from what I have read, you were inspired to pursue sculpture after seeing the seventeenth-century wax figures by Clemente Susini in*

the Museo La Specola in Florence. Was the transition really that unconditioned?

NG: It's not as if I never thought about sculpture at Yale. Rather, I didn't think about making *a body* of sculpture. But I became increasingly frustrated with painting in Paris. There was very little innovational work going on there except, ironically, what came in from America. The art focus was primarily American at that time. Painting did not seem to be viable. I had basically exhausted the art historical principles that I had been following and was groping for ways to break out on my own terms.

TP: *And sculpture provided that?*

NG: I think so. Clearly, the traditional approach to painting in terms of technique was not going to be the way. I wanted to develop a base from which my work could continue to grow for the next twenty to thirty years, not do something that was fashionable, not be part of a movement. This was probably because of gender, feeling that I would never be taken as seriously as someone who didn't have a female name. Therefore, I wanted to investigate ideas that weren't of issue in other artists' work—I wanted to be independent. Sculpture afforded me that clean break, as did my decision to leave Paris for Florence, where I lived for a year. Richard Serra and I were married and he and I chose Florence because it was a place where we could incubate and have the time to explore whatever came to mind without the pressures of day-to-day work. We began to work collaboratively on a number of things out of materials such as plumbing pipe, metal, wood, and ceramic. I have to tell you that it was far from successful. Every week we would more or less dump the residues of our failures in the Arno! In retrospect I think it was possible

to fail more openly in a culture that wasn't my own. If I had gone to New York right after school and tried to continue making art, the pressures of survival and competition would have been more immediate and I would not have been able to struggle so deeply. Anyway, in Florence one day, quite by chance, I saw the pathological and comparative anatomical wax pieces by Susini depicted life-size at La Specola, and a bell went off! The visual presentation was bizarre, something on the order of a morbid Botticelli: wax women laid out on pink satin with bows in their hair, smiling while flayed from throat to crotch. It prompted me to think of introducing a form from natural history into an art context.

TP: *And the first form you chose was that of a camel. What was your inspiration?*

NG: I was interested in the camel form because of its enigmatic aspect. Unlike the horse, the camel is relatively *unfamiliar* in Western culture; so the camel gave me the freedom to explore an image without reference to art history. As a child I frequently visited the Berkshire Museum, a museum of art and natural history. My father worked there, so I not only got to know the collection but saw behind the scenes and became aware of the degree of illusion involved in presenting natural-history objects as well as some of the means, such as taxidermy [see fig. 2]. I did research at La Specola and then later in New York at the American Museum of Natural History to learn as much as I could about the processes of taxidermy. In both the *Camel* and fossil sculptures I soon found my own way of working, which, while it departed from taxidermy, still alluded to it. I envisioned the group of camels as a study of motion, more specifically, motion arrested. Muybridge was certainly an influence, as were [Claes] Oldenburg's soft forms.

After making numerous studies I began to create the camel forms out of whatever materials were available to me in Florence.

TP: *You destroyed all the camels you made in Florence before you returned to the United States. What prompted this action?*

NG: I wasn't happy with the armature and didn't feel the camels were significant enough to preserve at that point. It was not until I got back to New York that I was able to work out the problems of the materials and armature. Even then I must have destroyed maybe twenty others in order to create the three that were shown at the Graham Gallery and the Whitney ["Nancy Graves: Camels," Graham Gallery, New York, April 6–May 4, 1968, and the Whitney Museum of American Art, New York, March 24–April 30, 1969].

TP: *Your reputation as a significant young artist was established when the Camels were exhibited at the Whitney in 1969. It is hard now to look back and imagine just how startling they must have been. What was the response from your peers when you began constructing them?*

NG: I don't remember. I think everybody knew that I was doing them and was interested in them.

TP: *You have mentioned that Florence was consciously chosen as a place to incubate. In the mid-1960s, was Florence a place where you could also see what was current in Italian art, such as Arte Povera?*

NG: Not really, no, but we did go to the galleries in Rome occasionally. In fact, Serra and I collaborated on a show that was presented at Galleria La

FIG. 18
Installation view of "Animal
Habitats Live and Stuffed . . . ,"
Galleria La Salita, Rome, 1966,
showing two works by Richard
Serra: *Squatter I* (1966) in the
foreground and *Live Pig Cage I*
(1966) in the background.

Salita in Rome [fig. 18, "Animal Habitats Live and
Stuffed . . . ," May–June 1966] that grew out of an
idea I had featuring live animals and animal parts
that I had injected with formaldehyde. It opened in
the spring of 1966. In hindsight I would say that
Rauschenberg was the preemptive source. If you
think about his ram and our chickens, they're not
that far apart [Graves refers to Robert Rauschen-
berg's *Monogram* (1959), a construction featuring a
stuffed ram encircled by an automobile tire and the
chickens included in *Animal Habitats*].

TP: *Your* Camels *appeared at a time when Minimal-
ism was the dominant mode in sculpture. Was your
turn toward organic form a conscious rejection of Mini-
malism's rational, hard-edged approach?*

NG: I saw Minimalism as a limited area in which to
work. Besides, I realized that my background and
affinity with organic form gave me a unique means
to approach sculpture. I began to make a great num-
ber of drawings and works in which I attempted to
explore what it meant to place an object in the con-
text of an art circumstance, whether it be a gallery
or museum. However, as different as the *Camels*
may now seem from Minimalist sculpture, they and
other works I completed in the early 1970s, such as
Calipers [fig. 12] and *Variability and Repetition of
Variable Forms* [fig. 5], dealt with issues that were
being brought up through Minimalism, such as
questioning the functions of the floor, ceiling, and
walls, repetition, dedifferentiation, and scattering,
things that almost every artist of the late 1960s,
including Eva Hesse, explored. So I took certain
themes common to Minimalism but used them in a
different context.

TP: *Did you feel an affinity with Hesse's work?*

NG: I thought her work was awesome. Eva was very innovative in her use of new materials such as fiberglass, liquid latex, and vinyl tubing. Her emphasis on process as content and her focus on female sexuality impressed me. I met Eva when I came back to the United States in 1966 and think that many artists took ideas from her but didn't acknowledge it; the sexual politics of the 1960s and 1970s no doubt contributed to the fact that her work was not properly credited at the time.

TP: *During the 1970s you alternated between periods of painting and making sculpture. Can you comment on that separation, and on why your printmaking only coincided with periods in which you were painting?*

NG: I think of two and three dimensions as opposites that require related but very different solutions. It wasn't until 1977 that I was able to think about the two simultaneously. In regard to my prints, they are an outgrowth of my drawing and paintings, so it is natural that my printmaking coincides with painting; the discoveries in each affect the other.

TP: *You have occasionally treated the same composition in a painting and print. In a work such as* Equivalent, *how would you say the painting and print [cat. no. 22] differ?*

NG: There is more contrast between the black and white in the print, due to the wide frame of the paper I left around the image. In the print, the overlapping opaque colors from the five screens reverberate on the black surface and give it more depth than the painting has with its transparent washes. Overall, though, I think the silkscreen process itself can impart a staccato rhythm, as it does in *Equivalent,* that I do not generally achieve in painting.

TP: *More than one critic discussing your paintings of the late 1970s questioned your use of many different techniques within a single work, wondering if you weren't more concerned with technical virtuosity than the final composition. Likewise, you combined a number of processes in your prints of the late 1970s. I'm referring specifically now to the works done at Tyler Graphics in 1977.*

NG: Aquatint, drypoint, and engraving are compatible with the etching process and I think served to make these prints richer spatially. The pastel added yet another visual plane to the prints; I added it by hand so that even though the prints were multiples, each has a colored gesture unlike, but complementary to, the abstraction in the print.

TP: *The boundaries between the various mediums in which you work seem increasingly permeable. For instance, your paintings are becoming more and more sculptural and your sculptures have the rich, colored surfaces of your paintings. Is this a conscious decision?*

NG: Of course, because it's not something I'm supposed to do! I am *supposed* to make sculpture *or* painting *or* paintings on paper. The areas are presumed to be explicitly defined. But I have always been interested in breaking down these boundaries.

TP: *Where do you see this philosophy taking your work?*

NG: Well, I certainly do not have the goal that someday I will create the perfect marriage and produce a sculpture that is a painting that is a print! But what enriches me is to translate the discoveries I make in one area into another medium, and then from that experience to push it even further. Given the fact that I now often work simultaneously in

both two and three dimensions, there is a constant cross-pollination.

TP: *Yet you once said that you were "interested in staying within traditional boundaries" [quoted in Diane Kelder, "New Editions by Nancy Graves,"* Arts Magazine *64 (October 1988): 17–18]. How do you reconcile that comment with your penchant for experimentation and your stated desire to break down boundaries?*

NG: Well, for instance, within the realms of etching, drypoint, and aquatint, there's a great deal to be accomplished without trying to get . . . fashionable, I guess the word would be. Often when you stay within boundaries or try to do the simplest thing, you can at the same time do the most complex work.

TP: *An example might be the prints you made at the Pilchuck Glass School in 1992 using only a glass plate, flowers, berries, and leaves.*

NG: Yes. The process was certainly simple. However, I was totally unprepared for the remarkably lush color and texture of organic residue that certain plants would yield in response to varying amounts of pressure.

TP: *What pushes you to experiment constantly with new techniques?*

NG: It's not that I like the pressure of researching or exploring the parameters of a new technique—it's what it gives back. It enables me to make a statement that is unique. But the fact that I am working with a new technique or in a new medium does not interrupt the linear aspect to my work.

TP: *In Florence you worked alone on your sculpture, yet, beginning with your fossil pieces in 1969, you have gravitated toward processes in painting, sculpture, and printmaking that by the very nature of their complexity require a large number of skilled assistants. Does this signify a change of attitude?*

NG: No, I don't think so. The perfecting of the camel form was an education in certain sculptural processes that I invented and, I guess, a means of understanding what the sculpture process was going to become for me. Evidently, I needed to work through that on my own. Having hired someone else to do it would have interrupted the flow of my thinking and execution. With the fossil pieces, I knew what I wanted, and because of the scale of the projects, it just made sense to hire assistants. In printmaking, the techniques and processes are largely the expertise of the printers, so assistance is inevitable.

TP: *Do you feel that you're giving up a level of control when you work with numerous assistants?*

NG: I began to feel that way in 1970, a year in which I had sixty-five assistants working with me on various sculpture projects. Trying to supervise them all, as well as travel on my own to set up large pieces in museums and galleries in the United States and Europe, proved to be too draining. I started thinking about getting back into the studio to paint, about responding directly to the results of my hand.

TP: *But in that same year you also began work in Morocco on* Goulimine, *the first of your five films. That must have required assistants.*

NG: Yes, but only two, so it wasn't the same thing.

Talking about filmmaking, it occurs to me that film and prints are somewhat analogous in that both are indirect processes and deal with layers of images that are never seen until the final print. Perhaps that's why I worked in both mediums at roughly the same time.

TP: *You were in Morocco for several weeks filming* Goulimine *in 1970 and returned a year later to film* Izy Boukir. *Was it difficult working in a non-Western country?*

NG: Yes. It was my first exposure to the Islamic culture, and given the role of women in Islam, there were real sociological implications in the work I was doing—for instance, directing a crew that included a man. There I was, an American woman, in an Islamic desert country where the only Western commodities in the village store were Tide and bubble gum! I can remember feeling that when we began to film it was almost like Conrad's *Heart of Darkness:* the longer I was there, the more of myself I had to reveal to these people and the more I became dependent upon them. The whole experience made me feel rather vulnerable. I remember thinking any number of times, "What is the meaning of what I am doing?" because there I was, using the resources of a people who had no understanding of what it was that I was attempting. I realized the enormity of the differences that separated us culturally and economically. Islam, you know, denies the validity of an individual artistic statement, and I suddenly understood how small a group contemporary Western art affects in the larger context of global cultures.

TP: *Do you see your extensive travel as integral to the evolution of your work?*

NG: It does jolt my thinking and my vision, which then spills over into my work. For instance, a trip I made in 1972 to the archaeological sites outside Mexico City and in the Yucatán made me realize something that has evidently been more apparent all along to Mexicans than Americans: the degree of interface between the native peoples in pre-Columbian North, Central, and South America. These peoples traded objects, had cultural communication, intermarried, and exchanged ideas on any number of levels. That realization actuated my interest in cross-cultural communication.

TP: *In 1979, you were awarded an artist-in-residence fellowship at the American Academy in Rome. How would you characterize the difference between this and your earlier experience of living in Italy?*

NG: The difference lies in the evolution of my work. In Florence my work evolved from that of a student to that of an artist. During the year I spent there I was open to experimenting with just about anything, even rabbit ears! Whereas when I went to Rome in 1979, I already had a career of twelve years behind me and was focused on two specific projects, making drawings for sculpture based on archaeological research at the academy and beginning an etching project [*Paleolinea,* cat. no. 58] with Valter and Eleonora Rossi.

TP: *Let's talk about the first prints you made, the* Lunar *series [cat. nos. 1–10], at Landfall Press in 1972. You mentioned that you didn't have any interest in printmaking at Yale. What made you decide to make prints in 1972?*

NG: Well, I was invited by Jack Lemon to work at Landfall in lithography, and unlike my experience at Yale, I finally had the time to devote to printmaking.

TP: *How did you find the experience?*

NG: In retrospect, I would like to have played around more with the ground, or field, on which the dots occur. The prints then would have been more distinguished from the related gouaches on paper and the paintings. But it was my first print project, and I guess I just didn't ask the right questions! We did, however, experiment with Mylar and printing on Japanese rice [*shin ten gu*] and mulberry [*amime*] papers. These prints certainly have merit, but I don't think lithography was necessarily the ideal form for them.

TP: *Did you complete the Lunar prints before or after the Lunar paintings?*

NG: After, though the drawings were the basic point of departure for both.

TP: *In our last conversation you mentioned that your Lunar and Synecdoche series are related; yet formally they appear quite different . . .*

NG: The Tyler prints are actually an abstraction— the bare bones, so to speak—of my earlier paintings, washes, and prints, which in turn are abstractions from actual Lunar Orbiter satellite imagery. Of course, all of this leads to the fundamental question, What is abstraction? What are dots? What is the Moon?

TP: *And what is a map but an abstract concept of space?*

NG: Exactly. Measurement of time and space certainly takes us into the realm of abstraction.

TP: *In the Synecdoche series you applied pastel by hand through a stencil. Was your intent to subvert the mechanical process of printmaking?*

NG: I think so, yes, in the sense that each print became more immediate. I added pochoir to each print: a line or gesture in pastel.

TP: *Were the embossed collages found on your large-scale prints, such as* Stuck, the Flies Buzzed *[cat. no. 73], another means to expand beyond the limitations of the plate?*

NG: Yes. Plus the fact that they parallel the reliefs found on my paintings.

TP: *What is the largest edition size you have made?*

NG: One hundred and seventy, but I prefer editions in the thirties, especially when I am working in aquatint, as the subtleties of aquatints die after that.

TP: *Have you ever destroyed a print series?*

NG: No, but I would have liked to in a couple of benefit prints where I was working with limited budgets and inflexible printers.

TP: *Do you feel printmaking is at all inferior to painting?*

NG: Certainly not since the 1960s. People like Ken Tyler and Don Saff have really helped expand print-making. It has become highly experimental and replete with technical innovations such as combinations of etching, lithography, and woodcut, pulp prints, and even multiples made by vacuum forms. In my next print I would like to combine woodcut with etching, lithography, linocut, and embossing.

TP: *Have the master printers you have worked with encouraged you to use new techniques?*

NG: Definitely! Tyler, Saff, Valter and Eleonora Rossi, Hiroshi Kawanishi, Deli Sacilotto, all of them thrive on experimentation. At Tyler Graphics, for instance, Ken Tyler suggested that I combine etching with lithography in the making of *Calibrate* [cat. no. 24], something that I had not thought of. The two processes are visually compatible, but from a technical standpoint the paper must be wet or expanded in the etching process, while for lithography it must be dry or of a smaller dimension.

TP: *Do you go to a print workshop with a technique in mind, or does it evolve out of initial discussions with the printer?*

NG: In the first project I did with the Rossis, *Paleo-linea* [cat. no. 58], Valter and I knew we wanted to work with a big plate and that the color would be black. At the same time, I really wanted to investigate drypoint, etching, and aquatint. I had certain images that I had already discussed with him, and then together we figured out their logic in the composition. Rossi then guided me through the different techniques. In 1990, I started a print project with Don Saff, and our initial conversations led to *Canoptic Legerdemain* [fig. 17], which became a wall sculpture with an embossed lithograph mounted on honeycomb aluminum. Just one of six elements measures 78 by 95 by 35 inches! The particular skills of each of the participants at Graphicstudio—mold making, casting in epoxy, translation of a graphic image into laser-cut stainless steel—and a carte blanche attitude determined the outcome.

TP: *In the mid-1980s you began to incorporate*

images from art history into your work. Over the years, the inventory of these forms has grown and become closely identified with your work. What prompted their introduction at that time?

NG: I was excited about the challenge of introducing the human figure into my work, thereby inviting comparison with figurative sculpture from every culture and historical period. I felt it would bring my work into a different kind of art historical context. The bust of Nefertiti was the first figurative image to appear in any of my prints [in *Approaches the Limit of I* and *Approaches the Limit of II,* cat. nos. 25 and 26]. By selecting only parts of figurative forms, such as male and female heads, a breast, penis, or hand, from Hellenistic sculptures, for example, rather than the whole, the figures became abstract and acquired a new identity through juxtaposition.

TP: *Was their introduction prompted by your experience at the American Academy in Rome?*

NG: I think so, yes, because in that year I was literally immersed in Etruscan and Roman history by way of my research in the academy's library and visits to archaeological sites, all of which I think later influenced my choice of subjects.

TP: *But what made you use those forms specifically?*

NG: I chose them because they embody some of the earliest Western figurative ideas.

TP: *Are you interested in the iconography of the figures or their individual histories and associations?*

NG: Both, I would never use a form that I wasn't knowledgeable about. I am interested in how a form

that is well known, such as Michelangelo's *Dying Slave,* can be reintroduced and do new things. One way is to use fragments—for example, only the hand of the *Dying Slave*—rather than the whole. The fragments, whether they be icons from Egyptian, Japanese, Korean, Indian, or Western art history, function formally as building elements in the composition of my two- and three-dimensional work, where they create a clash between cultural expectations and the new uses to which they are put. You might say that I am interested in making art out of what has *been* art, what in fact are the *shards* of art.

TP: *What did this inventory of figures, these ideograms, as Jean Feinberg has termed them, allow you to say that was absent before?*

NG: They gave me a means to connect between past and present. They provide contextual relationships and allow overladen meanings to occur and reoccur, lending any given piece a reverberation of time. They allow me to deal with art history—and thus the history of man—in a decontextualized fashion. My work has evolved to the point where it is now possible to change and combine tenses. Meaning is derived through my highly personal mélange of art styles and objects ranging from, let's say, Native American to Hindu. Similar tendencies to change and combine historical tenses also occur in other disciplines—I can think of the theater of Arianne Mnouchkine, who borrows from a range of cultures, the architecture of Frank Gehry, or the writings and essays of Susan Sontag as parallels.

TP: *The images of the Egyptian queen Nefertiti and the sixth-century Byzantine empress Theodora both appear frequently in your work. Was their power something that attracted you to them?*

NG: Yes, but I am more interested in them as women who transcended their times in various ways. On occasion I have introduced female archetypes who historically and culturally had power, like Nefertiti or Theodora, or women of mythic power, like Aphrodite. Eve is a good example; she appears in *Canoptic Prestidigitation* from 1990 [cat. no. 74]; certainly *she* is a woman of power. All of these women were chosen for their references, both symbolic and specific. However, in *Canoptic Prestidigitation* you will also find women who did not hold power, such as the anonymous mourning women taken from a Theban tomb painting.

TP: *Are you ever concerned about the sentimentality that might arise from the use of these well-known images?*

NG: Well, it is probably in the back of my mind, even though I have never articulated it before. The work itself has to be tough enough or it could all get silly and sentimental. It is a constant challenge to keep it from becoming bathos.

TP: *Very few of the historical figures you choose are recognizable to the general public. Even the ones that probably are, Nefertiti for example, are often so fragmented or buried between the layers of your prints as to be almost unreadable. Do you expect the viewer to recognize all the figures—or fragments of them—and is it necessary that they do in order to understand your purpose?*

NG: I am aware that the general audience will not recognize all of these figures, though an art historian or anyone familiar with art history certainly would know them. But probably everyone will recognize some. If one is able to interpret the work on that level, if

one understands the nomenclature, so to speak, it does add another dimension. Printmaking allows me to create many layers where I place the figures. I then guide the viewer's eye through a single work vis-à-vis separate compositions of color, line, painterliness, graphic aspect, and content. There is a cross-pollination among all those levels that becomes layered into the final composition. Because everyone sees differently and relates to content according to one's own experience, each individual makes his or her own path into works as complex and layered as these. As the artist, I have made certain decisions that have to be taken into consideration along with any individual predispositions. There is a dialogue there.

TP: *Do you consider yourself an abstract artist? I am asking because you once mentioned that because of your use of figurative ideograms some people might question your status as an abstract artist.*

NG: I guess in saying that we would have to refer specifically to the [Clement] Greenberg camp, which in the 1970s and 1980s was still a powerful influence; anything figurative or organic was definitely not de rigueur! But at this point it doesn't seem as if it's an issue. I happen to use concrete forms for their abstraction, but clearly I'm an abstract artist.

TP: *Is your juxtaposition of images from various times and cultures related to your interest in cross-cultural communication?*

NG: Yes, and it is a very meaningful aspect of my work, because I think this juxtaposition reflects the way we live today. We are asked to grapple with this clash of cultures, so to speak, on a daily basis. But I think that is one of the positive aspects of the time we're living in now, because it makes us all far more open and aware.

TP: *Yet much of your iconography is based on ancient sources. Can you comment on that and the absence of contemporary imagery?*

NG: It's probably more that I haven't worked my way up to the present time. I started with Egyptian sources and am now just about in the Renaissance! Were I to use contemporary imagery, I would have to create the context for it, and I just haven't gotten there yet.

TP: *Does your art comment on contemporary issues, nonetheless? If so, what is the message?*

NG: I think so, although probably not as specifically as someone who is a political artist per se. That I'm not. But there is certainly a point of view in my work: it is basically a positive one. I draw on sources ranging from art history to sports and hope that the eclectic, nonnarrative, and nonlinear juxtapositions of forms create an open-ended dialogue, a free-associative thinking. The visual shift of my ideogram juxtapositions is my response to the fact that history is being rewritten daily.

TP: *Your work is free of the cynicism that characterizes much of the art of the last two decades.*

NG: It's very easy to comment on what's wrong with something. Then there are people like Matisse, who amidst the brutality of World War II continued to paint those beautiful women in luminous, full-blown colors. That's one route you can go. The other is to contest the immediate problems we face overtly, and while I admire those who do so very much, I happen to be someone who takes a quieter route. For example, *Head on Spear* [a 1969 sculpture of steel, wax, marble dust, acrylic, hide, and oil paint featuring a camel head impaled on a steel fence spear]

was a comment on the Vietnam War but veiled in the context of how I was working, and at that time I was making the *Camels.*

TP: *It has been said that your combination of unlike objects aligns you with the Surrealists. Do you feel that by linking figures from different eras and cultures you extend the Surrealist sensibility?*

NG: Yes, certainly by my choice of figuration and combinations thereof, there is that linkage; however, I'm not calling upon emotional and psychological states and the reaction of the viewer to those, which was the Surrealists' objective. The figures and objects that I select to use are only abstractions in my work, both contextually and formally. Their psychological implications are not explored. I also feel that in my work the particular medium or technique—be it printmaking, gouache, oil, bronze, or aluminum— informs the image in a way it did not for the Surrealists.

TP: *You mentioned in an interview with Mario Amaya ["Artist's Dialogue: A Conversation with Nancy Graves,"* Architectural Digest *39 (February 1982): 146] that the level of whimsy in your work is important, saying that the whimsy was "a very intel- lectual, high academic spoof."*

NG: I have to say that I have come to think of the word whimsy applied to my work as a sexist remark; I have never heard of any men whose work is whimsi- cal. I feel my work is a serious outreach into areas that haven't been explored. Yes, there is humor in the work, but it's only one aspect. I think in any good work there's humor. In the quote you refer to I guess I was just politely trying to answer a question and yet make that statement at the same time. Whimsy, irony, humor, whatever, is the result of attempting to turn

the screw back in on itself, to break apart the whole, to join the parts in unexpected ways. It's not some- thing that I intentionally try to create. Rather, humor evolves naturally, just as it does in my work.

TP: *So you feel that sexist criticism is alive and well in the arts?*

NG: Yes, I feel it goes on daily.

TP: *But in reading through the copious essays, articles, and reviews now spanning more than three decades, I think your work is discussed on its own terms, inde- pendent of the fact that you are a woman.*

NG: But what they say is, "Well, she looks a little like so-and-so." They *never* say that "so-and-so looks a little like a woman," because that would be totally degrading to a man. Another word that is used is *playful.* I doubt that men's work will ever be seen as playful.

TP: *You have talked often of the importance of color and how color can subordinate the identity of parts to the whole. Is this why you said that working in black and white is the greatest challenge?*

NG: In printmaking you concentrate on the nitty- gritty of making marks on a given plate; that is quintessentially what printmaking affords. Certainly in printmaking the most productive attitude would be to limit yourself to black and white. With a black-and-white print you have just pure form and nothing more. Color adds another dimension, and inasmuch as I am a colorist, I often like to enrich prints with color. When you are able to use color, you can deal with luminosity, be it translucent or opaque. Color is also a way to determine space and a means for the artist to choose the way the viewer

reads the piece. How do I want the piece to read? What do I want to be seen first? How do I want the eye to travel? Color is a way of achieving all that, in addition, or contradiction, to the way the form itself naturally reads.

TP: *You have said that your work "most importantly must be risky, complicated and surprising" [quoted in Debra Bricker Balken, "An Interview with Nancy Graves," in* Nancy Graves: Painting, Sculpture, Drawing, 1980–1985, *exh. cat. (Poughkeepsie, N.Y.: Vassar College Art Gallery, 1986), 23]. What is surprising about your prints?*

NG: It may be something that happens during the process that I choose to integrate in some way.

Recent examples would be the *collé* piece in *Stuck, the Flies Buzzed* [cat. no. 73], which was cast from plants gathered in the Rossis' garden and added spontaneously. Also, *Iconostasis of Water* [cat. no. 85] has an embossing, which I decided to add on the spur of the moment, of three fish from an Italian market that were later cooked for lunch. Even more recent is the aquatint ground of *Tracing Its Own Footsteps* [cat. no. 77], which is actually rice left over from my lunch. Food seems to be a common denominator!

TP: *Do you have an overall philosophy that guides your work?*

NG: I try to push my work to its limits and then beyond. *That* is my philosophy.

CATALOGUE RAISONNÉ

Pages 48–49: Detail of *XI/12/92* (cat. no. 125)

NOTES ON THE CATALOGUE RAISONNÉ

This catalogue documents Nancy Graves's graphic oeuvre through 1992. Prints are listed chronologically in order of completion (signing by the artist), which, unless otherwise noted, is also the date of publication. Within a series, prints are ordered by numerical titles or by publisher's print identification numbers. The titles of series have been provided or approved by the artist.

The documentation is based on written records provided by the publisher of each print. Additional information has been added in consultation with the artist, publishers, and printers. While documentation records vary in completeness, the information included here is as accurate and complete as possible.

Individual entries provide the printing technique or techniques used (see Glossary for definitions of all printing processes) and, where available, the actual printing sequence. Paper is identified by name. Technical information given in the overall series introduction pertains to all of the prints in the series.

MEASUREMENTS: Measurements indicate the size of the sheet. Height precedes width, in inches. The measurements of prints reflect the largest dimensions of archival proofs, but slight variations may occur within an edition.

SIGNATURES, INSCRIPTIONS, AND CHOPMARKS: Information on the content and location of signatures, inscriptions, and chopmarks is given for prints inscribed and/or stamped consistently within the edition.

EDITION: The number of prints issued by the publisher.

PROOFS: Terms and abbreviations are defined below in the order in which they appear.

AP Artist's proof. A print for the artist's use that is equal in quality to but not included in the edition.

TP Trial proof. A print pulled during proofing to check the appearance of the image.

CTP Color trial proof. Similar to a trial proof, it indicates color variations in the image.

WP Working proof. A proof on which the artist has added work by hand.

BAT Bon à tirer proof. A proof chosen by the artist and printer as the standard against which every print in the edition are to be judged for aesthetic and technical merit.

PPI & PPII Printer's proofs. Prints for the master printer's (or printers') use that are equal in quality to but not included in the edition.

SP Special proof. A dedication print equal in quality to but not included in the edition.

HC Hors commerce. Literally, "not for sale"; a special proof not included in the edition produced for presentation purposes.

A Archive. A print produced for the publisher's archive that is equal in quality to but not included in the edition.

C Cancellation.

PRINTING SEQUENCE: The printing sequence consists of any number of runs, that is, single operations during which the paper receives an inked impression from a printing element or the paper is altered by embossing, debossing, drawing, or the adherence of collage elements. The following format has been used to detail individual runs: first, the ink color as designated by the publishers for each printed element is given; next, the printing element is designated; information on how the element was created, inked, printed, or reused may follow.

LITERATURE: Lists books, articles, and exhibition catalogues that refer to the print, using abbreviated references in alphabetical order. Full citations of references listed by author and year can be found in the Bibliography. Full citations of references listed by city and year can be found in Exhibitions. Illustrations are indicated by italicized page numbers.

EXHIBITIONS: Lists chronologically exhibitions, indicated by city, in which the print was shown. Full citations of the abbreviated references can be found in Print Exhibitions.

COMMENTS: Comments on individual prints may include the derivation and correlation of imagery to work in other mediums or the occasion of the print's publication. Full citations to abbreviated references included in the comments can be found in the Bibliography.

LITHOGRAPHS BASED ON GEOLOGIC MAPS OF LUNAR ORBITER AND APOLLO LANDING SITES

Following her earlier series of drawings and paintings related to maps and charts of remote geographic regions such as the ocean floor and Antarctica, Graves completed this suite of ten lithographs, her first prints to be produced in an edition, at Landfall Press, Chicago, in 1972.

Graves made an extensive study of the lunar maps that were produced by NASA (see fig. 6) in preparation for the Apollo manned space missions to the Moon beginning in 1968. With varying degrees of faithfulness to the originals, the artist transposed portions of individual lunar maps in a large group of drawings, which subsequently served as the basis for this series. Working with Jack Lemon, Graves drew the stippled images directly on sheets of Mylar, which were then transferred to light-sensitive aluminum plates. To achieve a variety of spatial effects, the artist experimented with chine collé and printing on Mylar sheets that were laminated to Arches Cover paper.

EDITION: Each work in the series was printed in an edition of 100. Printed by Landfall Press Inc., Chicago. Published by Carl Solway Gallery, Cincinnati

1
I Part of Sabine D Region, Southwest Mare Tranquilitatis. 1972

Lithograph on Arches Cover white paper, 22½ × 30″. Signed: *Graves* in pencil and dated, lower right; numbered in pencil, lower left; chop: logo of Landfall Press Inc., lower left; workshop's marks: title, date, dimensions, identification stamp, and workshop number NG72-321, lower left verso

PROOFS: 6 AP, 3 TP, BAT, 2 PPII, 2 A (Walker Art Center, Minneapolis), C. Processing, proofing, and printing supervised by Jack Lemon; edition printing by Jerry Raidiger, assisted by David Panosh. 7 runs from 7 aluminum plates: 1 blue; 2 green; 3 red; 4 violet; 5 orange; 6 yellow; 7 black

EXHIBITIONS: La Jolla 1973; New York 1988; Cincinnati 1993

COMMENTS: This lunar region was the landing site for *Apollo 11* in 1969.

2
II Fra Mauro Region of the Moon. 1972

Lithograph on Arches Cover white paper, 22½ × 30″. Signed: *Graves* in pencil and dated, lower right; numbered in pencil, lower left; chop: logo of Landfall Press Inc., lower left; workshop's marks: title, date, dimensions, identification stamp, and workshop number NG72-322, lower left verso

PROOFS: 6 AP, 2 TP, BAT, 2 PPII, 2 A (Walker Art Center, Minneapolis), C. Processing, proofing, and printing supervised by Jack Lemon; edition printing by David Keister, assisted by David Panosh. 8 runs from 8 aluminum plates: 1 blue; 2 violet; 3 orange; 4 gray; 5 pink; 6 red; 7 yellow; 8 black

LITERATURE: Armstrong and McGuire 1989, pp. 80, *81;* La Jolla 1973, p. *25;* O'Connor 1988, p. *6*
EXHIBITIONS: La Jolla 1973; New York 1988; Minneapolis 1989; Cincinnati 1993

COMMENTS: This lunar region was the landing site for *Apollo 14* in 1971.

3
III Maestlin G Region of the Moon. 1972

Lithograph on Arches Cover white and *shin ten gu* papers with *chine collé,* 22½ × 30″. Signed: *Graves* in pencil and dated, lower right; numbered in pencil, lower left; chop: logo of Landfall Press Inc., lower left; workshop's marks: title, date, dimensions, identification stamp, workshop number NG72-325, lower left verso

PROOFS: 6 AP, BAT, 2 PPII, 2 A (Walker Art Center, Minneapolis), C. Processing, proofing, and printing supervised by Jack Lemon; edition printing by David Keister, assisted by Arthur Kleinman. 6 runs from 6 aluminum plates: 1 rust, printed on *shin ten gu;* 2 pink, printed on *shin ten gu;* 3 yellow, printed on *shin ten gu;* 4 orange, printed on *shin ten gu;* 5 violet, printed on *shin ten gu;* 6 green, printed on *shin ten gu*

LITERATURE: Armstrong and McGuire 1989, p. 80
EXHIBITIONS: La Jolla 1973; New York 1988; Minneapolis 1989; Cincinnati 1993

COMMENTS: The six colors were printed on six sides of three sheets of *shin ten gu* paper, which were *chine colléd* to the Arches Cover paper. This is the only print in the series in which Graves rendered the latitudinal and longitudinal lines (in violet) present in the original lunar map. Graves left irregular sections of paper unprinted here and elsewhere in the series to mimic those sectors in the original maps where topographical information was incomplete.

1

2

3

4

5

6

7

8

VIII Geologic Map of the Sinus Iridum Quadrangle of the Moon. 1972

Lithograph on Arches Cover white paper, 22½ × 30″. Signed: *Graves* in pencil and dated, lower right; numbered in pencil, lower left; chop: logo of Landfall Press Inc., lower left; workshop's marks: title, date, dimensions, identification stamp, workshop number NG72-327, lower left verso

PROOFS: 6 AP, 3 TP, BAT, 2 PPII, 2 A (Walker Art Center, Minneapolis), C. Processing, proofing, and printing supervised by Jack Lemon; edition printing by Jerry Raidiger, assisted by Arthur Kleinman. 8 runs from 8 aluminum plates: 1 gray; 2 light orange; 3 pink; 4 green; 5 yellow; 6 blue violet; 7 red violet; 8 black

EXHIBITIONS: La Jolla 1973; New York 1988; Cincinnati 1993

9

IX Sabine DM Region of the Moon. 1972

Lithograph on Arches Cover white paper and Mylar with *chine collé,* 22½ × 30″. Signed: *Graves* in pencil and dated, lower right; numbered in pencil, lower left; chop: logo of Landfall Press Inc., lower left; workshop's marks: title, date, dimensions, identification stamp, workshop number NG72-314, lower left verso

PROOFS: 6 AP, TP, BAT, 2 PPII, 2 A (Walker Art Center, Minneapolis), C. Processing, proofing, and printing supervised by Jack Lemon; edition printing by David Keister, assisted by David Panosh. 5 runs from 5 aluminum plates: 1 blue; 2 green; 3 red; 4 yellow; 5 black, printed on Mylar

EXHIBITIONS: La Jolla 1973; New York 1988; Cincinnati 1993

COMMENTS: The fifth color was printed on Mylar, which was laminated to the Arches Cover paper.

10

X Riphaeus Mountains Region of the Moon. 1972

Lithograph on Arches Cover white paper, 22½ × 30″. Signed: *Graves* in pencil and dated, lower right; numbered in pencil, lower left; chop: logo of Landfall Press Inc., lower left; workshop's marks: title, date, dimensions, identification stamp, workshop number NG72-326, lower left verso

PROOFS: 6 AP, TP, BAT, 2 PPII, 2 A (Walker Art Center, Minneapolis), C. Processing, proofing, and printing supervised by Jack Lemon; edition printing by David Keister, assisted by David Panosh. 5 runs from 5 aluminum plates: 1 orange; 2 green; 3 red; 4 violet; 5 black

EXHIBITIONS: La Jolla 1973; New York 1988; Cincinnati 1993; Kansas City 1996

8

9

10

11
Quipu. 1974

Offset lithograph, 22⅝ × 29⅞". Signed: *Graves* in pencil and dated, upper left; numbered in pencil, upper left

EDITION: 25
PROOFS: 25 AP, 2C. Printed by Falcon Press, Philadelphia. Published by the Institute of Contemporary Art, Philadelphia. 3 process colors, plus brown: 1 yellow; 2 red; 3 blue; 4 brown

COMMENTS: This offset lithograph was commissioned as a benefit for the Institute of Contemporary Art, Philadelphia. It depicts a *quipu,* an ancient Andean counting device consisting of strands of knotted string.

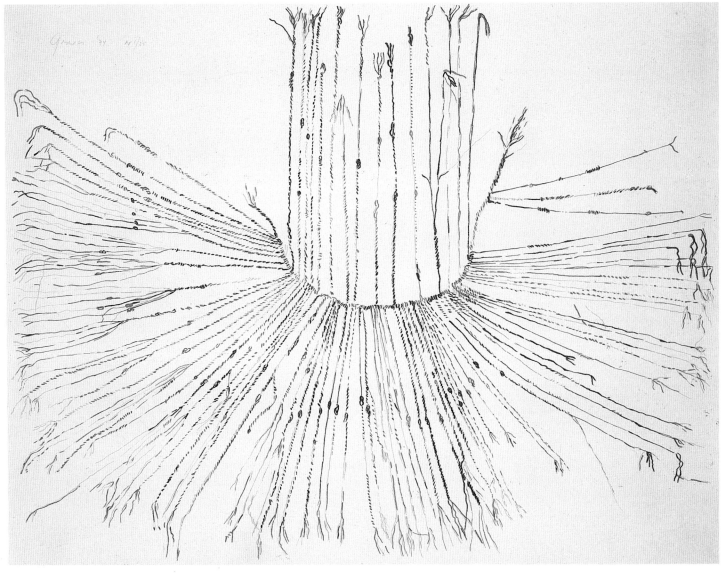

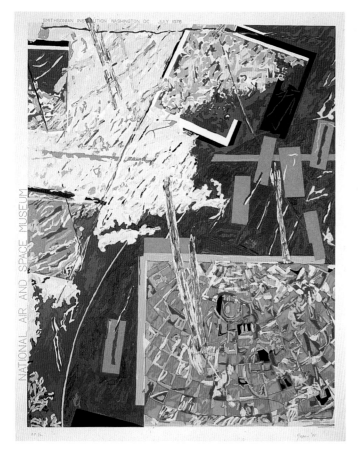

12

13

12

National Air and Space Museum Silkscreen. 1975

Screenprint on Hahnemuhle Copperplate paper, 38¼ × 31″. Signed: *Graves* in pencil and dated, lower right; numbered in pencil, lower left; chop: logo of Simca Print Artists, Inc., lower left; publisher's mark: copyright Smithsonian Institution 1976, lower left

EDITION: 30

PROOFS: 30 AP, BAT, 4 PPI. Processing and proofing supervised by Hiroshi Kawanishi; edition printing by Kenjiro Nonaka, Kawanishi, and Takeshi Shimada. Printed by Simca Print Artists, Inc., New York. Published by Smithsonian Institution, Washington, D.C. Documentation of number of screens is not extant; color sequence was determined by examination: 1 orange; 2 black; 3 red; 4 purple; 5 green; 6 light lemon yellow; 7 pink; 8 light blue; 9 light chrome yellow; 10 warm white; 11 light blue; 12 dark blue; 13 light gray; 14 bluish white

EXHIBITION: Kansas City 1996

COMMENTS: This screenprint was commissioned by the Smithsonian Institution, Washington, D.C., as a benefit for the National Air and Space Museum on the occasion of the opening of its new building in 1976. Revealing her continued interest in strategies of mapping, Graves juxtaposed variously scaled images of Earth derived from infrared and weather satellite photographs—the large white form descending from top left represents a portion of the Atlantic coastline of the United States, while the discrete rectangles, mimicking the format of the source photographs, contain imagery based on views of Earth from a lower altitude. She arranged these images in a collagelike formal structure that paralleled her painting. Initiating her practice of reinterpreting her earlier work, Graves reused the same screens for *Ertsne* (cat. no. 13), completed the following year.

13

Ertsne. 1976

Screenprint on Arches Cover white paper, 38¾ × 30¾″. Signed: *N. S. Graves* in pencil and dated, lower right; numbered in pencil, lower left; chop: logo of Simca Print Artists, Inc., lower right

EDITION: 35

PROOFS: 10 AP, BAT, 4 PPI. Processing and proofing by Hiroshi Kawanishi; edition printing by Kenjiro Nonaka, Kawanishi, and Takeshi Shimada. Printed by Simca Print Artists, Inc., New York. Published by Nancy Graves and Simca Print Artists, Inc., New York. Documentation of number of screens is not extant; color sequence was determined by examination: 1 light blue green; 2 light yellow; 3 olive; 4 gray; 5 opaque pale yellow; 6 light green blue; 7 pink; 8 mauve; 9 light gray; 10 light beige white; 11 white

EXHIBITIONS: New York 1988; Kansas City 1996

Cat. Nos. 14–19
SYNECDOCHE SERIES, 1977

Working with Kenneth Tyler, Graves produced this series, her first intaglio prints, in 1977 at Tyler Graphics Ltd. Though related formally to the spare and gestural paintings and watercolors Graves made in the mid- to late 1970s, these etchings are based on the Lunar series (cat. nos. 1–10), each being an abstraction of a specific lithograph from the earlier series—another example of the artist's reinterpretation of her own work.

Printed and published by Tyler Graphics Ltd., Bedford Village, New York

14
Saille. 1977

Etching, aquatint, and pochoir with pastel on Arches Cover white paper, 31½ × 35½". Signed: *N. S. Graves* in pencil and dated, lower right; numbered in pencil, lower left; chop: logo of Tyler Graphics Ltd., lower right; workshop number NG77-335, lower left verso

EDITION: 27
PROOFS: 10 AP, 3 TP, BAT, PPI, A, C. Plate preparation, processing, proofing, and edition printing by Rodney Konopaki, assisted by Paul Sanders. 3 runs from 3 copperplates: 1 pale yellow ocher (etching); 2 pale yellow green and light green (etching and aquatint); 3 dark orange, yellow ocher, red, violet red, light violet, cobalt blue, light turquoise blue, turquoise blue, brown green, and black (etching and aquatint)

LITERATURE: Museum of Modern Art, New York 1986, p. 136; Tyler 1987, pp. 142, *142,* the illustration is misidentified as *Toch* (cat. no. 16)
EXHIBITIONS: New York 1977; New York 1988; Minneapolis 1993–94; Kansas City 1996

COMMENTS: The print is an abstraction of *VIII Geologic Map of the Sinus Iridum Quadrangle of the Moon* (cat. no. 8) from the Lunar series. Graves used a plastic stencil to apply the purple pastel on the edition prints.

15

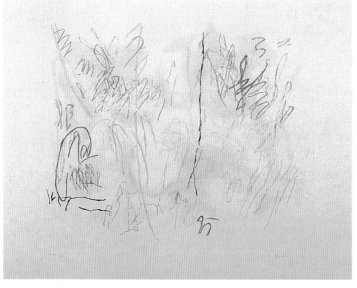

16

17

15

Onon. 1977

Etching, aquatint, drypoint, engraving, and pochoir with pastel on Arches Cover white paper, 31½ × 35½″. Signed: *N. S. Graves* in pencil and dated, lower right; numbered in pencil, lower left; chop: logo of Tyler Graphics Ltd., lower right; workshop number NG77-336, lower left verso

EDITION: 29

PROOFS: 10 AP, 3 TP, BAT, PPI, A, C. Plate preparation, processing, proofing, and edition printing by Rodney Konopaki, assisted by Paul Sanders. 4 runs from 4 copperplates: 1 transparent red, transparent light violet, transparent violet, and transparent blue purple (etching and aquatint); 2 purple (drypoint and engraving); 3 light yellow, medium yellow, pink, violet, cobalt blue, turquoise blue, and black (etching and aquatint); 4 transparent yellow (aquatint)

LITERATURE: Associated American Artists 1989, p. *42;* Goldman 1977, pp. 35, 38; Tyler 1987, pp. 142, *142*
EXHIBITIONS: Hempstead 1977; New York 1977; New York 1988; New York 1989; Minneapolis 1993–94

COMMENTS: The print is an abstraction of *I Part of Sabine D Region, Southwest Mare Tranquilitatis* (cat. no. 1) from the Lunar series. Graves used a plastic stencil to apply the light yellow-green and blue-green pastel on the edition prints.

16

Toch. 1977

Hard- and soft-ground etching, aquatint, drypoint, engraving, and pochoir with pastel on Arches Cover white paper, 31½ × 35½″. Signed: *N. S. Graves* in pencil and dated, lower right; numbered in pencil, lower left; chop: logo of Tyler Graphics Ltd., lower right; workshop number NG77-337, lower left verso

EDITION: 28

PROOFS: 11 AP, 3 TP, 2 CTP, BAT, PPI, SP, A, C. Plate preparation and processing by Rodney Konopaki; proofing by Konopaki and Kenneth Tyler; edition printing by Konopaki. 3 runs from 3 copperplates: 1 transparent pink, transparent red ocher, transparent orange brown, transparent turquoise blue, transparent yellow green, and trans-

parent green (aquatint and etching); 2 transparent yellow, transparent red, transparent violet, and transparent gray blue (aquatint); 3 transparent orange red and transparent gray (hard- and soft-ground etching, aquatint, drypoint, and engraving)

LITERATURE: Friedman et al. 1987, p. *86;* Goldman 1977, pp. 35, *37,* 38; Tyler 1987, pp. 142, *142,* the illustration is misidentified as *Saille* (cat. no. 14)
EXHIBITIONS: Hempstead 1977; New York 1977; Minneapolis 1984–85; New York 1988; Minneapolis 1993–94; Kansas City 1996

COMMENTS: The print is an abstraction of *II Fra Mauro Region of the Moon* (cat. no. 2) from the Lunar series. Graves used a plastic stencil to apply the cobalt blue pastel on the edition prints.

17

Muin. 1977

Etching, aquatint, drypoint, and pochoir with pastel on Arches Cover white paper, 31½ × 35½″. Signed: *N. S. Graves* in pencil and dated, lower right; numbered in pencil, lower left; chop: logo of Tyler Graphics Ltd., lower right; workshop number NG77-338, lower left verso

EDITION: 32

PROOFS: 10 AP, 4 TP, BAT, PPI, SP, A, C. Plate preparation, processing, proofing, and edition printing by Rodney Konopaki, assisted by Paul Sanders. 4 runs from 4 copperplates: 1 transparent blue-green gray (etching); 2 transparent yellow and transparent pink orange (aquatint); 3 pale yellow orange, pink, medium purple, light gray tan, turquoise blue, brown green, and light blue green (etching, aquatint, and drypoint); 4 transparent orange, medium red, light violet, light green, medium gray, and black (etching, aquatint, and drypoint)

LITERATURE: Museum of Modern Art, New York 1986, p. 136; Tyler 1987, pp. 143, *143*
EXHIBITIONS: New York 1977; Minneapolis 1987; New York 1988; Minneapolis 1993–94

COMMENTS: The print is an abstraction of *III Maestlin G Region of the Moon* (cat. no. 3) from the Lunar series. Graves used a plastic stencil to apply the yellow and white pastel on the edition prints.

18
Ngetal. 1977

Etching, aquatint, engraving, drypoint, and pochoir with pastel on Arches Cover white paper, 31½ × 35½″. Signed: *N. S. Graves* in pencil and dated, lower right; numbered in pencil, lower left; chop: logo of Tyler Graphics Ltd., lower right; workshop number NG77-339, lower left verso

EDITION: 33
PROOFS: 9 AP, 3 TP, 4 CTP, 2 WP, BAT, PPI, SP, A, C. Plate preparation, processing, proofing, and edition printing by Rodney Konopaki, assisted by Paul Sanders. 3 runs from 3 copperplates: 1 orange red, light pink, blue purple, yellow green, and black (etching, aquatint, and engraving); 2 light yellow, red, cobalt blue, and black (etching and drypoint); 3 medium yellow, medium orange, dark orange, turquoise blue, yellow green, blue green, and light blue gray (etching)

LITERATURE: Field and Fine 1987, pp. 92, 93; Friedman et al. 1987, p. 87; Tyler 1987, pp. 143, *143*
EXHIBITIONS: New York 1977; Minneapolis 1984–85; South Hadley 1987; New York 1988; Minneapolis 1993–94; Kansas City 1996

COMMENTS: The print is an abstraction of *V Montes Apenninus Region of the Moon* (cat. no. 5) from the Lunar series. Graves used a plastic stencil to apply the dark orange, yellow green, medium blue, and violet-blue gray pastel on the edition prints.

19
Ruis. 1977

Etching, aquatint, engraving, and pochoir with pastel on Arches Cover white paper, 31½ × 35½″. Signed: *N. S. Graves* in pencil and dated, lower right; numbered in pencil, lower left; chop: logo of Tyler Graphics Ltd., lower right; workshop number NG77-340, lower left verso

EDITION: 33
PROOFS: 10 AP, 2 TP, BAT, PPI, SP, A, C. Plate preparation, processing, proofing, and edition printing by Rodney Konopaki. 5 runs from 5 copperplates: 1 transparent light blue gray and medium silver gray (aquatint); 2 transparent blue green (aquatint); 3 medium purple (etching); 4 light blue green (etching and engraving); 5 yellow and black (etching and engraving)

LITERATURE: Armstrong 1984, p. *11;* O'Connor 1988, p. 7; Tyler 1987, pp. 143, *143*
EXHIBITIONS: New York 1977; Minneapolis 1984–85; New York 1988; Minneapolis 1993–94

COMMENTS: The print is an abstraction of *X Riphaeus Mountains Region of the Moon* (cat. no. 10) from the Lunar series. Graves used a plastic stencil to apply the orange-red and black pastel on the edition prints.

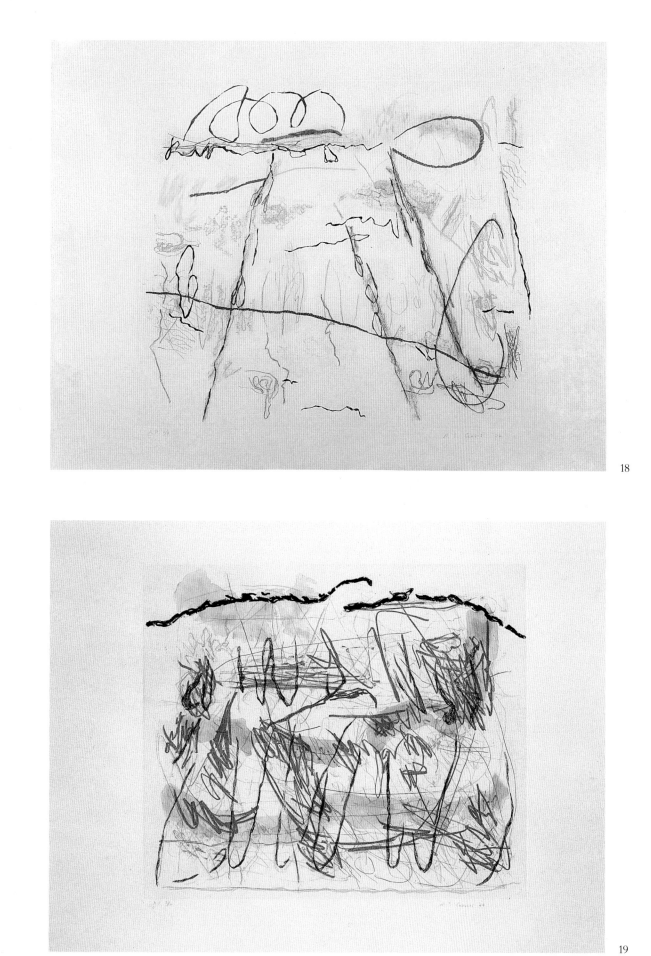

18

19

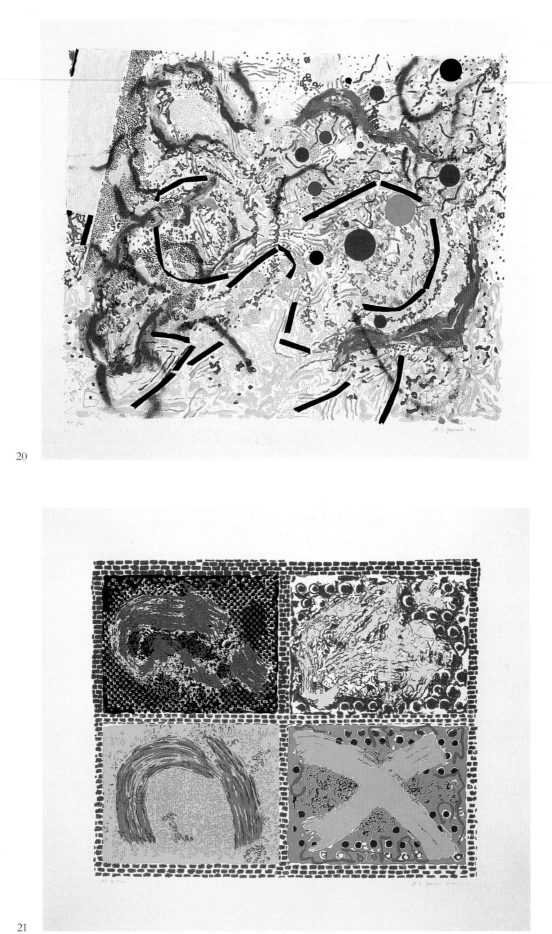

20

21

20
Vertigo. 1980

Screenprint on Arches Cover white paper, 29½ × 35½″.
Signed: *N. S. Graves* in pencil and dated, lower right;
chop: logo of Styria Studios, lower left

EDITION: 60

PROOFS: 12 AP. Processing, proofing, and edition printing
supervised by Adi Rischner. Printed by Styria Studios,
New York. Published by Trisha Brown Dance Company,
New York. Documentation of number of screens is not
extant; color sequence was determined by examination:
1 salmon; 2 bright orange; 3 transparent pink; 4 light
green; 5 dark green; 6 transparent light yellow; 7 chrome
yellow; 8 royal blue; 9 lemon yellow; 10 cherry red; 11
opaque very light yellow; 12 burnt orange; 13 magenta;
14 opaque light blue green; 15 black

COMMENTS: Produced as a benefit for the Trisha Brown
Dance Company in New York, this screenprint is closely
related to two paintings from 1980, *Equibrate* and *Shift,* in
which Graves reintroduced formal elements of her map-
inspired work of the early 1970s. The artist juxtaposed var-
iously sized dot matrices and broken lines, elements from
her lithographic Lunar series (cat. nos. 1–10), and explored
shifts of scale similar to those found in her direct-cast
bronze sculpture.

21
Lincoln Center Print. 1980

Screenprint on Arches Aquavella Satinee paper, 32¼ ×
38¼″. Signed: *N. S. Graves* in pencil and dated, lower
right; numbered in pencil, lower left; chop: logo of Charles
Cardinale Fine Creations, Inc., lower right

EDITION: 140

PROOFS: 18 AP. Printed by Charles Cardinale Fine
Creations, Inc., New York. Published by Lincoln Center
Poster and Print Program, New York. 15 runs from
15 screens: 1 magenta; 2 black; 3 transparent cadmium yel-
low; 4 orange; 5 light magenta; 6 blue; 7 mustard; 8 dark
blue; 9 red; 10 transparent light green; 11 dark blue green;
12 transparent yellow; 13 dark green; 14 light blue;
15 bright pink

EXHIBITION: Minneapolis 1993–94

COMMENTS: Commissioned as a benefit for Lincoln
Center for the Performing Arts, New York, this screen-
print is closely related to a series of paintings from 1980
(*Ergo, Quadra,* and *Where-There*) in which Graves
explored variations on a composition divided into four
quadrants, each dominated by imposing brushstrokes. A
poster of the image was also created and issued in an edi-
tion of 730.

22
Equivalent. 1980

Screenprint on Arches Aquavella Satinee paper,
29¼ × 40″. Signed: *N. S. Graves* and dated, lower right;
numbered in pencil, lower left; chop: logo of Styria
Studios, lower right

EDITION: 60
PROOFS: 12 AP. Processing, proofing, and edition printing
supervised by Adi Rischner. Printed by Styria Studios,
New York. Published by the Albright-Knox Art Gallery,
Buffalo, New York. Documentation of number of screens
is not extant; color sequence was determined by examina-
tion: 1 light pink; 2 chrome yellow; 3 orange; 4 cherry red;
5 royal blue; 6 black; 7 very dark gray; 8 dark gray; 9 blue
green; 10 lime green; 11 silver gray; 12 opaque light
magenta; 13 opaque pink white

EXHIBITION: Kansas City 1996

COMMENTS: This screenprint was commissioned as a ben-
efit for the Albright-Knox Art Gallery, Buffalo, New York.
Demonstrating the cross-pollination between her two- and
three-dimensional work, this screenprint is closely related
to a 1978 painting of the same name (Cathcart 1980,
p. *86*). In the center and extending to the side panels of
the tripartite composition is the image of the *quipu* from
the eponymous 1974 offset lithograph (cat. no. 11), which
in 1978 had also inspired Graves's first direct-cast bronze
sculpture (see fig. 11).

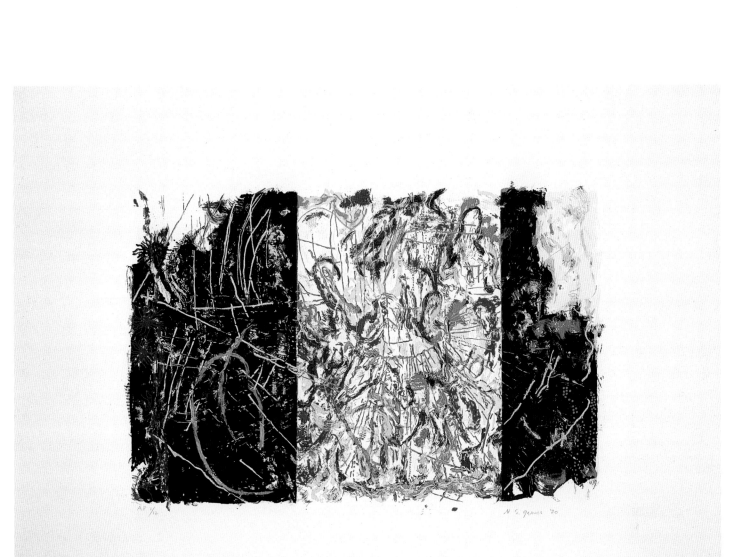

AP 1/12 N S graves '20

23

Four Times Four. 1981

Etching, aquatint, and drypoint on Fabriano Rosaspina cream paper, 24¼ × 24¼″. Signed: *N. S. Graves* in pencil and dated, lower right; numbered in pencil, lower left; chop: logo of 2RC Edizioni d'Arte, upper left

EDITION: 45
PROOFS: 5 AP, TP, BAT, PPI, PPII. Processing, proofing, and printing supervised by Valter and Eleonora Rossi; edition printing by Giuseppe Di Leo and Adriano Corazzi. Printed by Stamperia d'Arte, Rome. Published by the Metropolitan Museum of Art, New York. 4 runs from 4 copperplates: 1 solferino, violet, and yellow green (etching, aquatint, and drypoint); 2 red and orange (etching, aquatint, and drypoint); 3 blue (aquatint and drypoint); 4 yellow (etching and aquatint)

EXHIBITIONS: New York 1988; Kansas City 1996

COMMENTS: Produced as a benefit for the Metropolitan Museum of Art, New York, *Four Times Four* is related to a 1977 painting of the same name. The BAT was pulled in 1979, the edition in 1981.

24

Calibrate. 1981

Hard- and soft-ground etching, aquatint, engraving, and lithograph on Lana Gravure white paper, 29¼ × 32½″. Signed: *N. S. Graves* in pencil and dated, lower right; numbered in pencil, lower left; chop: logo of Tyler Graphics Ltd., lower right; workshop number NG 80-551, lower left verso

EDITION: 30
PROOFS: 12 AP, 2 TP, BAT, PPI, A, C. Stone preparation, processing, proofing, and edition printing by Kenneth Tyler; plate preparation, processing, proofing, and edition printing by Rodney Konopaki. Printed and published by Tyler Graphics Ltd., Bedford Village, New York. 7 runs from 1 stone, 1 zinc plate, and 5 copperplates: 1 violet (lithograph); 2 red and violet red (etching and aquatint);

3 medium blue, ultramarine, Prussian blue, and black (hard- and soft-ground etching and aquatint); 4 turquoise blue (etching and aquatint); 5 yellow (etching, aquatint, and engraving); 6 light blue, blue, dark blue, green, and gray green (etching, aquatint, and engraving); 7 dark brown green and white (etching on zinc)

LITERATURE: Armstrong 1984, p. 17; Field and Fine 1987, p. 93; Tyler 1987, pp. *140,* 141
EXHIBITIONS: South Hadley 1987; Minneapolis, 1987; Yokohama 1992; Minneapolis 1993–94; Kansas City 1996

COMMENTS: Graves depicted images of portions of three of her sculptures in the composition: the skeletal camel legs to the left and right represent *Variability of Similar Forms,* 1970 (Carmean, Jr., et al. 1987, p. *59*); the vertical pikes rising from the bottom represent *Variability and Repetition of Variable Forms,* 1971 (fig. 5); and the V-shaped lines represent *Calipers,* 1970 (fig. 12). The vibrant ink palette is related to the patinas and enamels the artist applied to her direct-cast bronze sculpture. *Calibrate* is closely related to a 1979 painting of the same name (Cathcart 1980, p. *99*). Graves reinterpreted the composition once again in an untitled drawing of 1987.

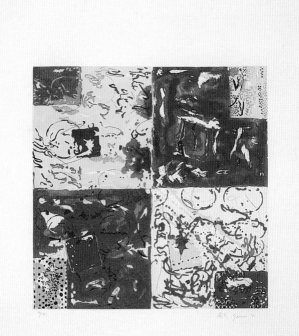

23

24

Cat. Nos. 25, 26

Like the 1978 painting Approaches the Limit *(Cathcart 1980, p. 82) on which it is based,* Approaches the Limit of I *features the image of Nefertiti inspired by the fourteenth-century* B.C. *limestone bust in the Staatliche Museen, Berlin, outlined in black dots in the central rectangle. Though Graves had introduced the iconic image of the Egyptian queen in earlier drawings and paintings (see fig. 15),* Approaches the Limit of I *marks the first time she had introduced a figurative element into her prints. Recalling the imagery hidden in the artist's 1971 Camouflage Series of paintings (see fig. 4), the bust of Nefertiti is obscured under layers of gestural drawing (the bust is most easily seen in the lower left corner of the rectangle where the chin and mouth are visible in profile). For* Approaches the Limit of II *Graves reused the plates from* Approaches the Limit of I, *adding one etching and five lithographic plates. Changes from the earlier print include the addition of a third vertical stroke (at right in violet) and a more intense ink palette. With these two prints, Graves began to extend the composition out into what would traditionally be the margin.*

25
Approaches the Limit of I. 1981

Lithograph on Arches Cover white paper, 46 × 31¾". Signed: *N. S. Graves* in pencil and dated, lower right; numbered in pencil, lower left; chop: logo of Tyler Graphics Ltd., lower right; workshop number NG 80-553, lower left verso

EDITION: 30
PROOFS: 14 AP, BAT, PPI, PPII, A, C. Plate preparation, processing, and proofing by Kenneth Tyler on press I; photo plate preparation and processing by Lee Funderburg; proofing and edition printing by Roger Campbell and Funderburg on press II. Printed and published by Tyler Graphics Ltd., Bedford Village, New York. 8 runs from 8 aluminum plates: 1 transparent pink; 2 orange red; 3 turquoise blue; 4 dark blue; 5 black; 6 white; 7 blend of medium yellow and medium orange yellow; 8 white

LITERATURE: Hansen and Heartney 1991, p. *79;* Tyler 1987, pp. 144, *144*
EXHIBITIONS: Minneapolis 1984–85; New York 1988; Washington, D.C. 1991; Minneapolis 1993–94

26
Approaches the Limit of II. 1981

Lithograph and etching on Arches Cover white paper, 48 × 31⅝". Signed: *N. S. Graves* in pencil and dated, lower right; numbered in pencil, lower left; chop: logo of Tyler Graphics Ltd., lower right; workshop number NG 80-553, lower left verso

EDITION: 30
PROOFS: 14 AP, BAT, PPI, PPII, A, C. Plate preparation, processing, and proofing by Kenneth Tyler on press I; photo plate preparation and processing by Lee Funderburg; proofing and edition printing by Roger Campbell and Funderburg on press II; magnesium plate preparation by Tyler, with processing by Pete Duchess; edition printing by Campbell and Funderburg. Printed and published by Tyler Graphics Ltd., Bedford Village, New York. 14 runs from 13 aluminum plates and 1 magnesium plate: 1 transparent pink (lithograph); 2 transparent orange red (lithograph); 3 orange (lithograph); 4 red (lithograph); 5 turquoise blue (lithograph); 6 blend of medium yellow and medium orange yellow (lithograph); 7 dark blue (lithograph); 8 violet (lithograph); 9 red brown (lithograph); 10 yellow pink (lithograph); 11 light orange (lithograph); 12 gray green (lithograph); 13 white (lithograph); 14 dark red, dark purple, and dark blue (etching on magnesium)

LITERATURE: Friedman et al. 1987, p. *10;* Gilmour 1989, p. *12;* O'Connor 1988, p. *8;* Tyler 1987, pp. 144, *144*
EXHIBITIONS: New York 1988; Minneapolis 1993–94; Kansas City 1996

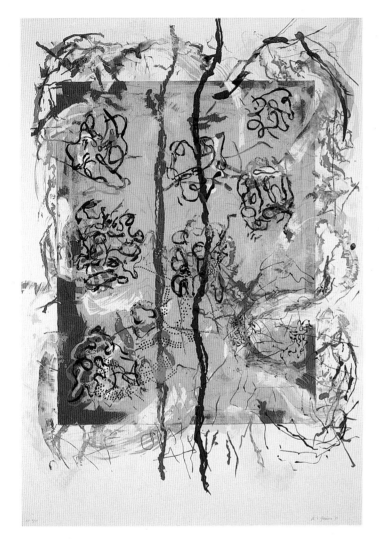

25

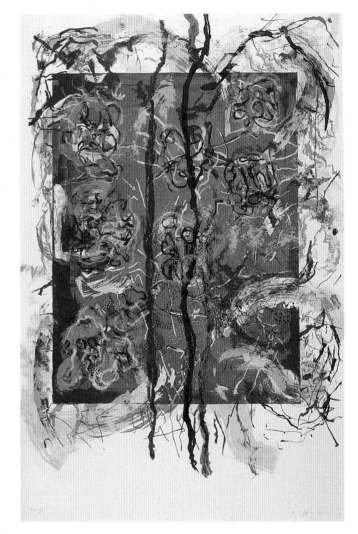

26

Cat. Nos. 27–57
MONOPRINT SERIES

*The monoprints Graves completed at Tyler Graphics in
1981 are the most painterly of the artist's prints. She applied
paint in heavy strokes directly to two etched copperplates and
a polished magnesium plate in varying combinations. To
heighten the contrast of color on selected prints, Graves print-
ed on paper that she had painted with printing inks thinned
with varnish.*

Papermaking by Steve Reeves and Tom Strianese of Tyler
Graphics Ltd.; plate preparation and processing by Rodney
Konopaki; printing by Konopaki, Roger Campbell, Lee
Funderburg, and Kenneth Tyler. Printed and published by
Tyler Graphics Ltd., Bedford Village, New York

27
Aha. 1981

Monoprint on handmade white paper, 31½ × 43″. Signed:
N. S. Graves in pencil and dated, lower left. Collection
Kass/Meridian, Chicago

28
Allia. 1981

Monoprint on handmade white paper, 30 × 43″. Signed:
N. S. Graves in pencil and dated, lower left

29
Alloca. 1981

Monoprint on handmade light blue paper, 32½ × 44¾″.
Signed: *N. S. Graves* in pencil and dated, upper left. Walker
Art Center, Minneapolis. Gift of Dr. Maelyn E. Wade, 1984

LITERATURE: Field and Fine 1987, p. 93
EXHIBITIONS: Minneapolis 1984–85; South Hadley 1987

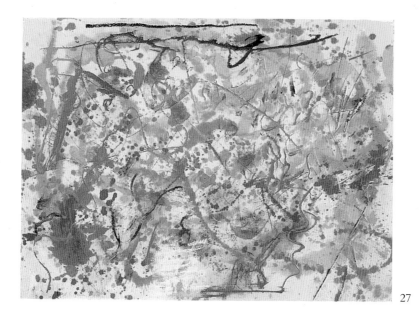

27

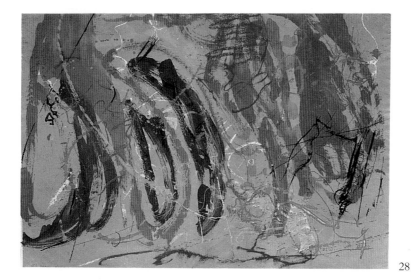

28

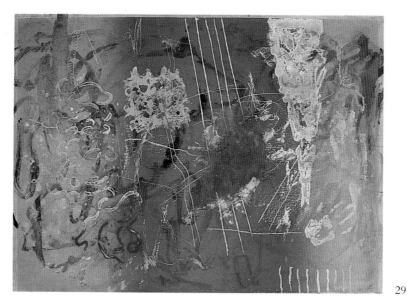

29

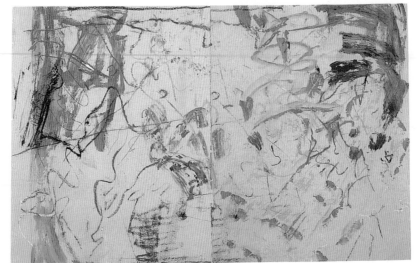

30

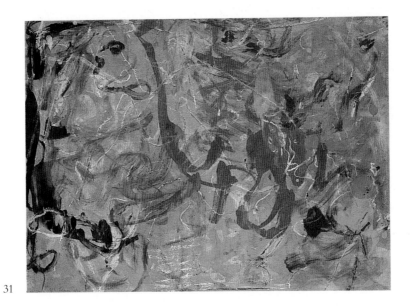

31

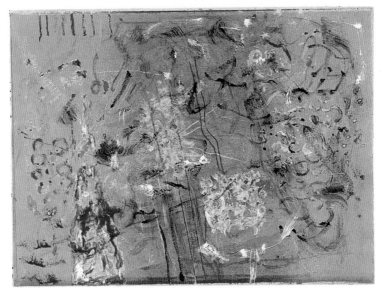

32

30
Cegena. 1981

Monoprint on handmade yellow paper, diptych, overall
30 × 49½″. Signed: *N. S. Graves* in pencil and dated, lower
center. Collection the artist

LITERATURE: Friedman et al. 1987, p. 86
EXHIBITION: Kansas City 1996

31
Ceive. 1981

Monoprint on handmade yellow tan paper, 30 × 40″.
Signed: *N. S. Graves* in pencil and dated, lower left

LITERATURE: Tyler 1987, pp. 145, *145*

32
Cellane. 1981

Monoprint on handmade light gray paper, 32 × 43¾″.
Signed: *N. S. Graves* in pencil and dated, lower right

33
Chala. 1981

Monoprint on handmade white paper, 30½ × 39¾″.
Signed: *N. S. Graves* in pencil and dated, lower left

LITERATURE: Friedman et al. 1987, pp. 83, *85*
EXHIBITIONS: New York 1988; Kansas City 1996

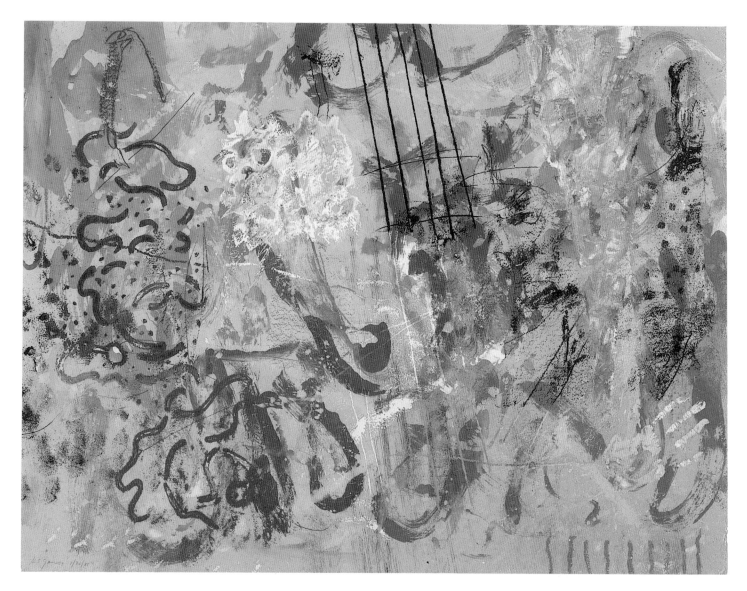

33

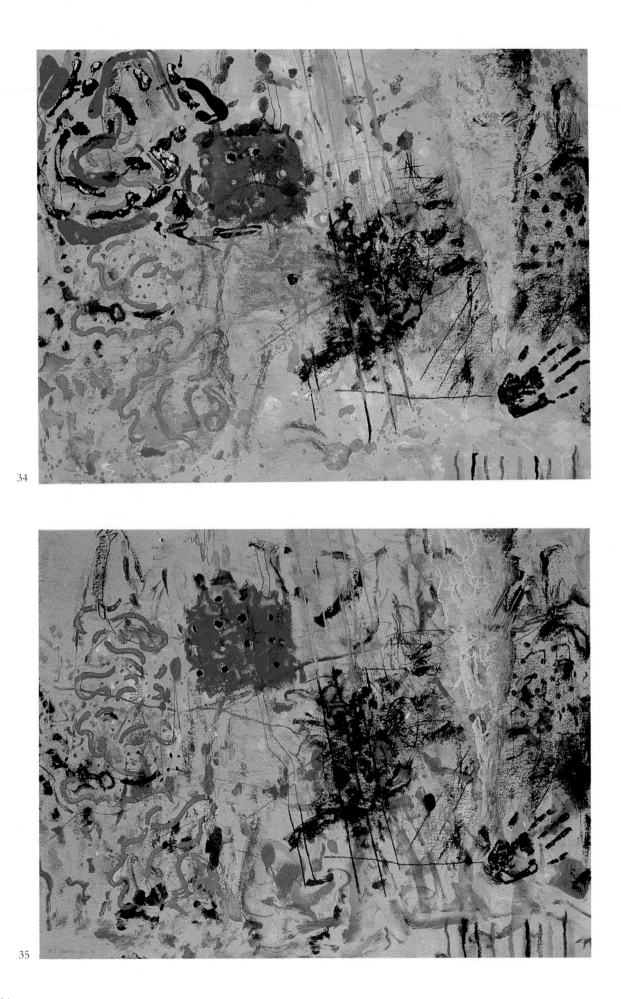

34

35

34
Chie. 1981

Monoprint on handmade light orange-pink paper, 30 ×
40″. Signed: *N. S. Graves* in pencil and dated, lower center.
Collection Kass/Meridian, Chicago

35
Cleate. 1981

Monoprint on handmade light orange-pink paper, 30 ×
40″. Signed: *N. S. Graves* in pencil and dated, lower left

36
Comba. 1981

Monoprint on handmade light pink paper, 30½ × 40¼″.
Signed: *N. S. Graves* in pencil and dated, lower left.
Collection the artist

37
Confo. 1981

Monoprint on handmade white paper, 32 × 37¾″. Signed:
N. S. Graves in pencil and dated, lower left

LITERATURE: Friedman et al. 1987, p. 83

38
Creant. 1981

Monoprint on handmade white paper, 30 × 40″. Signed:
N. S. Graves in pencil and dated, lower right

LITERATURE: Friedman et al. 1987, pp. 83, *85*

39
Formi. 1981

Monoprint on handmade light orange-pink paper, 30 ×
42″. Signed: *N. S. Graves* in pencil and dated, lower left

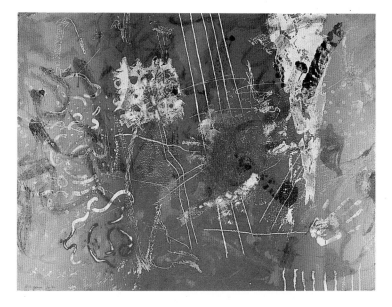

36

37

38

39

40

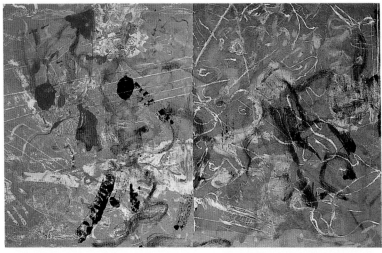

41

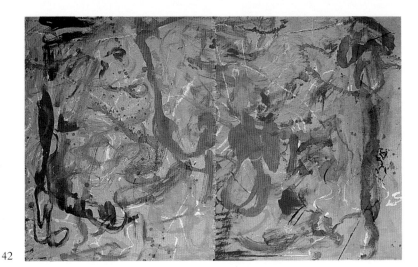

42

40
Gardli. 1981

Monoprint on handmade pale yellow paper, 40 × 30″.
Signed: *N. S. Graves* in pencil and dated, lower right.
Collection PepsiCo, Inc., Purchase, New York

LITERATURE: Friedman et al. 1987, p. 83

41
Gling. 1981

Monoprint on handmade white paper, 30 × 49″. Signed:
N. S. Graves in pencil and dated, upper left

LITERATURE: Tyler 1987, pp. 147, *147*

42
Ject. 1981

Monoprint on handmade light pink paper, 30 × 49″.
Signed: *N. S. Graves* in pencil and dated, upper center

43

Merab. 1981

Monoprint on handmade light orange paper, 30¼ × 40¼″.
Signed: *N. S. Graves* in pencil and dated, lower center.
Collection the artist

LITERATURE: Tyler 1987, pp. 146, *146*

44

Misun. 1981

Monoprint on handmade light orange-pink paper, 30 ×
40″. Signed: *N. S. Graves* in pencil and dated, lower right

45

Mosphe. 1981

Monoprint on handmade light blue paper, 32¼ × 43½″.
Signed: *N. S. Graves* in pencil and dated, lower left. Walker
Art Center, Minneapolis. Tyler Graphics Archive, 1983

LITERATURE: Tyler 1987, pp. 147, *147*
EXHIBITION: Yokohama 1992

46

Neous. 1981

Monoprint on handmade light green paper, 30 × 40″.
Signed: *N. S. Graves* in pencil and dated, lower left.
Collection Mr. and Mrs. George M. Ross

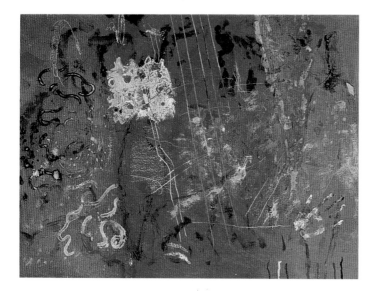

43

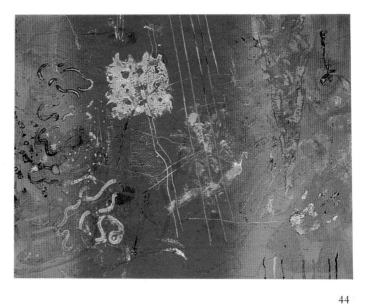

44

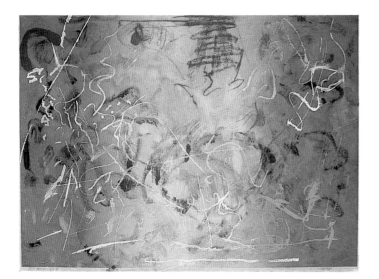

45

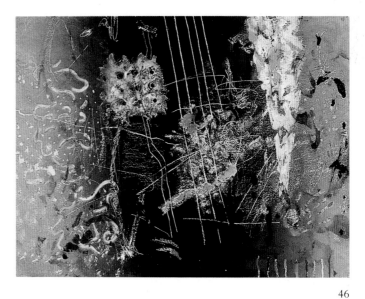

46

47
Nomer. 1981

Monoprint on handmade white paper, 32 × 38″. Signed: *N. S. Graves* in pencil and dated, lower left. Collection Daniel Mayo

LITERATURE: Tyler 1987, pp. 145, *145*

48
Nour. 1981

Monoprint on handmade yellow paper, 30 × 50″. Signed: *N. S. Graves* in pencil and dated, lower center

49
Owad. 1981

Monoprint on handmade white paper, 31¾ × 43¾″. Signed: *N. S. Graves* in pencil and dated, upper left. Walker Art Center, Minneapolis. Tyler Graphics Archive, 1984

LITERATURE: Friedman et al. 1987, pp. 83, *84;* Tyler 1987, pp. 146, *146*
EXHIBITION: Minneapolis 1984–85

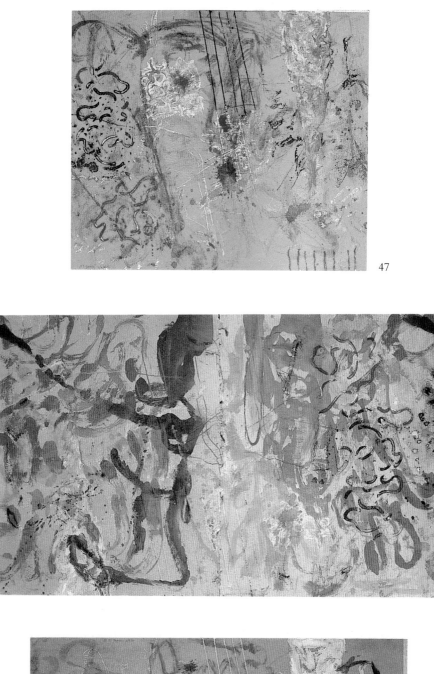

47

48

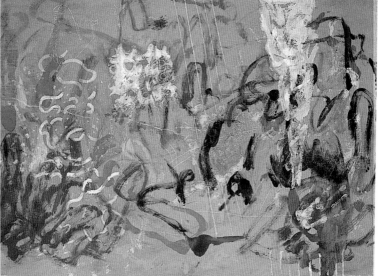

49

50
Pria. 1981

Monoprint on handmade light gray paper, 42 × 29″.
Signed: *N. S. Graves* in pencil and dated, lower left

51
Romus. 1981

Monoprint on handmade pale yellow paper, 30 × 40″.
Signed: *N. S. Graves* in pencil and dated, lower center

52
Tate. 1981

Monoprint on handmade light pink paper, 44 × 32″.
Signed: *N. S. Graves* in pencil and dated, lower right

LITERATURE: Friedman et al. 1987, p. 83; Tyler 1987, pp. 146, *146*
EXHIBITION: Yokohama 1992

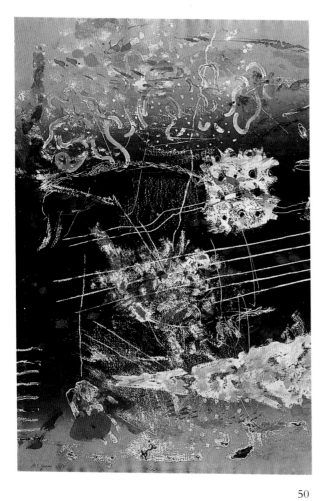

50

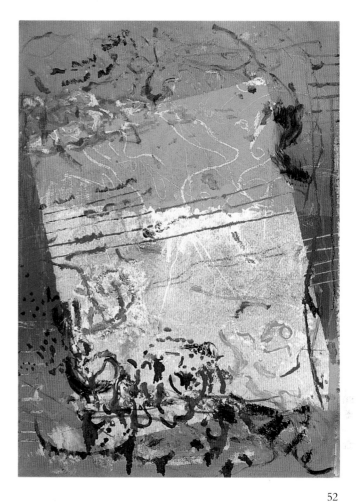

52

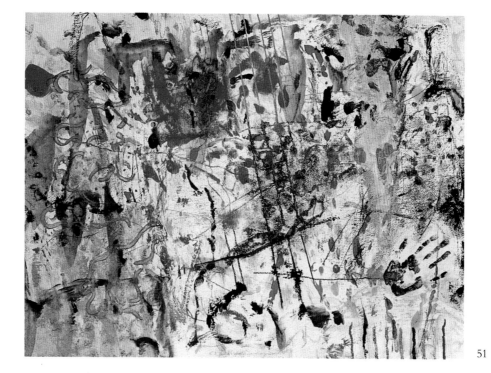

51

53
Tifica. 1981

Monoprint on handmade white paper, 32 × 43″

COMMENTS: The location of the print is unknown, and a
photograph unavailable from the publisher.

54
Trali. 1981

Monoprint on handmade light orange-pink paper,
40 × 30″

COMMENTS: The location of the print is unknown, and the
signature is not discernible from the photograph provided
by the publisher.

55
Turnal. 1981

Monoprint on handmade light gray paper, 42 × 28¾″.
Signed: *N. S. Graves* in pencil and dated, lower left.
Collection the artist

LITERATURE: Tyler 1987, pp. 147, *147*

56
Vitia. 1981

Monoprint on handmade white paper, 31½ × 43″. Signed:
N. S. Graves in pencil and dated, upper right. Collection
Prince Fine Arts, Highland Park, Illinois

57
Zospora. 1981

Monoprint on handmade white paper, triptych, 89½ × 24″

COMMENTS: The location of the print is unknown, and a
photograph unavailable from the publisher.

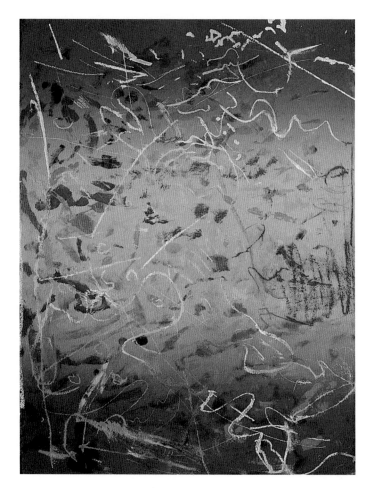

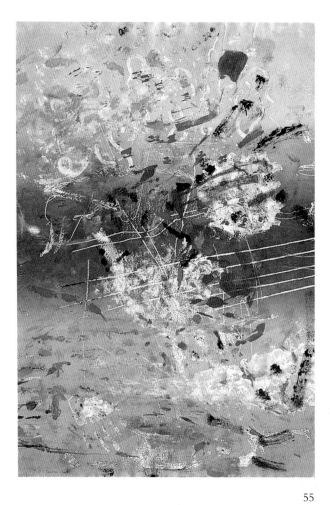

54

55

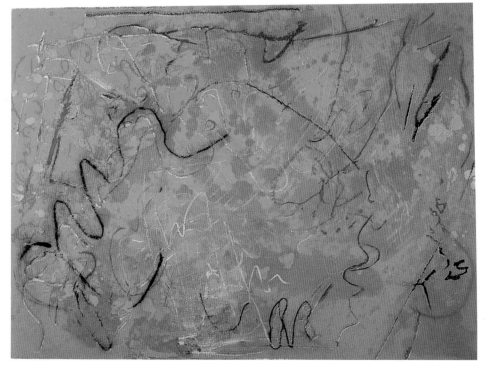

56

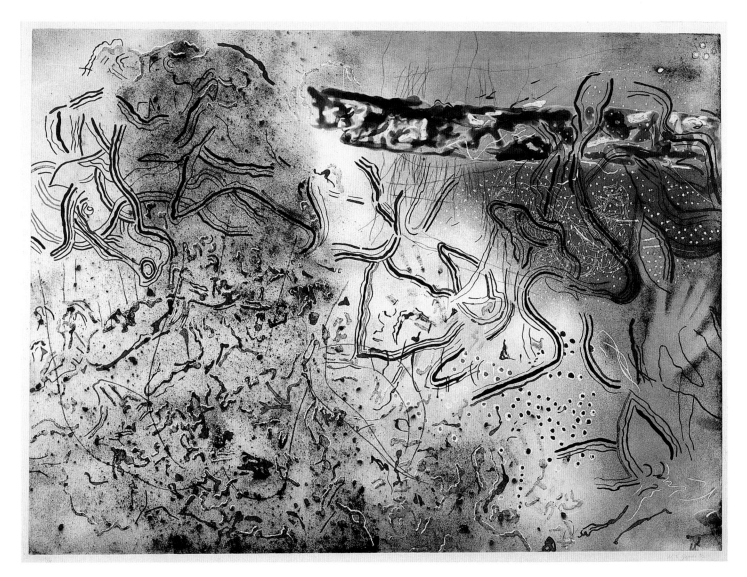

58
Paleolinea. 1982

Etching, aquatint, and drypoint on Magnani Pescha paper, 40¼ × 55″. Signed: *N. S. Graves* in pencil and dated, lower right; numbered in pencil, lower left; chop: logos of Vigna Antoniniana Stamperia d'Arte and 2RC Edizioni d'Arte, lower right

EDITION: 15
PROOFS: 5 AP, BAT, PPI, PPII. Processing, proofing, and printing supervised by Valter and Eleonora Rossi; edition printing by Adriano Corazzi. Printed by Vigna Antoniniana Stamperia d'Arte, Rome. Published by 2RC Edizioni d'Arte, Rome. 1 run from 1 copperplate: black (etching, aquatint, and drypoint)

LITERATURE: Museum of Modern Art, Toyama 1989, p. *152;* O'Connor 1988, p. *10*
EXHIBITIONS: New York 1988; Kansas City 1996

COMMENTS: Graves's first project with Valter and Eleonora Rossi of 2RC Edizioni d'Arte, this etching was begun in 1979 while she was a resident at the American Academy in Rome. Like much of her work, *Paleolinea,* though seemingly abstract, is based on imagery from the visible world. The composition is related to a 1977 painting, *Scaux* (fig. 8), and features an amalgam of motifs inspired by Upper Paleolithic artifacts and cave paintings integrated with the artist's abstract imagery. The form extending horizontally from the upper right margin is inspired by a type of carved horn found in many Upper Paleolithic sites (fig. 10). Directly underneath are the broken outlines of a group of animals (horse, bison, and bears) based on an Upper Paleolithic incised drawing in the cave of Les Trois Frères, France. Scattered diagonally across the composition is a motif (composed of three parallel lines), which terminates at left in a bull's head, inspired by a drawing in the Spanish cave of Altamira (fig. 9). Echoing one of the most haunting features of Paleolithic cave paintings—the handprints of the prehistoric people who made them—Graves incorporated her handprint in the composition. The artist's negative handprint is visible at right; less discernible are the two positive handprints, located just to the left of center and along the lower margin to the right of center, that Graves made by placing her inked hand directly on the copperplate before etching. The BAT was pulled in 1979, the edition in 1982.

59
Extracten. 1982

Soft-ground etching and aquatint on Hahnemuhle German Etching white paper, 29⅝ × 22″. Signed: *N. S. Graves* in pencil and dated, lower right; numbered in pencil, lower left; chop: logo of Donn H. Steward, lower right

EDITION: 30

PROOFS: 5 AP, BAT, PPI. Printed by Donn H. Steward, Halesite, New York. Published by Skowhegan School of Painting and Sculpture, Skowhegan, Maine. 3 runs from 3 copperplates: 1 springtime yellow and dark yellow (aquatint); 2 madderlake(soft-ground etching); 3 blue, ultramarine, blue, springtime yellow, viridian, opaque violet, opaque red, violet, and pink (sugar-lift aquatint)

EXHIBITIONS: Baltimore 1986; Kansas City 1996

COMMENTS: This intaglio was produced as a benefit for the Skowhegan School of Painting and Sculpture (Graves had received the Skowhegan Medal for Drawing and Graphics in 1980). To introduce natural form directly into the composition, the artist pressed plant forms into the soft-ground medium.[1] In 1992 Graves again used organic material in her prints in the Pilchuck series (cat. nos. 87–113), this time by means of embossing.

1. From an unpublished 1992 essay by Jean Feinberg.

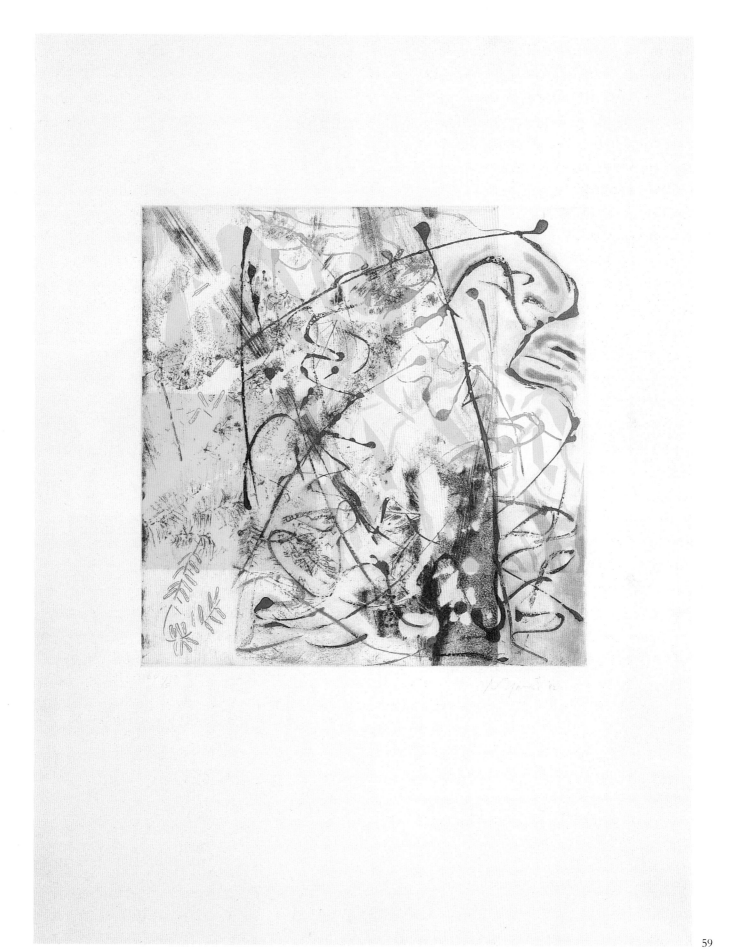

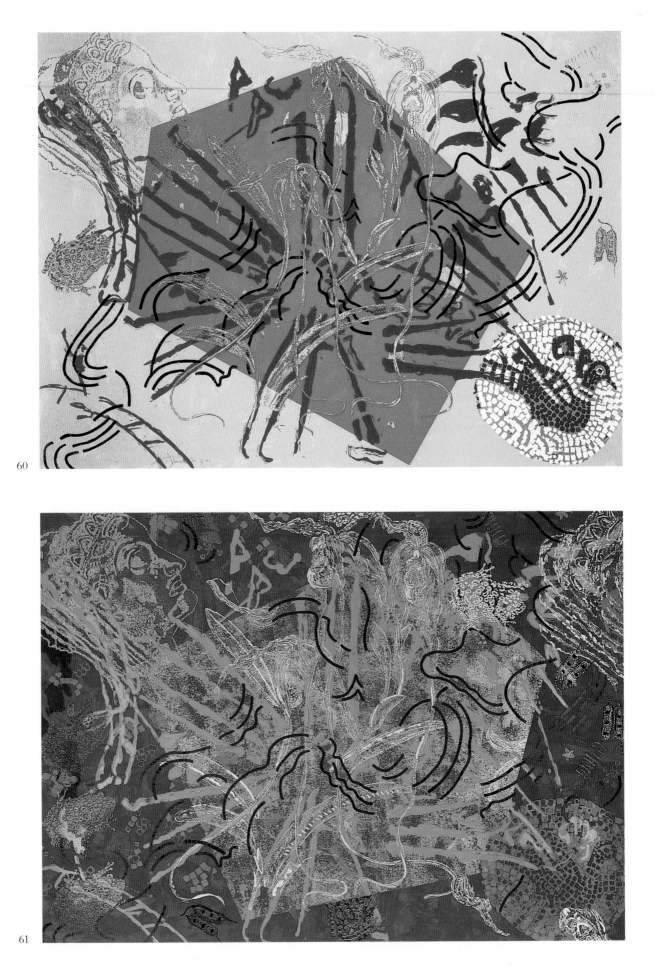

60

61

4

IV Julius Caesar Quadrangle of the Moon. 1972

Lithograph on Arches Cover white paper and Mylar with *chine collé,* 22½ × 30″. Signed: *Graves* in pencil and dated, lower right; numbered in pencil, lower left; chop: logo of Landfall Press Inc., lower left; workshop's marks: title, date, dimensions, identification stamp, workshop number NG72-328, lower left verso

PROOFS: 6 AP, TP, BAT, 2 PPII, 2 A (Walker Art Center, Minneapolis), C. Processing, proofing, and printing supervised by Jack Lemon; edition printing by Jerry Raidiger, assisted by Arthur Kleinman. 2 runs from 2 aluminum plates: 1 green, printed on Mylar; 2 black, printed on Mylar

EXHIBITIONS: La Jolla 1973; New York 1988; Minneapolis 1989; Cincinnati 1993; Minneapolis 1993–94; Purchase 1994; Kansas City 1996

COMMENTS: The two colors were printed on two sheets of Mylar, which were laminated to the Arches Cover paper. The green notations were inspired by markings Graves found on a copy of the lunar map.

5

V Montes Apenninus Region of the Moon. 1972

Lithograph on Arches Cover white paper, 22½ × 30″. Signed: *Graves* in pencil and dated, lower right; numbered in pencil, lower left; chop: logo of Landfall Press Inc., lower left; workshop's marks: title, date, dimensions, identification stamp, workshop number NG72-320, lower left verso

PROOFS: 6 AP, 2 TP, BAT, 2 PPII, 2 A (Walker Art Center, Minneapolis), C. Processing, proofing, and printing supervised by Jack Lemon; edition printing by David Keister, assisted by Arthur Kleinman. 5 runs from 5 aluminum plates: 1 blue; 2 pink; 3 red; 4 yellow; 5 black

EXHIBITIONS: La Jolla 1973; New York 1988; Cincinnati 1993; Kansas City 1996

COMMENTS: This lunar region was the landing site for *Apollo 15* in 1971. See fig. 6 for the map on which the print was based.

6

VI Maskelyne DA Region of the Moon. 1972

Lithograph on Arches Cover white and *amime* paper with *chine collé,* 22½ × 30″. Signed: *Graves* in pencil and dated, lower right; numbered in pencil, lower left; chop: logo of Landfall Press Inc., lower left; workshop's marks: title, date, dimensions, identification stamp, workshop number NG72-315, lower left verso

PROOFS: 6 AP, 2 TP, BAT, 2 PPII, 2 A (Walker Art Center, Minneapolis), C. Processing, proofing, and printing supervised by Jack Lemon; edition printing by David Keister, assisted by David Panosh. 6 runs from 6 aluminum plates: 1 green; 2 brown; 3 gray; 4 blue; 5 yellow; 6 pink, printed on *amime*

LITERATURE: Museum of Modern Art, New York 1986, p. 136
EXHIBITIONS: La Jolla 1973; New York 1988; Minneapolis 1989; Cincinnati 1993

COMMENTS: The sixth color was printed on *amime,* which was *chine colléd* to the Arches Cover paper. The frayed edges of the netlike *amime* paper are visible at top margin.

7

VII Sabine D Region of the Moon, Lunar Orbiter Site IIP-6 Southwest Mare Tranquilitatis. 1972

Lithograph on Arches Cover white paper, 22½ × 30″. Signed: *Graves* in pencil and dated, lower right; numbered in pencil, lower left; chop: logo of Landfall Press Inc., lower left; chop: logo of Landfall Press Inc., lower left; workshop's marks: title, date, dimensions, identification stamp, workshop number NG72-329, lower left verso

PROOFS: 6 AP, 3 TP, BAT, 2 PPII, 2 A (Walker Art Center, Minneapolis), C. Processing, proofing, and printing supervised by Jack Lemon; edition printing by David Keister, assisted by David Panosh. 4 runs from 4 aluminum plates: 1 yellow; 2 violet; 3 green; 4 dark green

LITERATURE: Armstrong and McGuire 1989, p. 80
EXHIBITIONS: La Jolla 1973; New York 1988; Minneapolis 1989; Cincinnati 1993; Kansas City 1996

COMMENTS: This lunar region was the landing site for *Apollo 11* in 1969.

Cat. Nos. 60–62
SIMCA SERIES

*Three screenprints that Graves completed at Simca Print Artists
in New York over a period of six months reveal the evolution
of the artist's work and a new direction for her printmaking.
The first, 5745 (cat. no. 60), was commissioned as a benefit
for the Jewish Museum, New York. Graves visually quoted
from two objects in the museum's collection: a second-century
Roman terra-cotta votive offering in the form of a woman's
head crowned with a wreath, seen in the print at upper left,
and a fragment of a fourth–fifth-century Byzantine mosaic of
a dove, seen at lower right (Ackerman and Braunstein 1982,
pp. 96 and 125, respectively). She also included an array of
organic motifs reminiscent of those in her direct-cast bronze
sculptures. Graves reinterpreted the composition in 75 × 75
(cat no. 61) and Six Frogs (cat. no. 62), introducing additional,
often fragmented imagery that repeats throughout. The artist
changed the printing order of the screens and made other sub-
tle, but distinct, changes in each print, such as the orientation
of the large pentagon in the center. Graves also replaced the
unmodulated opaque inks of 5745 with a combination of iri-
descent, fluorescent, metallic, and matte colors, demonstrating
a new concern for transparency and effects of light. With this
series, the artist began to use the sequential process of print-
making—here, numerous screens, creating overlapping layers of
color and form—to manipulate the ease with which the viewer
is able to discern the fragmented images buried in her prints.*

Processing and proofing supervised by Hiroshi Kawanishi;
edition printing by Kenjiro Nonaka, Kawanishi, and
Takeshi Shimada. Printed by Simca Print Artists, Inc.,
New York. Published by Nancy Graves and Simca Print
Artists, Inc., New York

60
5745. 1984

Screenprint on Arches Cover white paper, 30 × 42″.
Signed: *N. S. Graves* in pencil, dated, and numbered, lower
left; chop: logo of Simca Print Artists, Inc., lower left

EDITION: 90
PROOFS: 12 AP, BAT, PPI, PPII. 46 runs from 25 screens: 1
yellow; 2 orange yellow; 3 transparent yellow; 4 transparent
yellow; 5 opaque white yellow; 6 green; 7 transparent vio-
let; 8 copper; 9 copper; 10 copper; 11 copper; 12 blue; 13
opaque white; 14 opaque white; 15 transparent violet; 16
transparent blue black; 17 black; 18 white; 19 white; 20
white; 21 blue; 22 blue; 23 white; 24 white; 25 fluorescent
blue; 26 fluorescent blue; 27 silver; 28 silver; 29 karat gold;
30 karat gold; 31 karat gold; 32 karat gold; 33 white; 34
Day-Glo mint green; 35 white; 36 Day-Glo pink; 37 pink;
38 pink; 39 red; 40 violet; 41 opaque brown; 42 transparent
brown; 43 blue; 44 white; 45 white; 46 Day-Glo golden
yellow

EXHIBITION: Kansas City 1996

COMMENTS: The title *5745* refers to the year in which
the print was made, 1984, according to the Jewish calendar.

61
75 × 75. 1984

Screenprint on Arches Silkscreen paper, 29½ × 41¾″.
Signed: *N. S. Graves* in pencil and dated, lower right;
numbered in pencil, lower left; chop: logo of Simca Print
Artists, Inc., lower right

EDITION: 75
PROOFS: 9 AP, BAT, PPI, PPII. 79 runs from 38 screens:
1 brown; 2 brown; 3 brown; 4 silver; 5 silver; 6 silver; 7 iri-
descent red; 8 brown; 9 purple; 10 iridescent blue; 11 gold;
12 silver; 13 silver; 14 pink; 15 silver; 16 silver; 17 fluores-
cent orange; 18 white; 19 gradation: magenta to green to
magenta; 20 white; 21 gradation: blue to yellow to orange;
22 gold; 23 gold; 24 green; 25 gold; 26 iridescent white;
27 iridescent blue green; 28 black; 29 iridescent blue;
30 gold; 31 iridescent white; 32 black; 33 iridescent green;
34 iridescent blue green; 35 gold; 36 gold; 37 gold; 38 silver;
39 silver; 40 silver; 41 white; 42 gradation: blue to royal
blue to violet; 43 gradation: iridescent blue to iridescent
white; 44 black; 45 white; 46 fluorescent green; 47 white;
48 fluorescent pink; 49 white; 50 fluorescent magenta;
51 white; 52 white; 53 fluorescent blue; 54 fluorescent yel-
low; 55 white; 56 fluorescent pink; 57 karat gold; 58 black;
59 magenta; 60 copper; 61 red; 62 white; 63 blue; 64 white;
65 gradation: fluorescent green to fluorescent yellow;
66 white; 67 gradation: magenta to fluorescent magenta;
68 white; 69 gradation: blue to ultramarine; 70 black; 71 iri-
descent white; 72 white; 73 fluorescent pink; 74 black;
75 iridescent copper; 76 white; 77 gradation: fluorescent
orange to fluorescent red; 78 white; 79 iridescent red

LITERATURE: Museum of Modern Art, New York 1986,
p. 137; O'Connor 1988, *back cover*; *Print Collector's
Newsletter,* March–April 1985, p. 19
EXHIBITIONS: New York 1988; Minneapolis 1993–94;
Kansas City 1996

62
Six Frogs. 1985

Screenprint on Arches Silkscreen paper, 29½ × 41¾″.
Signed: *N. S. Graves* and dated in pencil, lower center;
numbered in pencil, lower left; chop: logo of Simca Print
Artists, Inc., lower right

EDITION: 66
PROOFS: 15 AP, BAT, PPI, 2 PPII. 90 runs from 38 screens:
1 yellow ocher; 2 light yellow ocher; 3 dark yellow ocher;
4 yellow ocher; 5 silver; 6 silver; 7 silver; 8 brown; 9 irides-
cent red; 10 iridescent red; 11 maroon; 12 orange; 13
orange; 14 green; 15 black; 16 iridescent green; 17 irides-
cent green; 18 white; 19 silver; 20 iridescent red; 21 silver;
22 gold; 23 white; 24 gradation: magenta to green to
magenta; 25 white; 26 gradation: blue to yellow to orange;
27 karat gold; 28 karat gold; 29 copper; 30 blue; 31 white;
32 iridescent red; 33 white; 34 iridescent gold; 35 black; 36
iridescent red; 37 iridescent red; 38 blue; 39 white; 40
gold; 41 black; 42 iridescent green; 43 iridescent green; 44
iridescent green; 45 gold; 46 gold; 47 blue; 48 blue; 49
pink; 50 pink; 51 white; 52 gradation: blue to royal blue to
violet; 53 gradation: iridescent blue to iridescent white; 54
black; 55 white; 56 fluorescent green; 57 white; 58 fluores-
cent pink; 59 white; 60 fluorescent blue; 61 white; 62
fluorescent red; 63 white; 64 fluorescent yellow; 65 white;
66 fluorescent pink; 67 gold; 68 black; 69 gold; 70 cerise;
71 copper; 72 red; 73 white; 74 blue; 75 white; 76 grada-
tion: fluorescent green to fluorescent yellow; 77 white;
78 gradation: magenta to fluorescent magenta; 79 white;
80 blue; 81 ultramarine; 82 black; 83 iridescent white; 84
white; 85 iridescent blue; 86 green; 87 black; 88 cerise; 89
white; 90 gradation: fluorescent orange to fluorescent red

LITERATURE: O'Connor 1988, p. *9; Print Collector's
Newsletter,* July–August 1985, p. 100; Walker 1986,
pp. 70, *70*
EXHIBITIONS: Brooklyn 1986; Minneapolis 1987; New
York 1988; Minneapolis 1993–94; Kansas City 1996

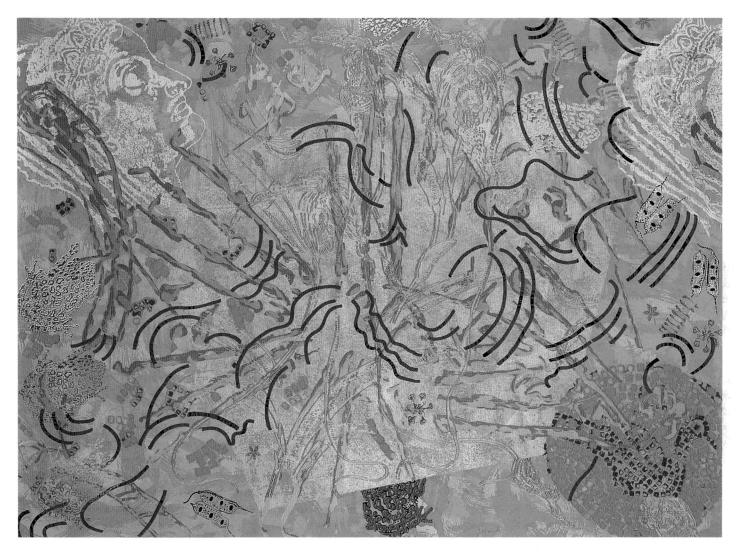

62

63
Aurelium. 1985

Etching, aquatint, and drypoint on Fabriano Artistico paper, 35⅛ × 44″. Signed: *N. S. Graves* in pencil and dated, lower left; numbered in pencil, lower right; chop: logos of Vigna Antoniniana Stamperia d'Arte and 2RC Edizioni d'Arte, lower left

EDITION: 36
PROOFS: 6 AP, BAT, PPI, PPII. Processing, proofing, and printing supervised by Valter and Eleonora Rossi; edition printing by Raffaele D'Orsogna, Adriano Corazzi, Giuseppe Di Leo, Antonio Di Leo. Printed by Vigna Antoniniana Stamperia d'Arte, Rome. Published by 2RC Edizioni d'Arte, Rome. 5 runs from 5 copperplates: 1 yellow and orange (aquatint); 2 red, violet, and lilac (aquatint); 3 blue mille, viridian, yellow green, warm blue, violet, and red (etching, aquatint, and drypoint); 4 sepia and black (etching and aquatint); 5 pink (aquatint)

LITERATURE: Associated American Artists 1989, p. *45;* Museum of Modern Art, Toyama 1989, p. *152;* O'Connor 1988, p. *11*
EXHIBITIONS: New York 1988; New York 1989; Minneapolis 1993–94; Kansas City 1996

COMMENTS: This intaglio is closely related to *Folium,* a painting from 1978 (Cathcart 1980, p. *88*). At the center of the composition, Graves depicted her 1978 bronze sculpture *Aurignac* (Carmean, Jr., et al. 1987, p. *65*). The BAT was pulled in 1979, the edition in 1985.

64
Mappe Rossi. 1985

Etching, aquatint, and drypoint on Fabriano Artistico paper, 35⅜ × 44″. Signed: *N. S. Graves* in pencil and dated, lower left; numbered in pencil, lower right; chop: logos of Vigna Antoniniana Stamperia d'Arte and 2RC Edizioni d'Arte, lower left

EDITION: 36
PROOFS: 6 AP, BAT, PPI, PPII. Processing, proofing, and printing supervised by Valter and Eleonora Rossi; edition printing by Adriano Corazzi and Giuseppe Di Leo. Printed by Vigna Antoniniana Stamperia d'Arte, Rome. Published by 2RC Edizioni d'Arte, Rome. 3 runs from 3 copperplates: 1 yellow (aquatint); 2 ultramarine, violet, yellow green, emerald green, solferino, light violet, and warm blue (aquatint); 3 warm red and red magenta (etching, aquatint, and drypoint)

LITERATURE: Associated American Artists 1989, p. *44;* Museum of Modern Art, Toyama 1989, p. *152;* O'Connor 1988, p. *5*
EXHIBITIONS: New York 1988; New York 1989; Minneapolis 1993–94; Kansas City 1996

COMMENTS: Reiterating Graves's long-standing interest in cartography, this seemingly nonobjective composition depicts an aerial view of a land form cutting diagonally across the composition. The artist had used a similarly shaped image in three earlier paintings: *Archaeo,* 1982, *Pentimento,* 1982, and *Naxa,* 1983. The title is a play on words between the last name of the printmakers with whom she made the print, Valter and Eleonora Rossi, and its meaning in Italian, red map. The BAT was pulled in 1984, the edition in 1985.

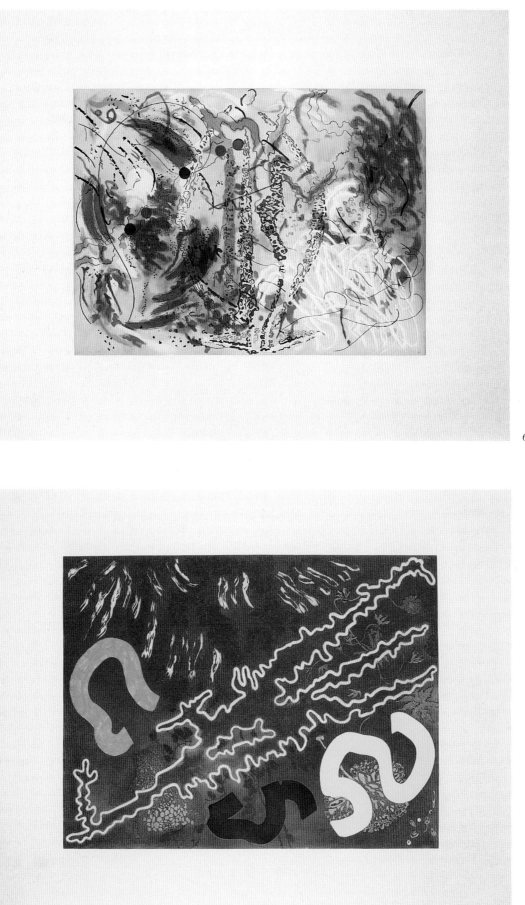

63

64

Cat. Nos. 65–67
BLACK GROUND SERIES, 1987

Josef Albers's "Interaction of Color," a course Graves had taken as a student at the School of Art and Architecture at Yale University in the early 1960s, was the inspiration for a series of paintings the artist completed between 1981 and 1983. In this related series of three intaglio prints, Graves explored the optical effects of intense color against black grounds. In Anifoglie, Neferchidea, *and* Radix, *the artist also manipulated the ability of various intaglio print techniques to create distinct planar entities. Adding to the complex spatial readings is the artist's selective use of embossing that included areas of the black ground, creating forms that are read almost subliminally. The BATs for all three prints were pulled in 1984, the editions in 1987.*

Signed: *N. S. Graves* in pencil and dated, lower right; numbered in pencil, lower left; chop: logos of Vigna Antoniniana Stamperia d'Arte and 2RC Edizioni d'Arte, lower left

EDITION: Each work in the series was printed in an edition of 36.
PROOFS: 6 AP, PPI, PPII. Processing, proofing, and printing supervised by Valter and Eleonora Rossi; edition printing by Adriano Corazzi, Antonio Di Leo, and Giuseppe Di Leo. Printed by Vigna Antoniniana Stamperia d'Arte, Rome. Published by 2RC Edizioni d'Arte, Rome

65
Anifoglie. 1987

Etching and aquatint on Magnani Acqueforti paper, 35⅜ × 44″

4 runs from 4 copperplates: 1 cold yellow, ocher, violet, emerald green, solferino, and medium yellow (aquatint); 2 orange, violet, springtime yellow, medium orange, ultramarine, blue mille, sky blue, cold red, medium red, and yellow green (aquatint); 3 warm yellow, orange, turquoise blue, solferino, springtime yellow, and yellow red (aquatint); 4 black (etching and aquatint)

LITERATURE: Associated American Artists 1989, p. *49;* Museum of Modern Art, Toyama 1989, p. *152;* O'Connor 1988, p. *12*
EXHIBITIONS: New York 1988; New York 1989; Hong Kong 1992; Minneapolis 1993–94

66
Neferchidea. 1987

Etching, aquatint, drypoint, and embossing on Fabriano Artistico paper, 35⅜ × 44″

4 runs from 4 copperplates: 1 yellow, orange, solferino, and yellow green (aquatint); 2 yellow green, violet, and light yellow red (aquatint); 3 ultramarine, blue mille, and emerald green (aquatint); 4 black (etching, aquatint, and drypoint)

LITERATURE: Kelder 1988, p. 18; Museum of Modern Art, Toyama 1989, p. 22, p. *152;* O'Connor 1988, p. *13*
EXHIBITIONS: New York 1988; Minneapolis 1993–94

67
Radix. 1987

Etching, aquatint, and embossing on Fabriano Artistico paper, 35⅜ × 44″

5 runs from 5 copperplates: 1 springtime yellow, yellow mille, orange, and violet (etching and aquatint); 2 medium red, violet red, and yellow red (aquatint); 3 viridian and turquoise blue (etching and aquatint); 4 ultramarine, blue mille, and solferino (etching and aquatint); 5 black (etching and aquatint)

LITERATURE: Associated American Artists 1989, p. *48;* Kelder 1988, p. 18; Museum of Modern Art, Toyama 1989, p. *152;* O'Connor 1988, *front cover*
EXHIBITIONS: New York 1988; New York 1989; Minneapolis 1993–94; Kansas City 1996

65

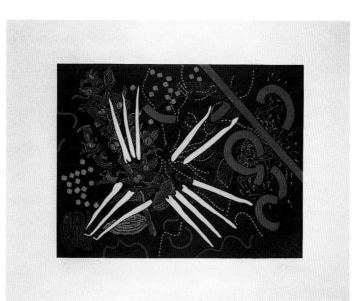

66

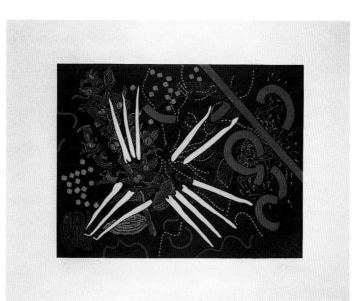

67

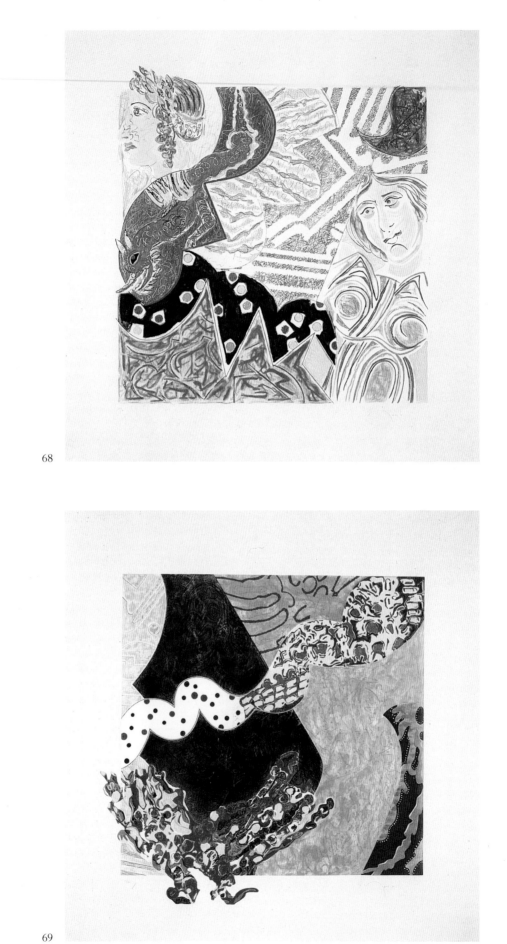

68

69

Beginning with The Clash of Cultures *(cat. no. 68), Graves developed a personal vocabulary of figures and motifs drawn largely from art history and the natural sciences and inspired by her travels and research. Presented in fragmented form and in differing scales and orientations, these images constitute a pictorial embodiment of the culture or disciplines from which they were drawn. With* The Tragedy of Alcione and Justice *a year later (cat. no. 70), Graves introduced a more translucent style relating to her watercolor drawings, in which the figurative and organic motifs were laid down in veils of semitransparent layers. Containing a wide range of metaphorical references, the compositions are enigmatic narratives in which Graves examines the chaos of modern life and the reverberation between past and present cultures.*

68

The Clash of Cultures. 1988

Etching, aquatint, and drypoint on Fabriano Artistico paper, 49¼ × 49½". Signed: *N. S. Graves* in pencil and dated, lower right; numbered in pencil, lower left; chop: logos of Vigna Antoniniana Stamperia d'Arte and 2RC Edizioni d'Arte, lower left

EDITION: 50
PROOFS: 8 AP, BAT, PPI, PPII. Processing, proofing, and printing supervised by Valter and Eleonora Rossi; edition printing by Dino Depetro, Raffaele D'Orsogna, Romeo Ramos, and Stefano Schiavo. Printed by Vigna Antoniniana Stamperia d'Arte, Rome. Published by 2RC Edizioni d'Arte, Rome. 4 runs from 4 copperplates: 1 lilac, cyclamen red, light ocher, violet, light blue, springtime green, and deep pink (aquatint and drypoint); 2 ocher, lilac, cyclamen red, medium yellow, pink, brown, mustard, solferino, light green, emerald green, and yellow red (aquatint and drypoint); 3 turquoise green, ultramarine, violet, mustard yellow, sienna, cold red, cyclamen red, and green blue (aquatint and drypoint); 4 light ocher, gray, emerald green, dark blue, violet, light pink, brown, warm yellow, solferino, sky blue, yellow red, and black (etching, aquatint, and drypoint)

LITERATURE: Kelder 1988, p. *17,* p. 18; Museum of Modern Art, Toyama 1989, pp. 22, *78*
EXHIBITIONS: Toyama 1989; Houston 1991; Palm Beach 1992; Bellevue 1993; New York 1993; Minneapolis 1993–94; Kansas City 1996

COMMENTS: *The Clash of Cultures* displays the interlocking pattern characteristic of the artist's drawings from 1986 to 1987 (in fact, the composition is based closely on a large untitled acrylic, oil pastel, glitter, and pencil drawing from 1987). Graves introduced several art historical images into the composition: from left is the head of Velcha, from the

Etruscan fourth-century B.C. Tomb of Orcus in Tarquinia; a dragon that Graves stated alludes to "medieval art history"; and the figure of Justitia from the twelfth-century mosaic on the central dome of the church of San Marco, Venice. In between is an abstract pattern inspired by designs for electrical circuitry. The BAT was pulled in 1987, the edition in 1988.

69

Borborygmi. 1988

Aquatint, drypoint, and screenprint on Fabriano Artistico paper, 49½ × 49⅛". Signed: *N. S. Graves* in pencil and dated, lower right; numbered in pencil, lower left; chop: logos of Vigna Antoniniana Stamperia d'Arte and 2RC Edizioni d'Arte, lower left

EDITION: 50
PROOFS: 6 AP, PPI, PPII. Processing, proofing, and printing supervised by Valter and Eleonora Rossi; edition printing by Dino Depetro, Raffaele D'Orsogna, Romeo Ramos, and Stefano Schiavo. Printed by Vigna Antoniniana Stamperia d'Arte, Rome. Published by 2RC Edizioni d'Arte, Rome. 5 runs from 4 copperplates and 1 screen: 1 light green, cold yellow, warm yellow, pink, light ocher, dark ocher, orange, and emerald green (aquatint and drypoint); 2 yellow red, pink, and solferino (aquatint and drypoint); 3 dark blue, lilac violet, sky blue, yellow red, turquoise blue, violet red, and pink (aquatint and drypoint); 4 green, ultramarine, and black (aquatint and drypoint); 5 gold leaf (screenprint)

LITERATURE: Associated American Artists 1989, p. *50;* Kelder 1988, pp. *17,* 18; Museum of Modern Art, Toyama 1989, pp. 22, *79*
EXHIBITIONS: Toyama 1989; New York 1989; Houston 1991; Palm Beach 1992; Minneapolis 1993–94; Kansas City 1996

COMMENTS: This composite is the first print to which Graves applied gold leaf, a material she had used often in her paintings and drawings. The material allowed the artist to explore contrasts of reflected light, here ranging from the light-absorbing density of the greenish black aquatinted ground to the refractive surface of the metal leaf. At bottom right is a passage inspired by the nineteenth-century *ukiyo-e* prints of Hokusai. The intestinal-like tube that bisects this composition first appeared in the artist's Australia series of paintings of 1985. Extending into the bottom margin is a two-dimensional translation of the aluminum reliefs that Graves has, since the mid-1980s, often added to her paintings. The composition is related to several large untitled drawings Graves executed between 1986 and 1987, most closely to *Untitled 6-11-86,* 1986.

70
The Tragedy of Alcione and Justice. 1989

Etching, aquatint, drypoint, and screenprint on Magnani Acqueforti paper, 51½ × 50¾". Signed: *N. S. Graves* in pencil and dated, lower right; numbered in pencil, lower left; chop: logos of Vigna Antoniniana Stamperia d'Arte and 2RC Edizioni d'Arte, lower left

EDITION: 60
PROOFS: 10 AP, PPI, PPII. Processing, proofing, and printing supervised by Valter and Eleonora Rossi; edition printing by Raffaele D'Orsogna, Adriano Corazzi, Antonio Di Leo, Giuseppe Di Leo, and Romeo Ramos. Printed by Vigna Antoniniana Stamperia d'Arte, Rome. Published by 2RC Edizioni d'Arte, Rome. 6 runs from 5 copperplates and 1 screen: 1 light sky blue and dark sky blue (aquatint); 2 light green (aquatint); 3 red vesuvio, yellow red, lilac, orange, violet, and emerald green (etching and aquatint); 4 ultramarine and azure (aquatint and drypoint); 5 sepia, dark violet, gray, light ocher, beige, emerald green, and yellow red (aquatint and drypoint); 6 gold leaf (screenprint)

LITERATURE: Associated American Artists 1989, p. *51;* University of Colorado 1992, p. *19*
EXHIBITIONS: New York 1989; Santa Fe 1990; Houston 1991; Boulder 1992; Palm Beach 1992; Bellevue 1993; New York 1993; Minneapolis 1993–94

COMMENTS: Related to *Burden of the Dream,* a large drawing with gold leaf from 1988, this print features the head of Fides at upper left from the twelfth-century mosaic on the central dome of the church of San Marco, Venice, superimposed on an animal's vertebrae. At upper right is a head inspired by an *oscillum* (a decorative element of classical architecture hung between columns) in the form of a theater mask from a mosaic in the circa first-century House of the Faun, Pompeii. A stylized waterfall inspired by an eighteenth-century Japanese *kosode* (small-sleeved robe) lies in between, echoed by the twisting snake at right. At left is the motif of the sun and the moon derived from Michelangelo's Sistine Chapel fresco *The Creation of the Sun and Moon.* Directly underneath is the head of Alcyoneus, which inspired the title of the print, from the second-century B.C. Pergamon Great Altar of Zeus.

71
Hercules, Eve and the Parting of Night and Day. 1989

Etching, aquatint, drypoint, and screenprint on Magnani Acqueforti paper, 51½ × 50⅜". Signed: *N. S. Graves* in pencil and dated, lower right; numbered in pencil, lower left; chop: logos of Vigna Antoniniana Stamperia d'Arte and 2RC Edizioni d'Arte, lower left

EDITION: 60
PROOFS: 10 AP, PPI, PPII. Processing, proofing, and printing supervised by Valter and Eleonora Rossi; edition printing by Raffaele D'Orsogna, Adriano Corazzi, Antonio Di Leo, Giuseppe Di Leo, and Romeo Ramos. Printed by Vigna Antoniniana Stamperia d'Arte, Rome. Published by 2RC Edizioni d'Arte, Rome. 5 runs from 4 copperplates and 1 screen: 1 red vesuvio and solferino (aquatint and drypoint); 2 pink, springtime yellow, sky blue, gray, warm yellow, medium orange, dark lilac, light lilac, and light green (aquatint); 3 light violet, dark violet, orange, lilac, ultramarine, blue mille, viridian (aquatint and drypoint); 4 gray, turquoise blue, yellow red, medium red, sky blue (etching, aquatint, and drypoint); 5 silver and gold leaf (screenprint)

LITERATURE: Bourdon 1991, p. 5
EXHIBITIONS: Santa Fe 1990; Houston 1991; Palm Beach 1992; Staten Island 1992; Bellevue 1993; Lancaster 1993; New York 1993; Minneapolis 1993–94

COMMENTS: Characters based on Egyptian hieroglyphic writing appear at upper left (in violet), superimposed on the figure of Dionysus (in brown), the Greek god of wine, shown carrying a panther, a motif from a sixth-century B.C. Athenian red-figured vase. Flanking the images of the Sun and the Moon based on Michelangelo's Sistine Chapel ceiling fresco are two images (in purple) of the mythical Apophis snake, which, according to ancient Egyptian religion, challenged the Sun God, Re, for dominance every morning. Underneath the Sun and Moon motif, and barely visible to the right, is a scene (in gray with pink highlights) based on an archaic Corinthian bronze helmet depicting two heraldic winged youths (their two pairs of sandaled feet are visible along the lower left margin) holding entwined serpents. To the left of the large carp are leaves and an offering procession (in blue) based on an Egyptian New Kingdom tomb relief. Two forms overlap at lower right: a stylized wave (in red) that moves upward, curving over to the left, inspired by the nineteenth-century Japanese *ukiyo-e* woodblock prints of Hokusai, and an orchid plant (in pink) curving diagonally to the upper left.

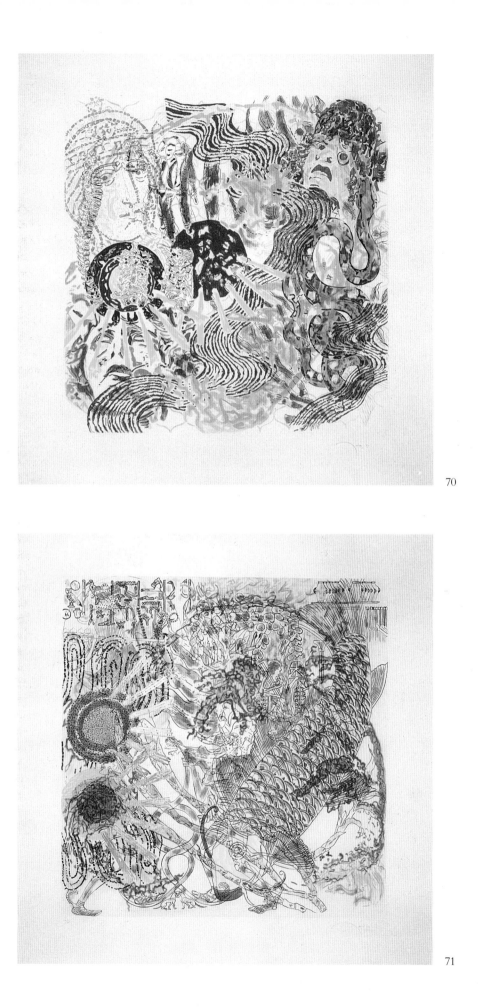

70

71

72
Explicate Unfolded Order. 1989

Screenprint on Stonehenge warm white paper with hand-applied glitter, 30¼ × 29¾″. Signed: *N. S. Graves* in pencil and dated, lower right; numbered in pencil, lower left

EDITION: 170

PROOFS: 5 AP, BAT, 20 PPI.[1] Processing, proofing, and printing supervised by Rafael Alvarez and Rafael Bretón; edition printing by Yanko Lucero, assisted by Diogenes Alcala and Francisco Sandoval. Printed by Altos de Chavon Cultural Center Foundation, La Romana, Dominican Republic. Published by the Institute of Contemporary Art, Philadelphia. 8 runs from 8 screens: 1 very light blue; 2 light blue; 3 blue; 4 dark blue; 5 very dark blue; 6 light gray; 7 gray; 8 dark gray

LITERATURE: Institute of Contemporary Art 1991, p. 5

COMMENTS: Commissioned as a benefit by the Institute of Contemporary Art, Philadelphia, this screenprint is related to *Medusa,* a drawing from 1988, and features a frontal female head based on a fourth-century Roman mosaic (the same head can be seen in *Time Shapes the Stalactite,* cat. no. 75) beneath a corallike arrangement of black lines. Graves completed this screenprint under adverse conditions in the Dominican Republic; direct sunlight solidified the image on the screen and, according to the artist, destroyed its nuances. Silver glitter was applied by hand to the edition in the artist's studio. The BAT was pulled in 1988, the edition in 1989.

1. Graves printed the artist's proofs without glitter and donated them to the Altos de Chavon School of Design, New York. The artist retained the printer's proofs and dated them 1990.

73
Stuck, the Flies Buzzed. 1990

Etching, aquatint, drypoint, and screenprint on Magnani Acqueforti paper with screenprinted and embossed collage, 47½ × 90½″. Signed: *N. S. Graves* in pencil and dated, lower right; numbered in pencil, lower left; chop: logos of Vigna Antoniniana Stamperia d'Arte and 2RC Edizioni d'Arte, lower left

EDITION: 68

PROOFS: 20 AP, PPI, PPII, 2 HC. Processing, proofing, and printing supervised by Valter and Eleonora Rossi; edition printing by Dino Depetro, Raffaele D'Orsogna, Romeo Ramos, Antonio Di Leo, and Giuseppe Di Leo. Printed by Vigna Antoniniana Stamperia d'Arte, Rome. Published by 2RC Edizioni d'Arte, Rome. 6 runs from 5 copperplates and 1 screen: 1 cold yellow, springtime yellow, and ocher (aquatint); 2 orange, yellow green, emerald green, warm yellow, turquoise blue, and violet (aquatint and drypoint); 3 ultramarine, lilac, blue mille, dark blue, emerald green, orange, sky blue, light sky blue, yellow red, springtime green, and cyclamen red (etching, aquatint, and drypoint); 4 light lilac, springtime yellow, pink, dark red, brown, solferino, and violet (aquatint and drypoint); 5 red vesuvio, solferino, green black, and black (etching, aquatint, and drypoint); 6 silver leaf (screenprint). Collage: 2 runs from 2 screens: 1 black; 2 violet (screenprint)

EXHIBITIONS: Santa Fe 1990; Houston 1991; Palm Beach 1992; New York 1993; Minneapolis 1993–94; Kansas City 1996

COMMENTS: This composite print is closely related to a painting, *Footscray,* and drawing, *Jabiro* (Balken 1986, p. *38*), from the artist's 1985 Australia series. The print features a paper relief (made from embossed leaves), a formal device related to the aluminum reliefs Graves has frequently added to her paintings since 1983.

72

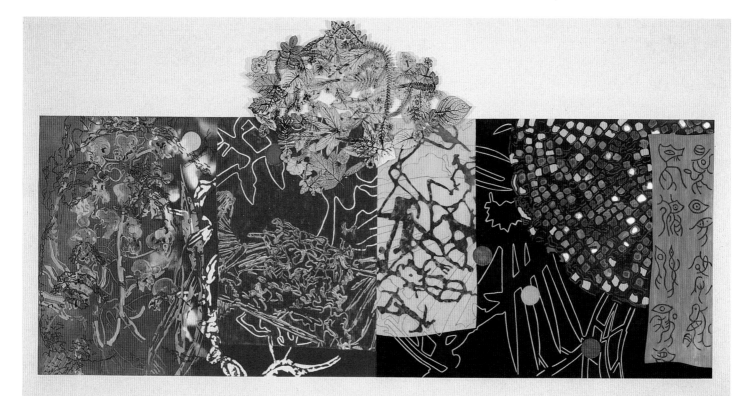

73

74

Canoptic Prestidigitation. 1990

Lithograph on Arches Cover white paper with *chine collé* and cast-paper collage from Arches pulp, 36½ × 74½″. Signed: *N. S. Graves,* dated, and numbered in pencil, lower left; chop: logo of Graphicstudio, lower left; publisher's mark: copyright Nancy Graves and Graphicstudio, stamped, lower right verso

EDITION: 40

PROOFS: 10 AP, BAT, 2 PPI, 7 SP, 2 A (1 Graphicstudio Archive at the National Gallery of Art, Washington, D.C., and 1 Graphicstudio, University of South Florida, Tampa). Conceptual collaboration, Donald Saff and Alan Eaker; technical collaboration, Saff and Deli Sacilotto; proofing by Alan Holubeck, Tom Pruitt, and Patrick Foy; edition printing by Conrad Schwable; production assistance by Tim Baker and Elizabeth Hagy; production coordination by Kelly Medei. Printed and published by Graphicstudio, Institute for Research in Art, University of South Florida, Tampa. 18 runs from 18 aluminum plates: 1 transparent yellow and brown; 2 teal green and yellow; 3 warm yellow and light yellow; 4 light pink; 5 dark pink and orange; 6 light orange; 7 bright green; 8 light blue; 9 blue; 10 light yellow and transparent gray; 11 silver; 12 brown; 13 transparent black; 14 light magenta; 15 red orange; 16 dark gray; 17 dark brown; 18 purple on Sekishu paper

LITERATURE: Corlett and Fine 1991, pp. *281,* 282, *307*

EXHIBITIONS: Houston 1991; Washington, D.C. 1991–92; Kansas City 1996

COMMENTS: At left Graves superimposed the design of flowing robes (in brown and silver) inspired by a first-century Roman sculpture on top of images of ducks and offering jars (in yellow) from a painting in the Egyptian New Kingdom Tomb of Mena in Thebes. The partially obscured head of Eve (in red), based on Michelangelo's Sistine Chapel fresco *The Temptation and the Expulsion* (see fig. 16) gazes upward to the right. The image of the hand of God, also from the Sistine Chapel, is superimposed over Eve's head. At right are two snakes (in green and yellow); female mourning figures drawn from the painted decoration of the New Kingdom tomb of Ramose in Thebes; and an offering procession (upside down, in blue), part of another Egyptian tomb decoration. Finally, a cast-paper relief of the ancient Egyptian falcon-headed sky god Horus is laminated to the support at bottom right. "Canoptic" is the artist's version of the word "canopic," referring to the jars in which the ancient Egyptians preserved the viscera of the deceased, usually for burial with the mummy.

Exemplifying her synthesis of two- and three-dimensional art, Graves used this lithograph as the background element in *Canoptic Legerdemain* (fig. 17), a sculpture produced in an edition that Graves completed with Donald Saff at Graphicstudio the same year.

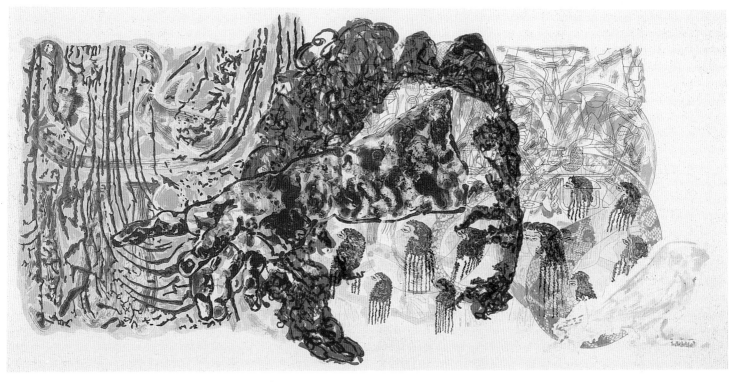

74

75
Time Shapes the Stalactite. 1991

Aquatint, drypoint, and screenprint on Magnani
Acqueforti paper, 51½ × 52½". Signed: *N. S. Graves* in
pencil and dated, lower right; numbered in pencil, lower
left; chop: logos of Vigna Antoniniana Stamperia d'Arte
and 2RC Edizioni d'Arte, lower left

EDITION: 60
PROOFS: 12 AP, BAT, PPI, PPII, SP. Processing, proofing,
and printing supervised by Valter and Eleonora Rossi; edi-
tion printing by Raffaele D'Orsogna, Piero Faliciotti,
Adriano Corazzi, Dino Depetro, Antonio Di Leo,
Giuseppe Di Leo, and Romeo Ramos. Printed by Vigna
Antoniniana Stamperia d'Arte, Rome. Published by 2RC
Edizioni d'Arte, Rome. 5 runs from 4 copperplates and
1 screen: 1 ultramarine, brown green, beige, violet, sepia,
and dark ocher (aquatint and drypoint); 2 yellow, red,
springtime yellow, cyclamen, mustard (aquatint); 3 violet
and light violet black (aquatint and drypoint); 4 bordeaux,
medium orange, warm yellow, turquoise blue (aquatint and
drypoint); 5 bronze and silver leaf (screenprint)

EXHIBITIONS: New York 1993; Minneapolis 1993–94;
Kansas City 1996

COMMENTS: The upper half of the composition features a
hunting scene (in yellow highlighted with bronze leaf)
based on a relief from an Egyptian New Kingdom tomb.
An orchid (in gray) spans the left half of the print, framing
a female head inspired by a fourth-century Roman mosaic
highlighted with tessera-like squares in silver leaf. The
waterfall motif was inspired by an eighteenth-century
Japanese *kosode,* a small-sleeved robe. The image of a carp,
similar to those found in Korean art, runs diagonally from
the top right to the bottom center, where it, along with
the waterfall, intersects with a geometric design (in mus-
tard and brown) based on a Minoan bowl. The yellow fili-
gree at lower left is a stylized snake, the ancient Egyptian
symbol signifying the infinity of time. The composition is
related to *Imaginary Time,* a large drawing with gold leaf
from 1988. The BAT was pulled in 1990, the edition in
1991.

76
To Belittle Consciousness. 1991

Hard- and soft-ground etching, aquatint, drypoint, and
screenprint on Hahnemuhle German Etching white paper,
31⅜ × 42½". Signed: *N. S. Graves* in pencil and dated,
lower right; numbered in pencil, lower left; chop: logo of
Aldo Crommelynck, lower left. Processing, proofing, and
printing supervised by Aldo Crommelynck; edition print-
ing by Michele Cornu, Paris, and Joseph Stauber, New
York. Printed by Aldo Crommelynck, Paris, and Brand X
Editions, New York. Published by Mémoire de la Liberté,
Fondation Mitterand, Paris

EDITION: 75
PROOFS: 25 AP, TP, 5 PPI, 5 SP, 5 HC. 5 runs from 4 cop-
perplates and 1 screen: 1 dark blue, light blue, and violet
(hard- and soft-ground etching, aquatint, and drypoint);
2 red and green (soft-ground etching and aquatint); 3 pink,
violet sienna, and carmine (soft-ground etching and
aquatint); 4 dark yellow and orange yellow (soft-ground
etching and aquatint); 5 gold and aluminum leaf
(screenprint)

LITERATURE: Bosio et al. 1991, p. *63*
EXHIBITIONS: Paris 1991; Kansas City 1996

COMMENTS: Commissioned as a benefit for the Fondation
Mitterand, Paris, *To Belittle Consciousness* is related to
Continuity and Fusion, a drawing dated September 10,
1990. A carp flanked by the heads of two snakes (in blue)
dominates the left half of the composition. At right is a
motif from a relief in the tomb of Rameses VI illustrating
a passage from the Egyptian *Book of Gates.* It features a
large hand, extending from the upper right margin, hold-
ing a rope, which in turn is held by the figures of the three
sons of Horus and two images of the Apophis snake. After
the edition was printed in Paris, Graves added gold and
aluminum leaf, which was screenprinted in New York.

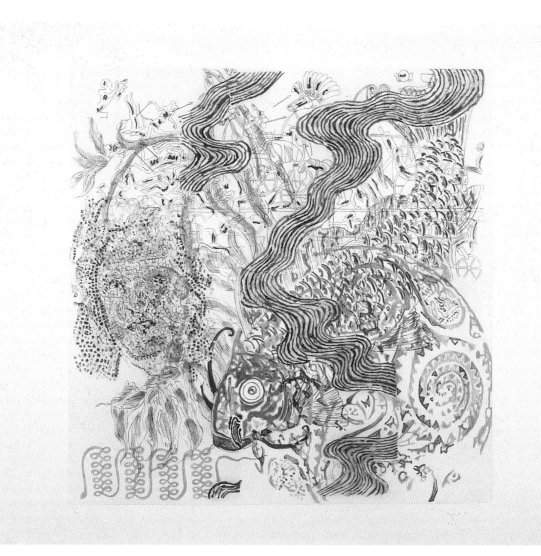

75

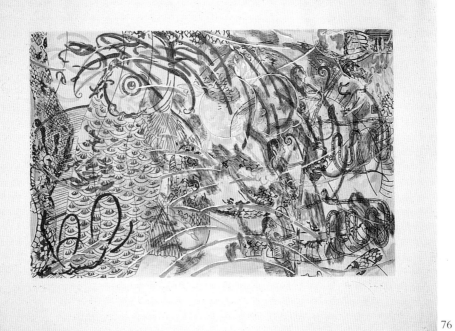

76

Cat. Nos. 77–84
TANGO. 1991

*Graves collaborated with the poet Pedro Cuperman on
Tango, a large folio published by Iris Editions in New York
featuring eight intaglio prints by Graves and thirteen pages of
text by Cuperman. Working with Deli Sacilotto and using
direct gravure for the first time, Graves drew on sheets of
frosted acetate that were transferred to copperplates by means
of sensitized carbon tissues. After the direct gravure was
etched, the artist worked on the plates directly with drypoint
(using power tools), aquatint, and spit biting. Graves con-
ceived of the suite as a tonal study of black and white, rang-
ing from* Logic of Neon Signs *(cat. no. 80), which she called
the "white print," to the dense imagery of* Tracing Its Own
Footsteps *(cat. no. 77). The images, inspired by natural
history and botanical illustrations, recall, as Joan Simon has
noted, the* livre de luxe *folios of eighteenth- and early
nineteenth-century botanical prints.[1] Individual titles were
selected by Graves from Cuperman's text.*

Signed: *N. S. Graves* in pencil and dated, lower right;
numbered in pencil, lower left; chop: logo of Iris Editions,
lower right

EDITION: Each work in the series was printed in an edi-
tion of 26. Proofing by Deli Sacilotto, assisted by Rebecca
Litowich-Sacilotto; edition printing by John Wagner,
assisted by Robert Hurwitz. Printed and published by Iris
Editions, New York. 1 run from 1 copperplate: black and
red ocher

1. From an unpublished 1991 essay by Joan Simon.

77
Tracing Its Own Footsteps. 1991

Direct gravure etching with aquatint, drypoint, and bur-
nishing on Arches Cover white paper with photogravure
on Arches Text Wove paper, 36 × 26″

PROOFS: 10 AP, TP, BAT, PPI, PPII

EXHIBITION: Kansas City 1996

COMMENTS: The small photogravure image of the flea is
laminated to the upper right corner of the print.

78
In Circles, Circling. 1991

Direct gravure etching with aquatint, burnishing, drypoint,
and embossing on Arches Cover white paper, 36 × 26″

PROOFS: 10 AP, TP, BAT, PPI, PPII

EXHIBITION: Kansas City 1996

COMMENTS: The image is based on an illustration of the
fossil of *Archaeornis*, a prehistoric bird.

79
Imagine the Music. 1991

Direct gravure etching with spit biting, aquatint, burnish-
ing, and drypoint on Arches Cover white paper, 36 × 26″

PROOFS: 10 AP, TP, BAT, PPI, PPII

EXHIBITION: Kansas City 1996

80
Logic of Neon Signs. 1991

Direct gravure etching with aquatint, drypoint, and bur-
nishing on Arches Cover white paper, 36 × 26″

PROOFS: 10 AP, TP, BAT, PPI, PPII

EXHIBITION: Kansas City 1996

COMMENTS: The image of a praying mantis is repeated
throughout the composition.

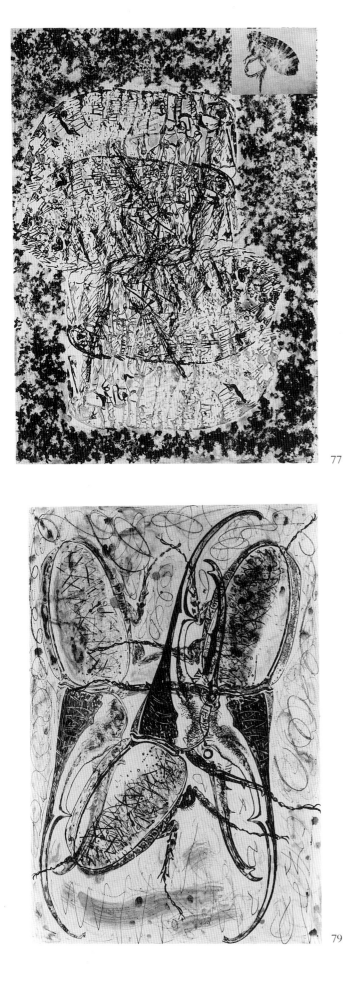

77

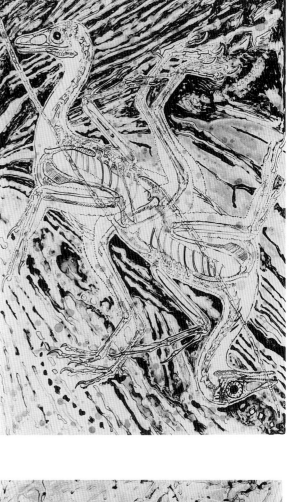

78

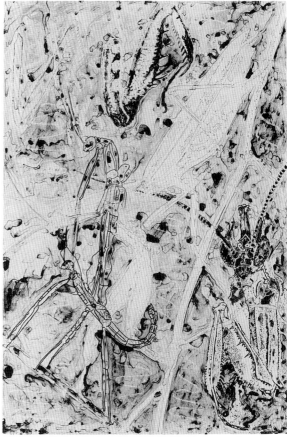

79

80

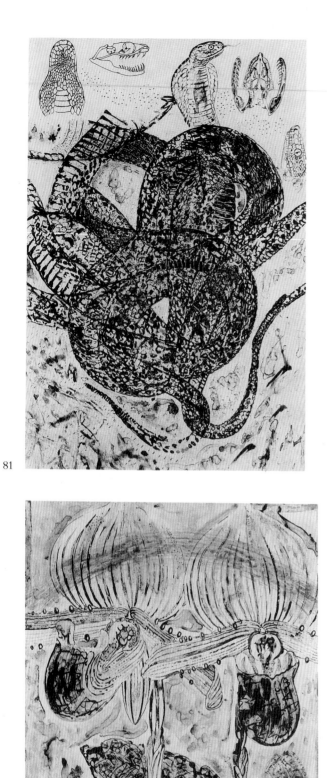

81

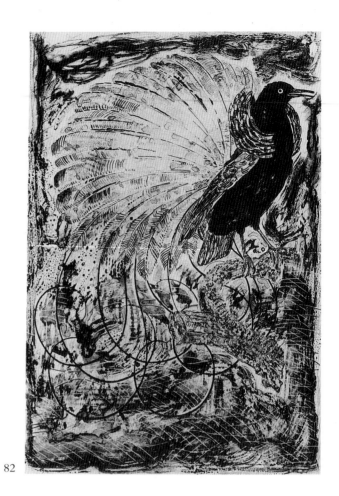

82

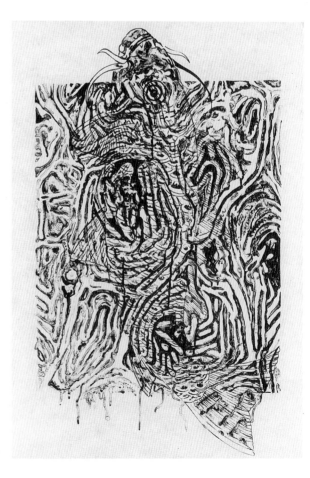

83

84

81

Parables of Nostalgia. 1991

Direct gravure etching with aquatint, drypoint, and burnishing on Arches Cover white paper, 36 × 26″

PROOFS: 10 AP, TP, BAT, PPI, PPII

EXHIBITION: Kansas City 1996

COMMENTS: Graves reinterpreted this composition in *Sculptor's Vacated Touch,* a gouache and watercolor drawing dated February 13, 1992 (unrelated to cat. no. 84). In the same year she reused the copperplate for *Growling with a Cry* (cat. no. 86).

82

Reversed Polychrome. 1991

Direct gravure etching with aquatint and drypoint on Arches Cover white paper, 36 × 26″

PROOFS: 10 AP, TP, BAT, PPI, PPII

COMMENTS: The image is inspired by a nineteenth-century illustration of a bird of paradise.

83

His Fires Fully. 1991

Direct gravure etching with spit biting, aquatint, burnishing, and drypoint on Arches Cover white paper, 36 × 26″

PROOFS: 10 AP, TP, BAT, PPI, PPII

84

Sculptor's Vacated Touch. 1991

Direct gravure etching with aquatint, drypoint, and burnishing on Arches Cover white paper, 36 × 26″

PROOFS: 10 AP, TP, BAT, PPI, PPII

COMMENTS: In 1992 Graves painted one of the proofs with gouache and watercolor to create *Cyprentinus,* superimposing onto the carp a tangle of snakes similar to those found in *Parables of Nostalgia* (cat. no. 81). In the same year, the artist completed *Growling with a Cry* (cat. no. 86), a direct gravure etching utilizing the copperplate for *Sculptor's Vacated Touch.*

85
Iconostasis of Water. 1992

Etching, aquatint, and drypoint on Fabriano Artistico paper with screenprinted and embossed collage, 54¾ × 94½".
Signed: *N. S. Graves* in pencil and dated, lower right; numbered in pencil, lower left; chop: logos of Vigna Antoniniana Stamperia d'Arte and 2RC Edizioni d'Arte, lower left

EDITION: 68
PROOFS: 6 AP, BAT, PPI, PPII. Processing, proofing, and printing supervised by Valter and Eleonora Rossi; edition printing by Raffaele D'Orsogna, Piero Faliciotti, Adriano Corazzi, Dino Depetro, Antonio Di Leo, Giuseppe Di Leo, Romeo Ramos, and Franca Marangoni. Printed by Vigna Antoniniana Stamperia d'Arte, Rome. Published by 2RC Edizioni d'Arte, Rome. 5 runs from 5 copperplates: 1 springtime yellow and violet (aquatint); 2 violet, dark blue, light sky blue, blue mille, springtime yellow, and blue green (aquatint and drypoint); 3 violet, turquoise blue, sepia, dark brown, and light blue (aquatint and drypoint); 4 violet, ultramarine, viridian, yellow green, dark blue, solferino, blue green, and light blue (aquatint and drypoint); 5 violet red, orange, and yellow red (etching, aquatint, and drypoint). Collage: 3 runs from 3 screens: 1 violet; 2 black; 3 silver (screenprint)

EXHIBITIONS: New York 1993; Minneapolis 1993–94; Kansas City 1996

COMMENTS: The head of Cleopatra, complete with serpent winding around her hair and shoulders, inspired by Michelangelo's drawing from around 1533, appears in large scale at left. Below her is a pattern of blue stars, based on the painted ceiling decoration of the Egyptian New Kingdom tomb of Senenmut at Deir el Bahri. Dominating the right is the image of a girl and her dove taken from a fifth-century B.C. Greek stela (in the collection of the Metropolitan Museum of Art, New York), the head of the dove just visible next to the girl's mouth. In smaller scale and spanning both halves of the composition is a group of ducks (in yellow) based on an Egyptian tomb painting (most easily seen on the lower portion of Cleopatra's face). At lower right (in green) is the filigree form of a snake, the ancient Egyptian symbol for the infinity of time. Surmounting the composition is an embossed relief made from three San Pietro fish that Graves bought at a Roman market. The addition of the embossed relief distinguishes the print from the drawing on which it is based, *Straight into Depth,* 1990. The BAT was pulled in 1991, the edition in 1992.

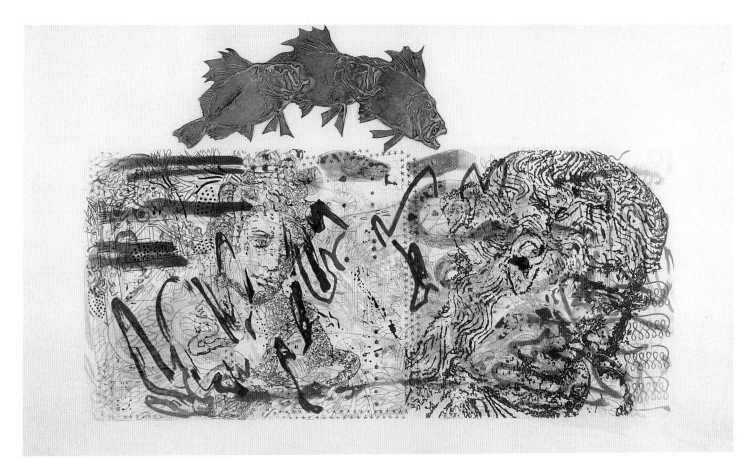

85

86
Growling with a Cry. 1992

Direct gravure etching, aquatint, burnishing, and drypoint on Dieu Donné handmade pigmented cotton paper, 39½ × 26½". Signed: *N. S. Graves* in pencil and dated, lower right; numbered in pencil, lower left

EDITION: 30
PROOFS: 18 AP, BAT, PPI, PPII. Printed by Iris Editions, New York. Published by Modern Art Museum of Fort Worth, Texas. 2 runs from 2 copperplates: 1 gradation: yellow to orange to red to purple (etching and drypoint); 2 blue (etching, aquatint, burnishing, and drypoint)

COMMENTS: For this print, commissioned as a benefit for the Modern Art Museum of Fort Worth, Graves combined plates from two works of the Tango series, *Parables of Nostalgia* (cat. no. 81) and *Sculptor's Vacated Touch* (cat. no. 84). A group of snakes lies in the center of a patterned ground, out of which rises the head of a carp. Along the top are four views (including skeletal) of a snake's head inspired by natural-history illustrations. Graves added gouache and watercolor to a print from the edition to create *Familiar Feeling of Transparency,* dated 12-11-92.

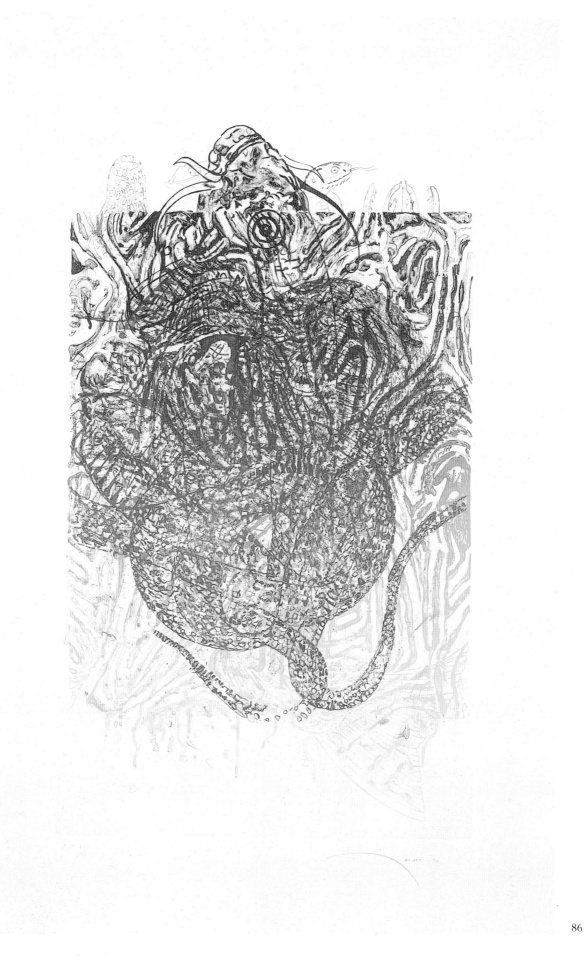

86

Cat. Nos. 87–113
PILCHUCK SERIES, 1992

While an artist-in-residence at the Pilchuck Glass School in Stanwood, Washington, Graves completed this series of monotypes in which she used embossing to introduce organic form directly into her prints. Working with master printer Cate Brigden, the artist selected a variety of plants from the grounds of the school, including a large number of flowers and berries, and placed them on a glass plate, which she then ran through an etching press. The pressure accentuated the subtlety and variety of the organic forms and extracted their natural colors. Graves added watercolor to certain works in the series after printing to balance the random stains of natural color.

The complete list of plant material utilized in the series is as follows: alder; baby's breath; baneberry; blackberry; blackcap raspberry; black-eyed Susan; cedar; cosmos; dahlia; daisy; deer fern; Douglas fir; elderberry; forget-me-not; goldenrod; huckleberry; horsetail; larkspur; lemon lily; lupine; pansy; Scotch broom; sword fern; thistle; tiger lily; yarrow

Printed by Cate Brigden and Nancy Graves at the Pilchuck Glass School, Stanwood, Washington. Published by Nancy Graves

87
VII-4-92

Monotype on Rives BFK white paper with watercolor, 29⅞ × 22¼″. Signed: *N. S. Graves* in pencil and dated, lower left. Collection the artist

88
VII-5-92

Monotype on Rives BFK white paper with watercolor, 29⅞ × 22¼″. Signed: *N. S. Graves* in pencil and dated, upper left. Collection the artist

89
VII-5-92

Monotype on Rives BFK white paper, 22¼ × 29⅞″. Signed: *N. S. Graves* in pencil and dated, lower right. Collection Kelly McLain

OVERLEAF:

90
VII-6-92

Monotype on Rives BFK white paper with watercolor, 22¼ × 29⅞″. Signed: *N. S. Graves* in pencil and dated, lower right. Collection Cate Brigden

91
VII-6-92

Monotype on Rives BFK white paper, 29⅞ × 22¼″. Signed: *N. S. Graves* in pencil and dated, upper left. Collection the artist

EXHIBITION: Kansas City 1996

87

88

89

90

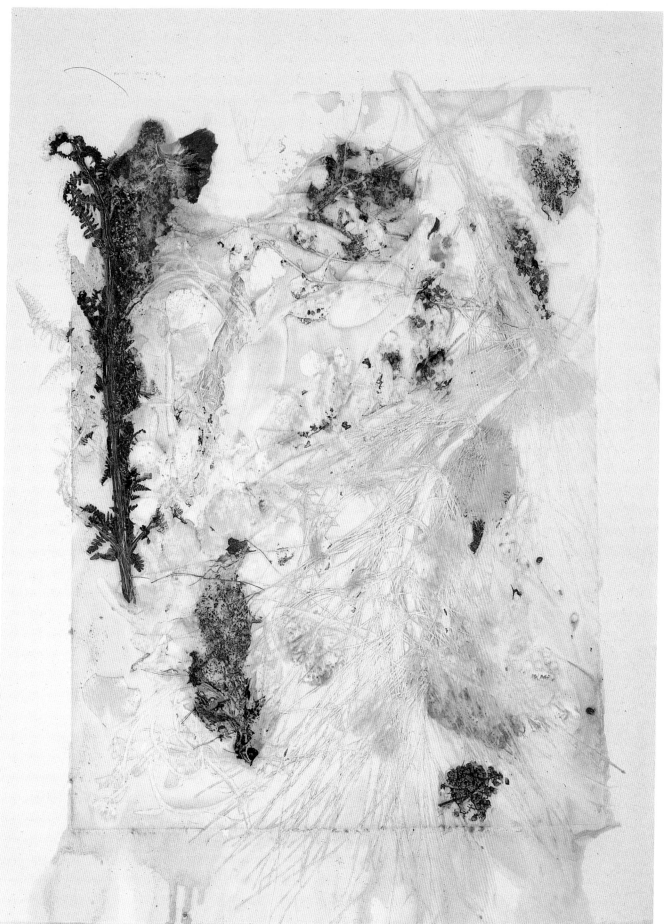

91

92
VII-7-92

Monotype on Rives BFK white paper, 29⅞ × 22¼″.
Signed: *N. S. Graves* in pencil and dated, upper right.
Collection the artist

93
VII-7-92

Monotype on Rives BFK white paper, 22¼ × 29⅞″.
Signed: *N. S. Graves* in pencil and dated, lower center.
Collection the artist

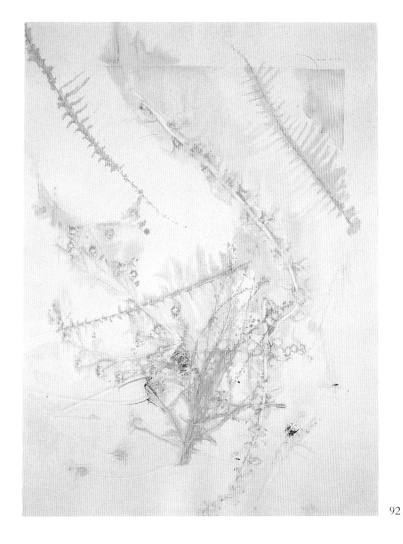

92

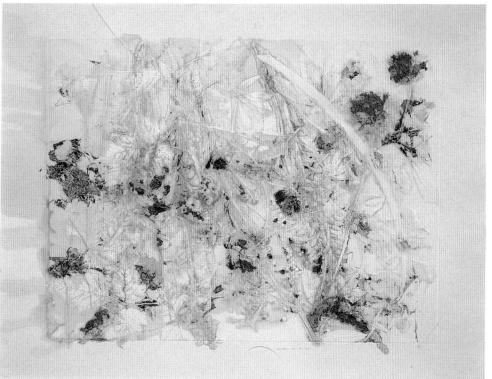

93

133

94
VII-8-92

Monotype on Rives BFK white paper, 29⅞ × 22¼".
Signed: *N. S. Graves* in pencil and dated, lower right.
Collection Pilchuck Glass School, Stanwood, Washington

95
VII-8-92

Monotype on Rives BFK white paper, 22¼ × 29⅞".
Signed: *N. S. Graves* in pencil and dated, upper right.
Collection the artist

96
VII-10-92

Monotype on Rives BFK white paper, 29⅞ × 22¼".
Signed: *N. S. Graves* in pencil and dated, lower right.
Collection the artist

94

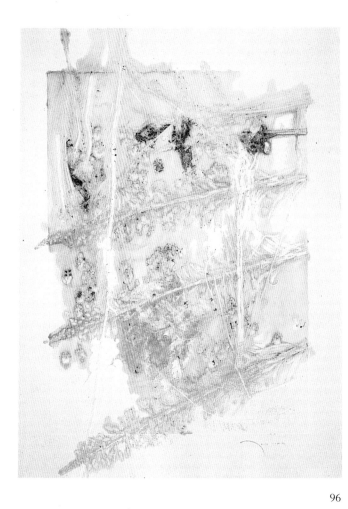

96

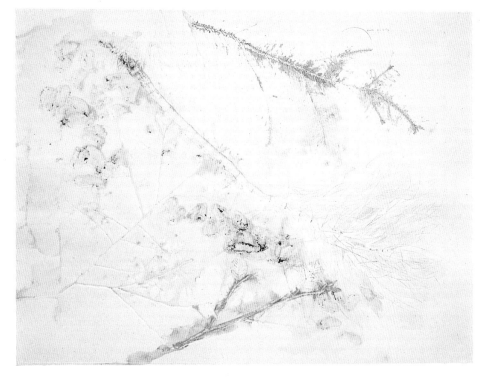

95

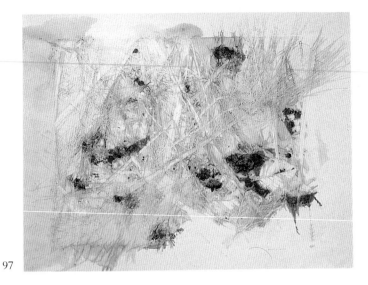

97

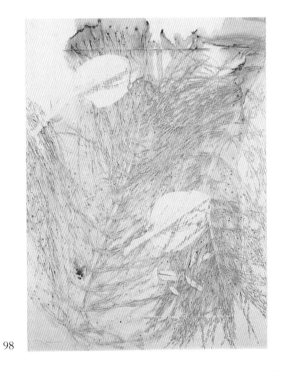

98

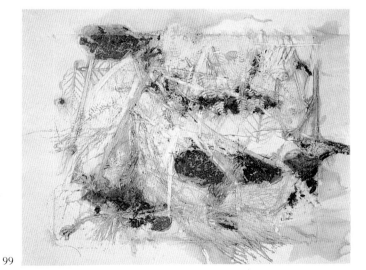

99

97
VII-10-92

Monotype on Rives BFK white paper, 22¼ × 29⅞".
Signed: *N. S. Graves* in pencil and dated, lower right.
Collection the artist

EXHBITION: Kansas City 1996

98
VII-11-92

Monotype on Rives BFK white paper with watercolor,
29⅞ × 22¼". Signed: *N. S. Graves* in pencil and dated,
lower left. Collection the artist

99
VII-12-92

Monotype on Rives BFK white paper, 22¼ × 29⅞".
Signed: *N. S. Graves* in pencil and dated, lower left.
Collection the artist

100
VII-12-92

Monotype on Rives BFK white paper with watercolor, 29⅞ × 22¼″. Signed: *N. S. Graves* in pencil and dated, lower right. Collection the artist

101
VII-13-92

Monotype on Rives BFK white paper with watercolor, 29⅞ × 22¼″. Signed: *N. S. Graves* in pencil and dated, upper right. Collection the artist

102
VII-15-92

Monotype on Rives BFK white paper with watercolor, 22¼ × 29⅞″. Signed: *N. S. Graves* in pencil and dated, lower right. Collection the artist

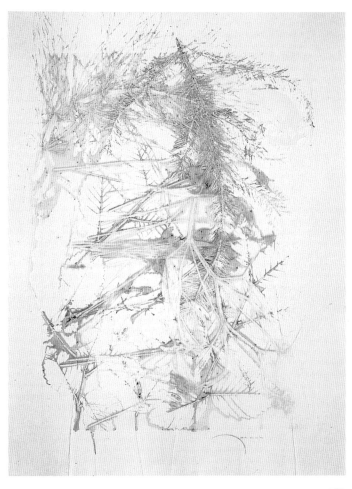

100

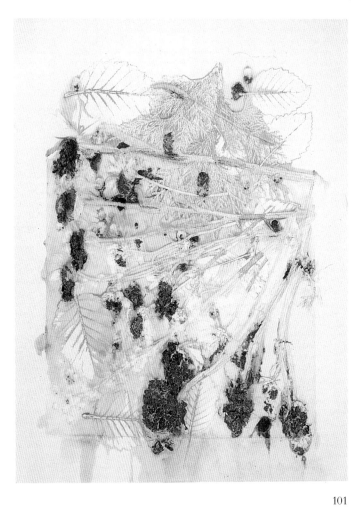

101

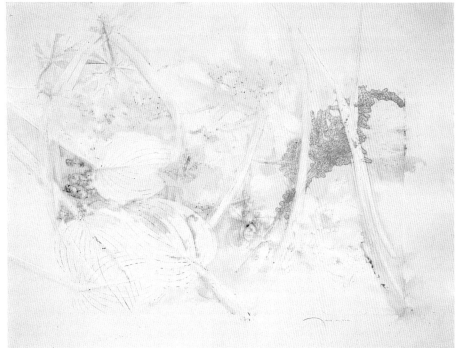

102

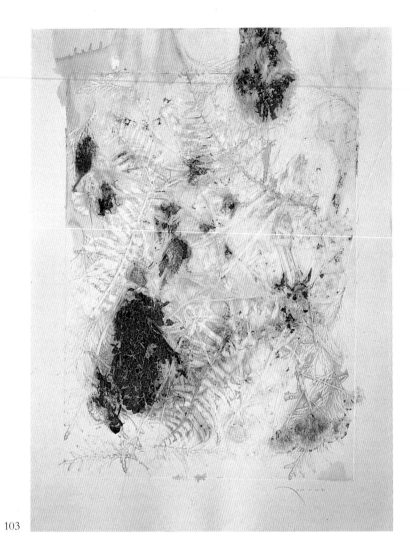

103

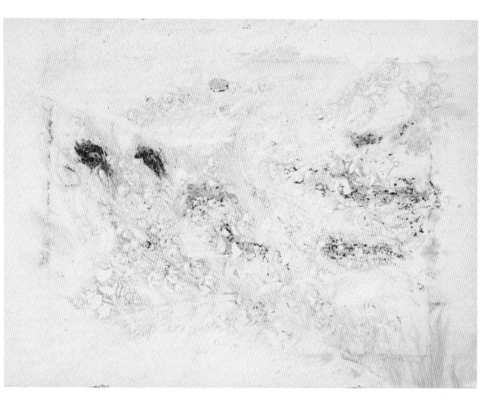

104

103
VII-15-92

Monotype on Rives BFK white paper, 29⅞ × 22¼″.
Signed: *N. S. Graves* in pencil and dated, lower right.
Collection the artist

104
VII-16-92

Monotype on Rives BFK white paper, 22¼ × 29⅞″.
Signed: *N. S. Graves* in pencil and dated, upper right.
Collection Pilchuck Glass School, Stanwood, Washington

105
VII-16-92

Monotype on Rives BFK white paper, 29⅞ × 22¼″.
Signed: *N. S. Graves* in pencil and dated, lower right.
Collection Pilchuck Glass School, Stanwood, Washington

106
VII-17-92

Monotype on Rives BFK white paper, 22¼ × 29⅞″.
Signed: *N. S. Graves* in pencil and dated, upper center.
Collection the artist

EXHBITION: Kansas City 1996

107
VII-17-92

Monotype on Rives BFK white paper, 29⅞ × 22¼″.
Signed: *N. S. Graves* in pencil and dated, lower left.
Collection the artist

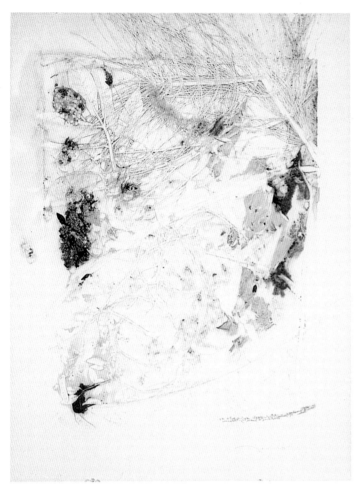

105

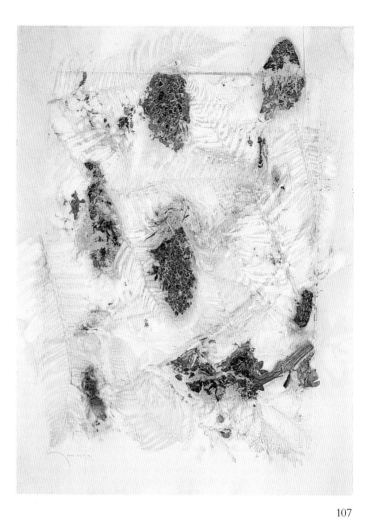

107

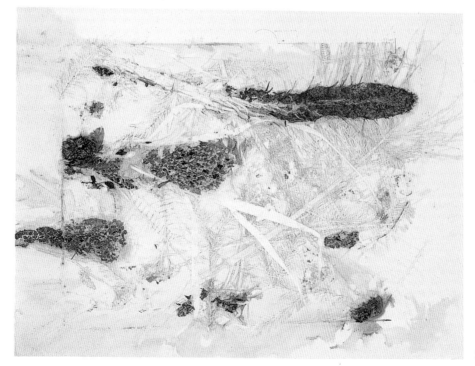

106

143

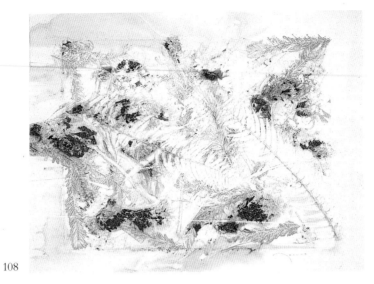

108

109

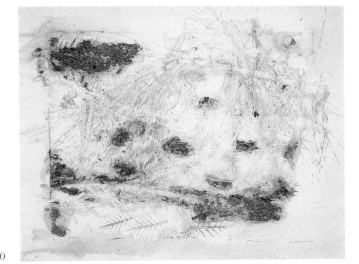

110

144

108
VII-18-92

Monotype on Rives BFK white paper, 22¼ × 29⅞".
Signed: *N. S. Graves* in pencil and dated, lower right.
Collection the artist

109
VII-18-92

Monotype on Rives BFK white paper, 29⅞ × 22¼".
Signed: *N. S. Graves* in pencil and dated, upper left.
Collection the artist

110
VII-19-92

Monotype on Rives BFK white paper, 22¼ × 29⅞".
Signed and inscribed: *N. S. Graves, For Sandy with Love* in
pencil and dated, lower right. Collection Sandy Hecht

111
VII-19-92

Monotype on Rives BFK white paper, 29⅞ × 22¼″.
Signed: *N. S. Graves* in pencil and dated, lower right.
Collection Pilchuck Glass School, Stanwood, Washington

112
VII-20-92

Monotype on Rives BFK white paper, 29⅞ × 22¼″.
Signed: *N. S. Graves* in pencil and dated, upper left.
Collection Paul DeSoma

113
VII-20-92

Monotype on Rives BFK white paper, 22¼ × 29⅞″.
Signed: *N. S. Graves* in pencil and dated, lower right.
Collection Pilchuck Glass School, Stanwood, Washington

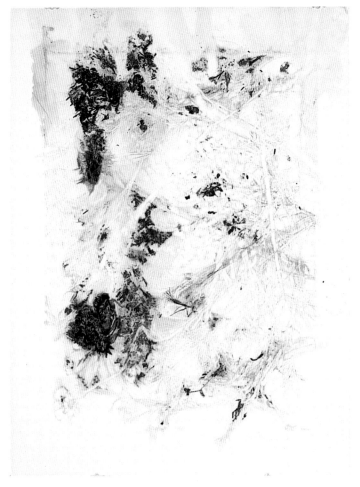

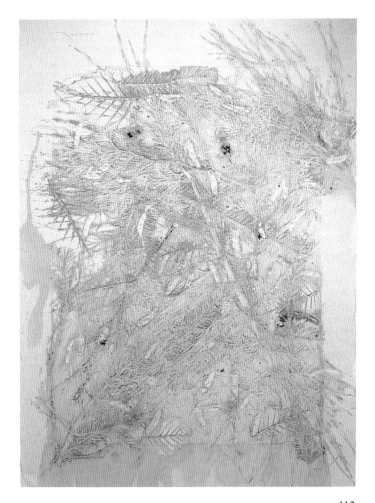

111

112

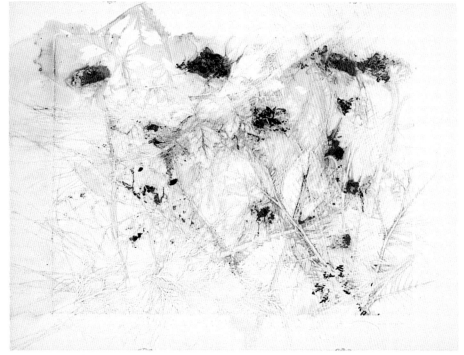

113

Cat. Nos. 114–74
FULL PLATE SERIES, 1992

Related to the Pilchuck series of the same year, the Full Plate series is a group of monotypes in which the artist embossed a wide variety of foods. Graves placed vegetables, fruit, beans, pasta, rice, and other foods, along with spices for coloration, directly on a sheet of Plexiglas, which was covered with moistened paper and run through an etching press to be embossed. In a departure from the process she followed with the Pilchuck series, Graves sprayed watercolor (a mixture of Winsor and Newton paints) on the organic material before printing; however, as she had done in that earlier series, Graves selectively added watercolor directly to the works following printing.

The complete list of organic material utilized in the series is as follows: apple; bean sprout; blueberry; red cabbage; carrot; cayenne; celery; clove; corn; cranberry; eggplant; grape; grapefruit; kale; kiwi; locust bean pod; leek; mango; orange; paprika; pasta; pea; green and red pepper; persimmon; pomegranate; raspberry; rice; dried sardine; scallion; spinach; dried squid; star fruit; strawberry

Printed by Deli Sacilotto at Iris Editions, New York.
Published by Nancy Graves

114
XI/1/92

Monotype on Rives BFK white paper with watercolor, 22 × 30″. Signed: *N. S. Graves* in pencil and dated, upper center. Collection the artist

115
XI/2/92

Monotype on Rives BFK white paper with watercolor, 22 × 30″. Signed: *N. S. Graves* in pencil and dated, lower center. Collection the artist

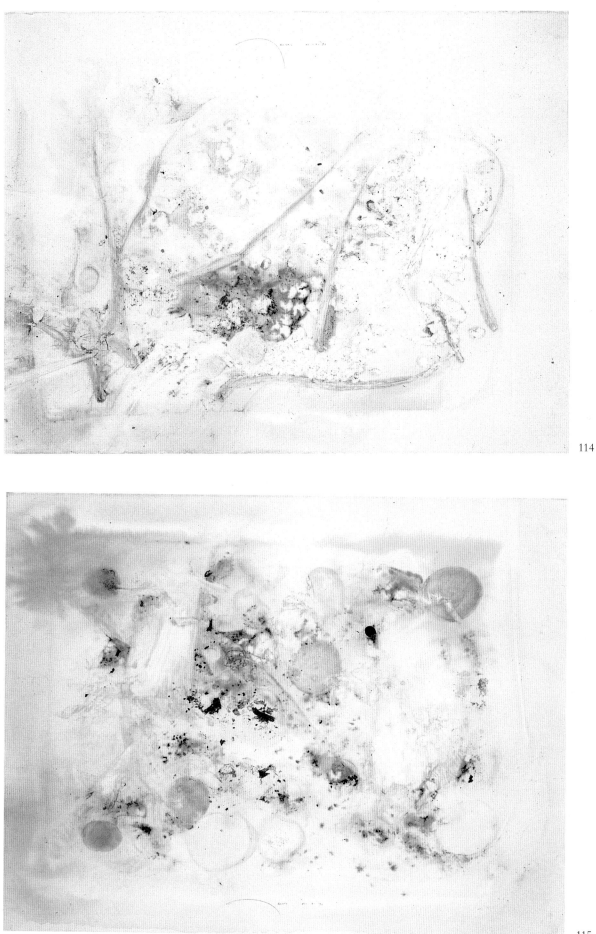

114

115

116
XI/3/92

Monotype on Rives BFK white paper with watercolor, 30 × 22″. Signed: *N. S. Graves* in pencil and dated, lower left. Collection the artist

117
XI/4/92

Monotype on Rives BFK white paper with watercolor, 30 × 22″. Signed: *N. S. Graves* in pencil and dated, upper left. Collection the artist

118
XI/5/92

Monotype on Rives BFK white paper with watercolor, 22 × 30″. Signed: *N. S. Graves* in pencil and dated, lower right. Collection the artist

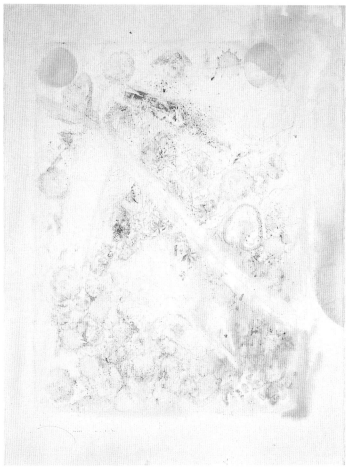

116

117

118

119

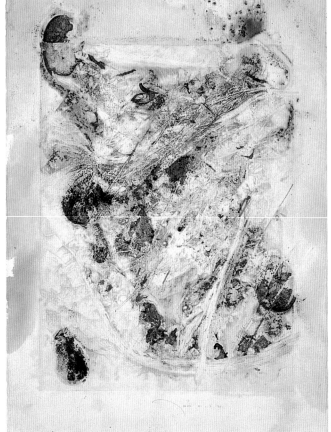

120

121

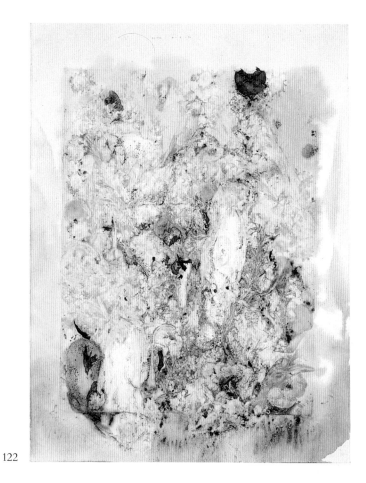

122

119
XI/6/92

Monotype on Rives BFK white paper with watercolor,
30 × 22″. Signed: *N. S. Graves* in pencil and dated, lower
center. Collection the artist

120
XI/7/92

Monotype on Rives BFK white paper with watercolor,
30 × 22″. Signed: *N. S. Graves* in pencil and dated, lower
center. Collection the artist

121
XI/8/92

Monotype on Rives BFK white paper with watercolor,
30 × 22″. Signed: *N. S. Graves* in pencil and dated, lower
right. Collection the artist

122
XI/9/92

Monotype on Rives BFK white paper with watercolor,
30 × 22″. Signed: *N. S. Graves* in pencil and dated, upper
left. Collection the artist

123
XI/10/92

Monotype on Rives BFK white paper with watercolor, 22 × 30″. Signed: *N. S. Graves* in pencil and dated, upper left. Collection the artist

124
XI/11/92

Monotype on Rives BFK white paper with watercolor, 30 × 22″. Signed: *N. S. Graves* in pencil and dated, upper right. Courtesy Betsy Senior Gallery, New York

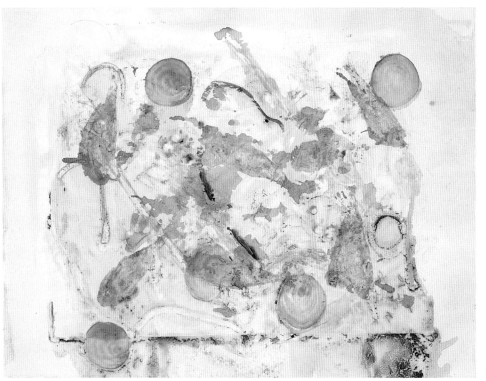

123

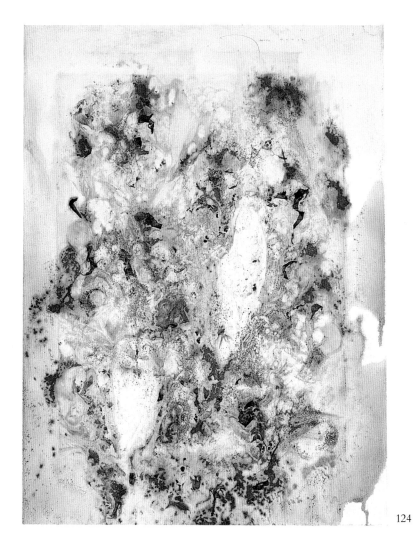

124

125
XI/12/92

Monotype on Rives BFK white paper with watercolor, 22 × 30″. Signed: *N. S. Graves* in pencil and dated, lower right. Collection the artist

126
XI/13/92

Monotype on Rives BFK white paper with watercolor, 30 × 22″. Signed: *N. S. Graves* in pencil and dated, upper right. Collection the artist

127
XI/14/92

Monotype on Rives BFK white paper with watercolor, 30 × 22″. Signed: *N. S. Graves* in pencil and dated, lower left. Collection the artist

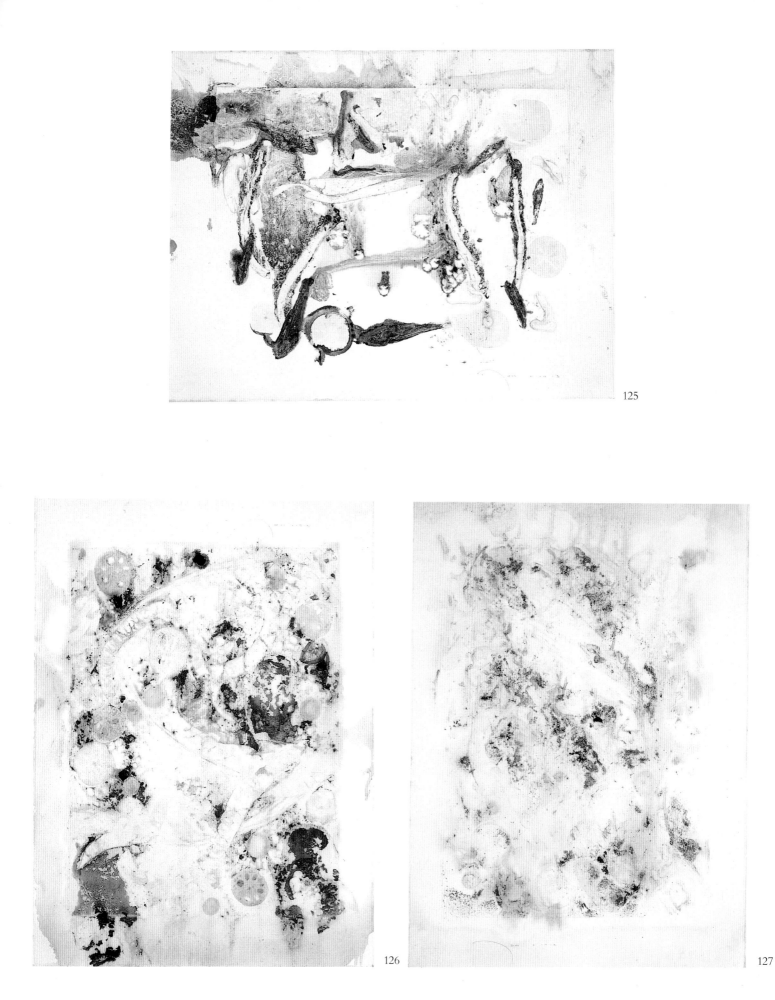

125

126

127

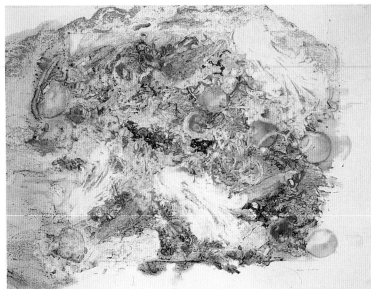

128

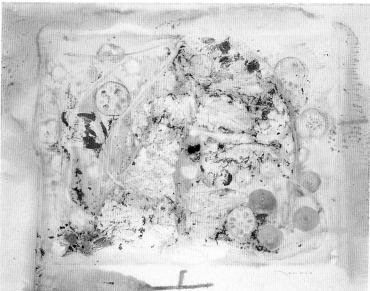

129

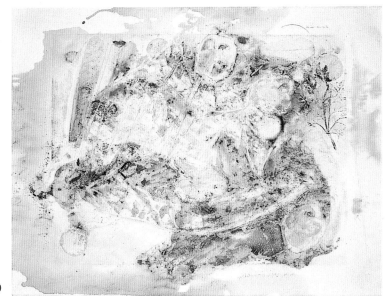

130

128
XI/15/92

Monotype on Rives BFK white paper with watercolor, 22 × 30″. Signed: *N. S. Graves* in pencil and dated, lower right. Collection the artist

129
XI/16/92

Monotype on Rives BFK white paper with watercolor, 22 × 30″. Signed: *N. S. Graves* in pencil and dated, lower right. Collection the artist

130
XI/17/92

Monotype on Rives BFK white paper with watercolor, 22 × 30″. Signed: *N. S. Graves* in pencil and dated, upper right. Collection the artist

131
XI/18/92

Monotype on Rives BFK white paper with watercolor,
22 × 30″. Signed: *N. S. Graves* in pencil and dated, lower
left. Collection the artist

132
XI/19/92

Monotype on Rives BFK white paper with watercolor,
22 × 30″. Signed: *N. S. Graves* in pencil and dated, lower
left. Collection the artist

131

132

133

134

135

133
XI/20/92

Monotype on Rives BFK white paper with watercolor, 30 × 22″. Signed: *N. S. Graves* in pencil and dated, lower left. Collection the artist

134
XI/21/92

Monotype on Rives BFK white paper with watercolor, 30 × 22″. Signed: *N. S. Graves* in pencil and dated, lower right. Collection the artist

135
XI/22/92

Monotype on Rives BFK white paper with watercolor, 30 × 22″. Signed: *N. S. Graves* in pencil and dated, upper left. Collection the artist

136
XI/23/92

Monotype on Rives BFK white paper with watercolor,
22 × 30″. Signed: *N. S. Graves* in pencil and dated, lower
right. Collection the artist

137
XI/24/92

Monotype on Rives BFK white paper with watercolor,
30 × 22″. Signed: *N. S. Graves* in pencil and dated, upper
left. Collection the artist

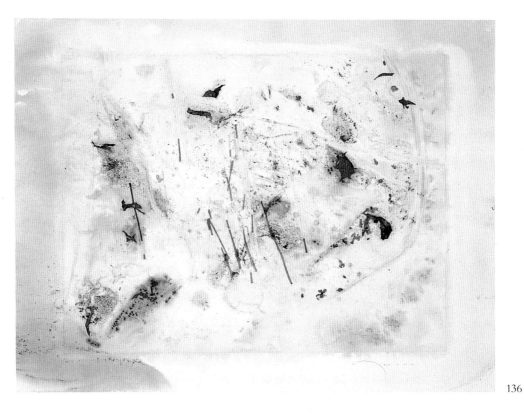

136

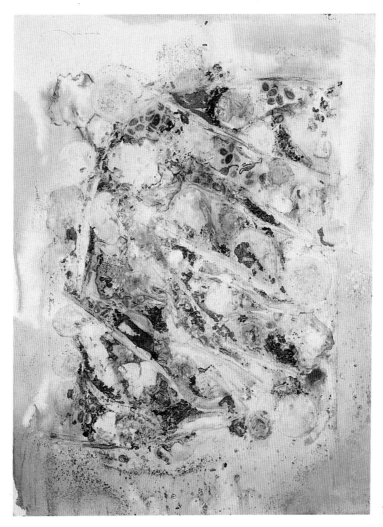

137

138
XI/25/92

Monotype on Rives BFK white paper with watercolor, 30 × 22″. Signed: *N. S. Graves* in pencil and dated, upper left. Collection the artist

EXHIBITION: Kansas City 1996

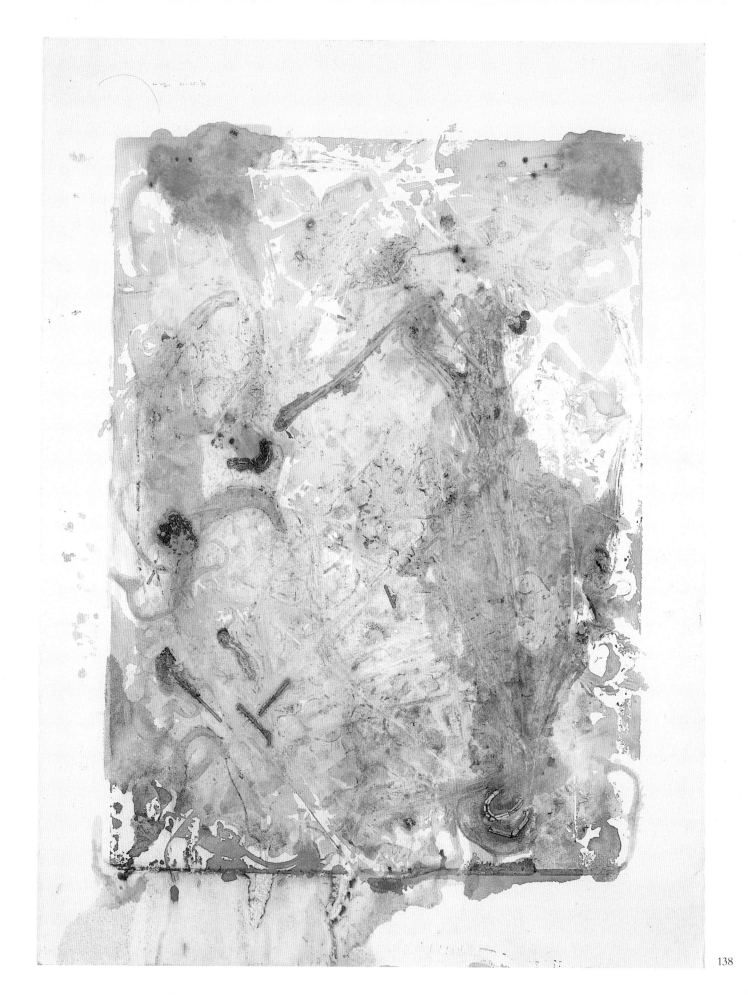

139
XI/26/92

Monotype on Rives BFK white paper with watercolor, 30 × 22″. Signed: *N. S. Graves* in pencil and dated, upper right. Collection the artist

140
XI/27/92

Monotype on Rives BFK white paper with watercolor, 30 × 22″. Signed: *N. S. Graves* in pencil and dated, upper left. Collection the artist

141
XI/28/92

Monotype on Rives BFK white paper with watercolor, 22 × 30″. Signed: *N. S. Graves* in pencil and dated, upper right. Collection Deli Sacilotto, New York

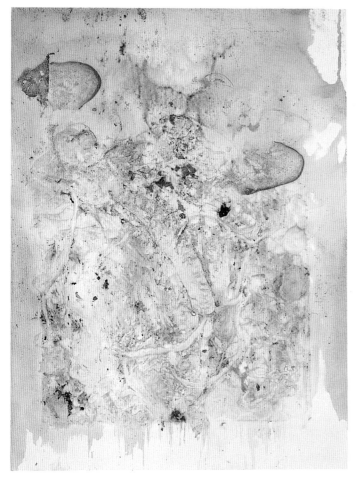

139

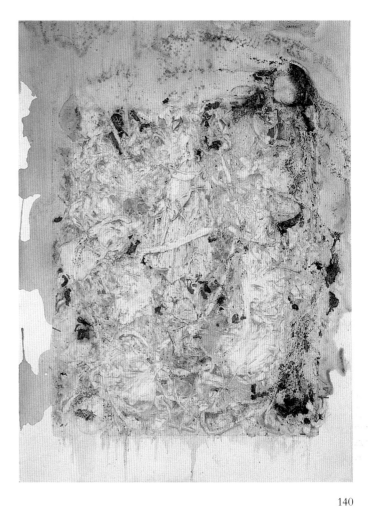

140

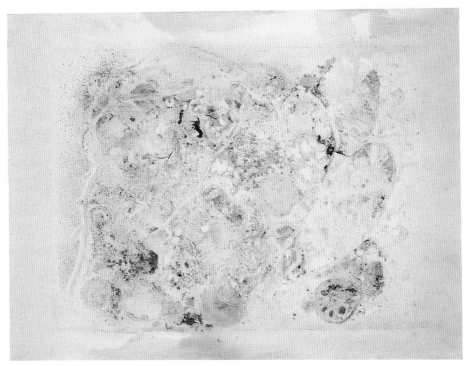

141

169

142
XI/29/92

Monotype on Rives BFK white paper with watercolor, 30 × 22″. Signed: *N. S. Graves* in pencil and dated, lower right. Collection Deli Sacilotto, New York

143
XI/30/92

Monotype on Rives BFK white paper with watercolor, 30 × 22″. Signed: *N. S. Graves* in pencil and dated, upper right. Collection Deli Sacilotto, New York

144
XII/1/92

Monotype on Rives BFK white paper with watercolor, 30 × 22″. Signed: *N. S. Graves* in pencil and dated, lower right. Collection the artist

145
XII/2/92

Monotype on Rives BFK white paper with watercolor, 30 × 22″. Signed: *N. S. Graves* in pencil and dated, upper right. Collection the artist

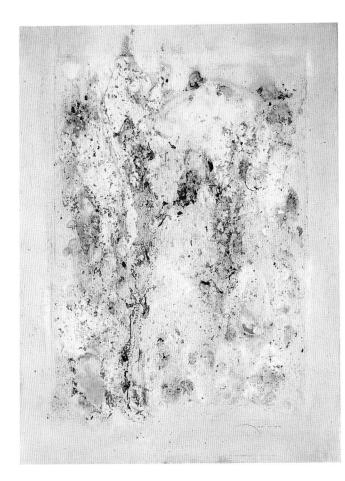

142

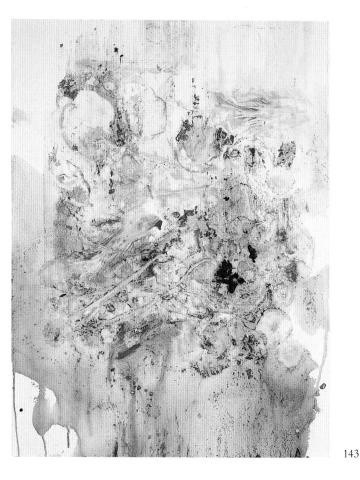

143

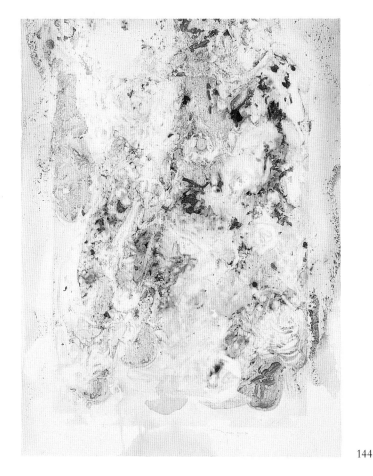

144

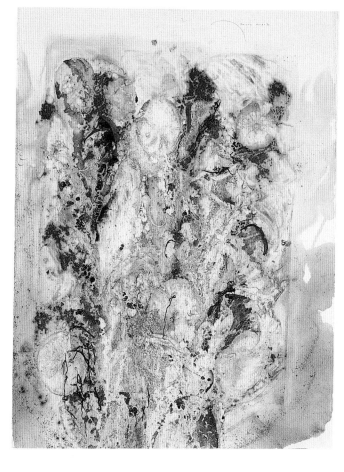

145

171

146

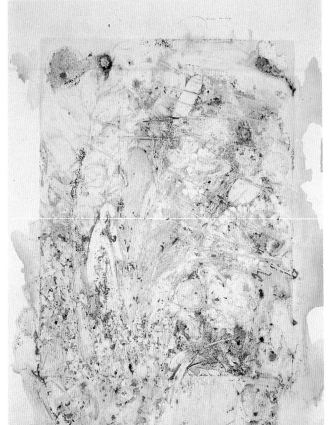

147

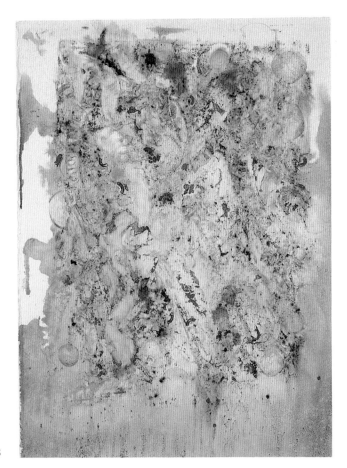

148

149

146
XII/3/92

Monotype on Rives BFK white paper with watercolor,
30 × 22″. Signed: *N. S. Graves* in pencil and dated, upper
right. Collection the artist

147
XII/4/92

Monotype on Rives BFK white paper with watercolor,
30 × 22″. Signed: *N. S. Graves* in pencil and dated, upper
right. Collection the artist

148
XII/5/92

Monotype on Rives BFK white paper with watercolor,
30 × 22″. Signed: *N. S. Graves* in pencil and dated, upper
right. Collection the artist

149
XII/6/92

Monotype on Rives BFK white paper with watercolor,
30 × 22″. Signed: *N. S. Graves* in pencil and dated, upper
right. Collection the artist

150
XII/7/92

Monotype on Rives BFK white paper with watercolor,
30 × 22″. Signed: *N. S. Graves* in pencil and dated, upper
left. Collection the artist

151
XII/8/92

Monotype on Rives BFK white paper with watercolor,
22 × 30″. Signed: *N. S. Graves* in pencil and dated, upper
left. Collection the artist

150

151

152

XII/9/92

Monotype on Rives BFK white paper with watercolor, 30 × 22″. Signed: *N. S. Graves* in pencil and dated, upper center. Collection the artist

153

XII/10/92

Monotype on Rives BFK white paper with watercolor, 30 × 22″. Signed: *N. S. Graves* in pencil and dated, lower right. Collection the artist

EXHIBITION: Kansas City 1996

154

XII/11/92

Monotype on Rives BFK white paper with watercolor, 30 × 22″. Signed: *N. S. Graves* in pencil and dated, lower right. Collection Leo Munick, Cincinnati

152

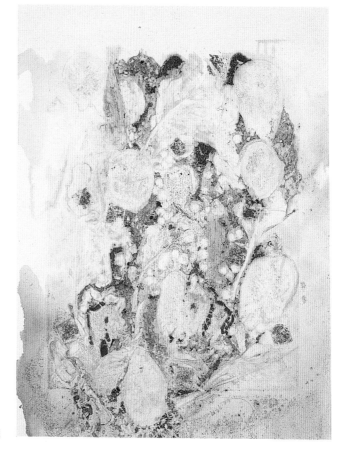

153

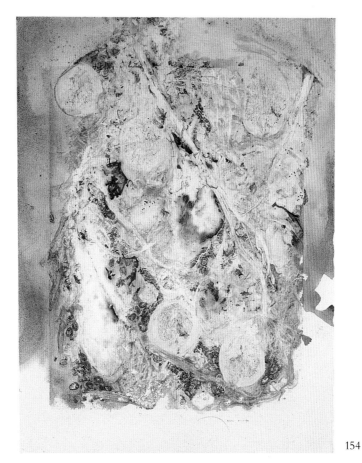

154

155
XII/12/92

Monotype on Rives BFK white paper with watercolor, 30 × 22″. Signed: *N. S. Graves* in pencil and dated, lower right. Collection the artist

156
XII/13/92

Monotype on Rives BFK white paper with watercolor, 22 × 30″. Signed: *N. S. Graves* in pencil and dated, upper right. Collection the artist

157
XII/14/92

Monotype on Rives BFK white paper with watercolor, 30 × 22″. Signed: *N. S. Graves* in pencil and dated, upper right. Collection the artist

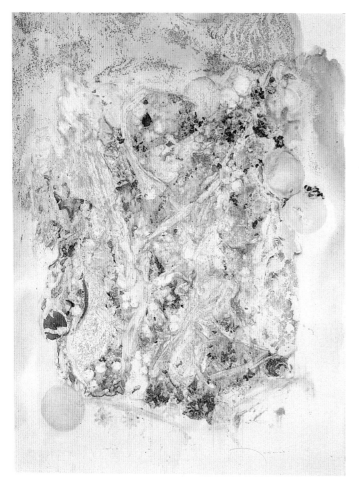

155

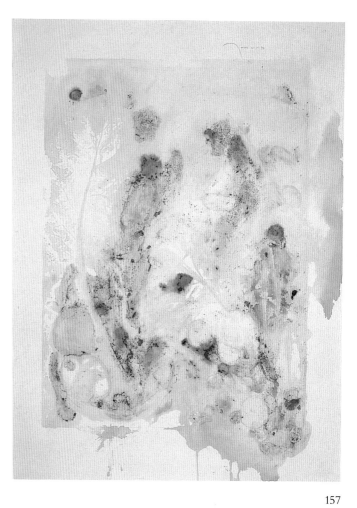

157

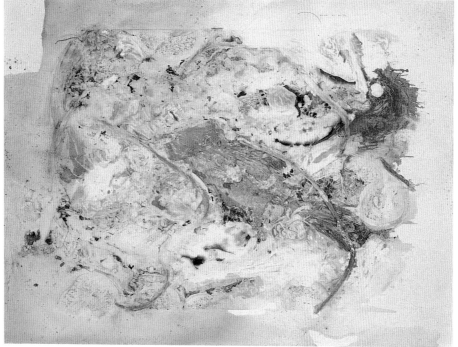

156

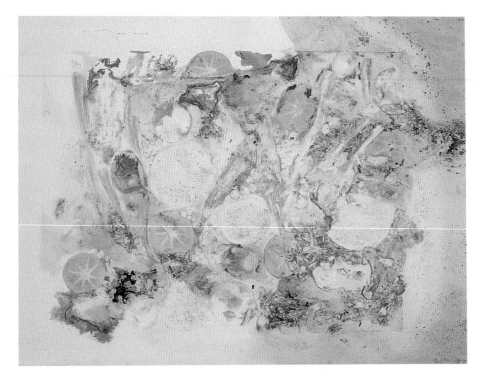

158

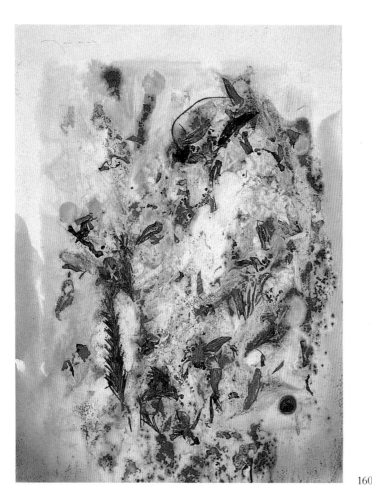

159

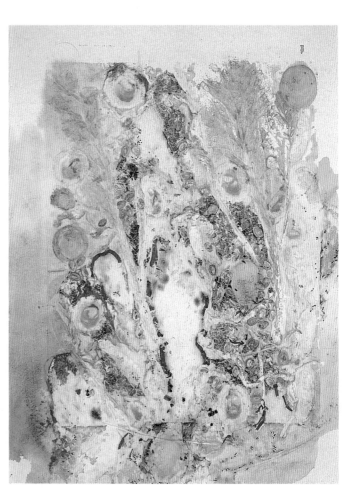

160

180

158
XII/15/92

Monotype on Rives BFK white paper with watercolor, 22 × 30″. Signed: *N. S. Graves* in pencil and dated, upper left. Collection the artist

159
XII/16/92

Monotype on Rives BFK white paper with watercolor, 30 × 22″. Signed: *N. S. Graves* in pencil and dated, upper left. Collection the artist

160
XII/17/92

Monotype on Rives BFK white paper with watercolor, 30 × 22″. Signed: *N. S. Graves* in pencil and dated, upper left. Collection the artist

161

XII/18/92

Monotype on Rives BFK white paper with watercolor,
30 × 22″. Signed: *N. S. Graves* in pencil and dated, upper
left. Collection the artist

162

XII/19/92

Monotype on Rives BFK white paper with watercolor,
30 × 22″. Signed: *N. S. Graves* in pencil and dated, lower
left. Collection the artist

163

XII/20/92

Monotype on Rives BFK white paper with watercolor,
30 × 22″. Signed: *N. S. Graves* in pencil and dated, upper
left. Collection the artist

164

XII/21/92

Monotype on Rives BFK white paper with watercolor,
30 × 22″. Signed: *N. S. Graves* in pencil and dated, upper
right. Collection the artist

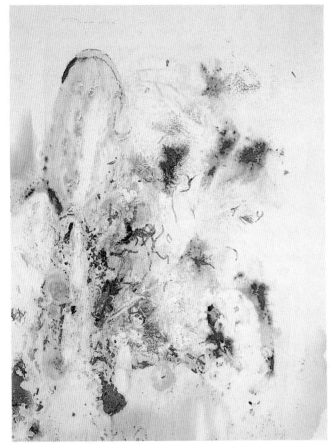

161

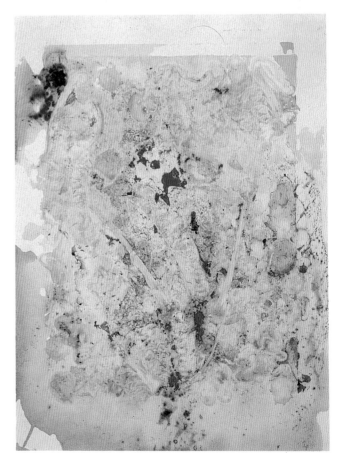

162

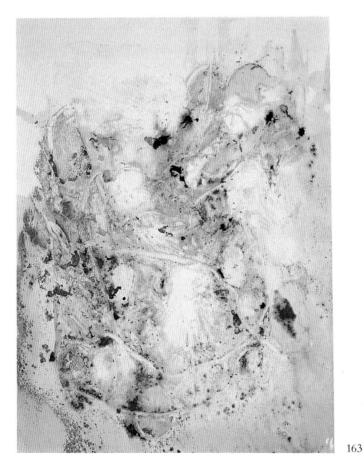

163

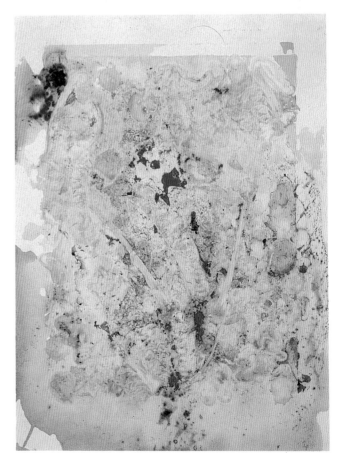

164

165
XII/22/92

Monotype on Rives BFK white paper with watercolor,
30 × 22″. Signed: *N. S. Graves* in pencil and dated, upper
right. Collection the artist

166
XII/23/92

Monotype on Rives BFK white paper with watercolor,
30 × 22″. Signed: *N. S. Graves* in pencil and dated, upper
left. Collection the artist

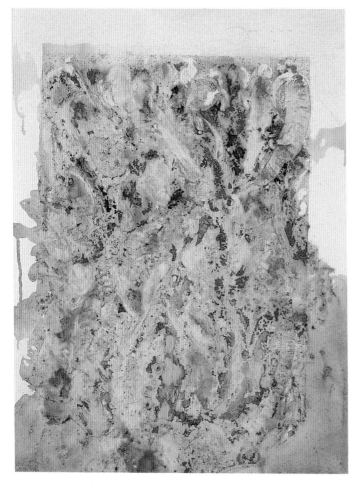

165

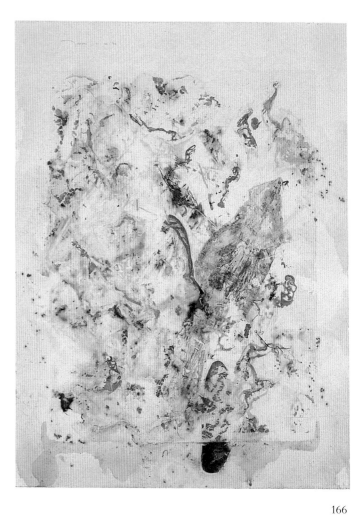

166

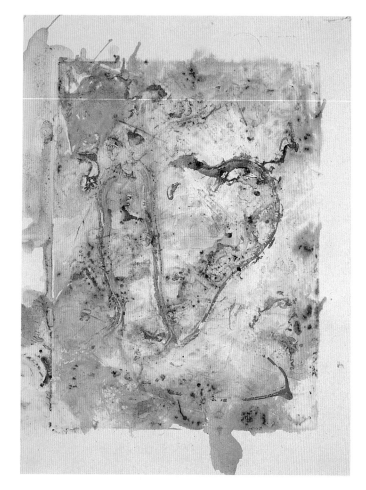

167

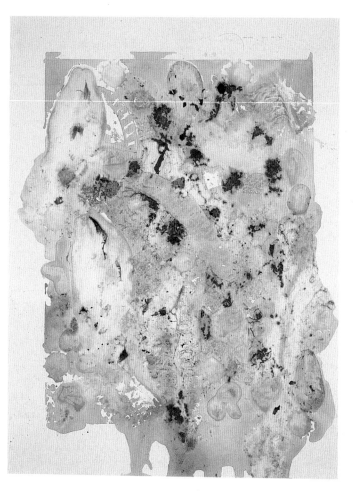

168

167
XII/24/92

Monotype on Rives BFK white paper with watercolor,
30 × 22″. Signed: *N. S. Graves* in pencil and dated, upper
right. Collection the artist

168
XII/25/92

Monotype on Rives BFK white paper with watercolor,
30 × 22″. Signed: *N. S. Graves* in pencil and dated, upper
right. Collection the artist

169
XII/26/92

Monotype on Rives BFK white paper with watercolor, 30 × 22″. Signed: *N. S. Graves* in pencil and dated, upper right. Collection the artist

170
XII/27/92

Monotype on Rives BFK white paper with watercolor, 30 × 22″. Signed: *N. S. Graves* in pencil and dated, upper right. Collection the artist

171
XII/28/92

Monotype on Rives BFK white paper with watercolor, 30 × 22″. Signed: *N. S. Graves* in pencil and dated, upper left. Collection the artist

172
XII/29/92

Monotype on Rives BFK white paper with watercolor, 30 × 22″. Signed: *N. S. Graves* in pencil and dated, upper right. Collection the artist

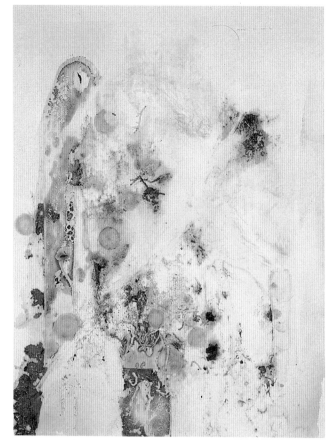

169

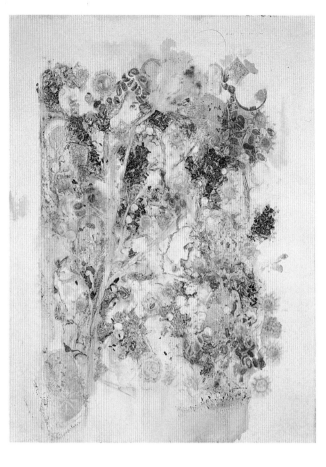

170

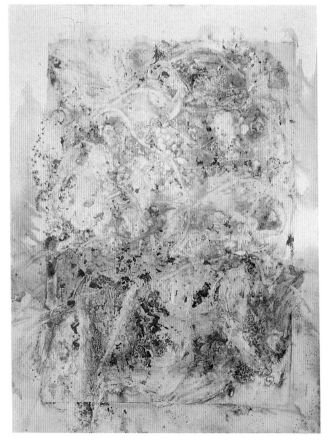

171

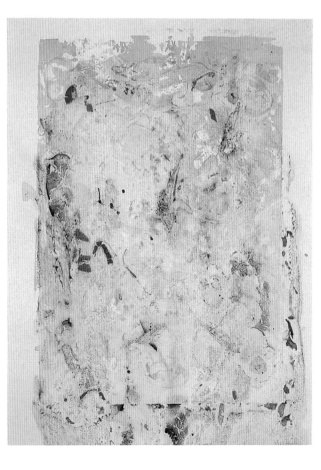

172

173
XII/30/92

Monotype on Rives BFK white paper with watercolor, 30 × 22″. Signed: *N. S. Graves* in pencil and dated, upper center. Collection the artist

174
XII/31/92

Monotype on Rives BFK white paper with watercolor, 30 × 22″. Signed: *N. S. Graves* in pencil and dated, upper left. Collection the artist

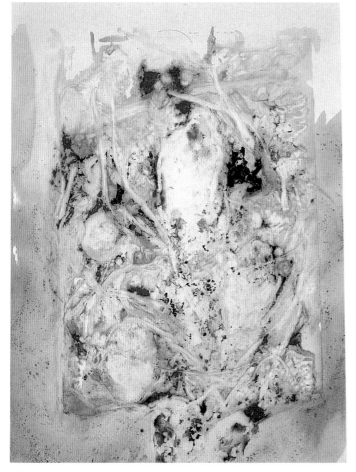

173

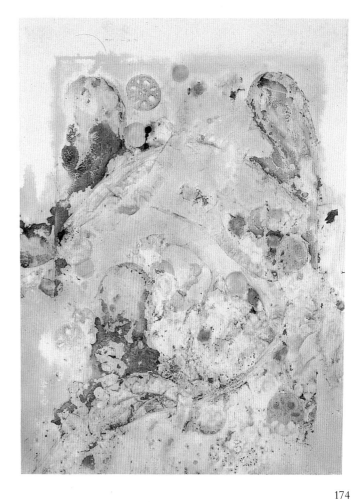

174

CHRONOLOGY OF PRINTMAKING ACTIVITY

For complete biographical information from 1940 to 1986, see E. A. Carmean, Jr. et al., *The Sculpture of Nancy Graves: A Catalogue Raisonné,* New York: Hudson Hills Press in association with the Fort Worth Art Museum, 1987.

1940
Born Nancy Stevenson Graves on December 23 in Pittsfield, Massachusetts.

1972
Completes Lithographs Based on Geologic Maps of Lunar Orbiter and Apollo Landing Sites (cat. nos. 1–10), a suite of ten lithographs, with Jack Lemon at Landfall Press, Chicago.

1974
Completes *Quipu* (cat. no. 11), an offset lithograph, as a benefit for the Institute of Contemporary Art, Philadelphia, at Falcon Press, Philadelphia.

1975
Completes *National Air and Space Museum Silkscreen* (cat. no. 12) with Hiroshi Kawanishi at Simca Print Artists, Inc., New York, as a benefit for the National Air and Space Museum, Smithsonian Institution, Washington, D.C.

1976
Completes *Ertsne* (cat. no. 13), a screenprint, with Hiroshi Kawanishi at Simca Print Artists, Inc.

1977
Completes Synecdoche series (cat. nos. 14–19), six intaglio prints, with Kenneth Tyler at Tyler Graphics Ltd., Bedford Village, New York.

1979
Begins three intaglio prints, *Four Times Four* (cat. no. 23), *Paleolinea* (cat. no. 58), and *Aurelium* (cat. no. 63), with Valter and Eleonora Rossi at 2RC Edizioni d'Arte, Rome, while a resident at the American Academy in Rome.

1980
Completes three screenprints, *Lincoln Center Print* (cat. no. 21) at Charles Cardinale Fine Creations, Inc., New York, as a benefit for the Lincoln Center for the Performing Arts, New York; *Vertigo* (cat. no. 20) as a benefit for the Trisha Brown Dance Company, New York; and *Equivalent* (cat. no. 22) as a benefit for the Albright-Knox Art Gallery, Buffalo, with Adi Rischner at Styria Studios, New York.

1981
Completes *Approaches the Limit of I* (cat. no. 25), a lithograph; two composite prints, *Approaches the Limit of II* (cat. no. 26) and *Calibrate* (cat. no. 24); and the Monoprint series (cat. nos. 27–57) with Kenneth Tyler at Tyler Graphics Ltd. *Four Times Four* (cat. no. 23) is published by the Metropolitan Museum of Art, New York.

1982
Completes *Extracten* (cat. no. 59), an intaglio print, with Donn H. Steward in Halesite, New York, as a benefit for the Skowhegan School of Painting and Sculpture, Skowhegan, Maine. *Paleolinea* (cat. no. 58) is published by 2RC Edizioni d'Arte.

1984
Begins four intaglio prints, *Mappe Rossi* (cat. no. 64), *Anifoglie* (cat. no. 65), *Neferchidea* (cat. no. 66), and *Radix* (cat. no. 67), at 2RC Edizioni d'Arte. Completes two screenprints with Hiroshi Kawanishi at Simca Print Artists, Inc., *5745* (cat. no. 60), as a benefit for the Jewish Museum, New York, and *75 × 75* (cat. no. 61).

1985
Completes *Six Frogs* (cat. no. 62), a screenprint, with Hiroshi Kawanishi at Simca Print Artists, Inc. *Aurelium* (cat. no. 63) and *Mappe Rossi* (cat. no. 64) are published by 2RC Edizioni d'Arte.

1987
Begins *The Clash of Cultures* (cat. no. 68), an intaglio print, at 2RC Edizioni d'Arte. *Anifoglie* (cat. no. 65),

Neferchidea (cat. no. 66), and *Radix* (cat. no. 67) are published by 2RC.

1988
Completes *Borborygmi* (cat. no. 69), a composite print with screenprinted gold leaf, at 2RC Edizioni d'Arte. *The Clash of Cultures* (cat. no. 68) is published by 2RC. Begins *Explicate Unfolded Order* (cat. no. 72), a screenprint with hand-applied glitter, at Altos de Chavon Cultural Center Foundation, La Romana, Dominican Republic, as a benefit for the Institute of Contemporary Art, Philadelphia.

1989
Completes two composite prints with screenprinted gold leaf, *The Tragedy of Alcione and Justice* (cat. no. 70) and *Hercules, Eve and the Parting of Night and Day* (cat. no. 71), also with silver leaf, at 2RC Edizioni d'Arte. *Explicate Unfolded Order* (cat. no. 72) is published by the Institute of Contemporary Art, Philadelphia. Begins *Stuck, the Flies Buzzed* (cat. no. 73), a composite print with silver leaf and a screenprinted and embossed paper collage, at 2RC.

1990
Stuck, the Flies Buzzed (cat. no. 73) is published by 2RC Edizioni d'Arte. Completes *Canoptic Prestidigitation* (cat. no. 74), a lithograph with cast-paper collage, with Donald Saff at Graphicstudio, University of South Florida, Tampa.

Begins *Time Shapes the Stalactite* (cat. no. 75), a composite print with screenprinted bronze and silver leaf, at 2RC.

1991
Completes *To Belittle Consciousness* (cat. no. 76), an intaglio print, with Aldo Crommelynck, Paris; subsequently adds screenprinted gold and aluminum leaf to the edition at Brand X Editions, New York. *Time Shapes the Stalactite* (cat. no. 75) is published by 2RC Edizioni d'Arte. Completes *Tango* (cat. nos. 77–84), a folio of eight direct gravure etchings by Graves and thirteen pages of printed text by Pedro Cuperman, with Deli Sacilotto at Iris Editions, New York. At 2RC begins *Iconostasis of Water* (cat. no. 85), an intaglio with a screenprinted and embossed paper collage, and *Vine Shoots of Virgins,* which the artist later decided not to print in an edition.

1992
Completes *Growling with a Cry* (cat. no. 86), an intaglio print, with Deli Sacilotto at Iris Editions as a benefit for the Modern Art Museum of Fort Worth, Texas. *Iconostasis of Water* (cat. no. 85) is published by 2RC Edizioni d'Arte. Completes two series of monotypes with embossed organic materials: Pilchuck series (cat. nos. 87–113), with Cate Brigden, while an artist-in-residence at the Pilchuck Glass School, Stanwood, Washington, and Full Plate series (cat. nos. 114–74), with Deli Sacilotto at Iris Editions.

BIBLIOGRAPHY

The Bibliography lists monographs (indicated with an asterisk) on Nancy Graves's work in painting, sculpture, and drawing as well as sources that deal primarily with her printmaking.

Ackerman, Andrew, and Susan L. Braunstein. *Israel in Antiquity.* Exh. cat. New York: The Jewish Museum, 1982.

Armstrong, Elizabeth. *Prints from Tyler Graphics.* Exh. cat. Minneapolis: Walker Art Center, 1984.

Armstrong, Elizabeth, and Sheila McGuire. *First Impressions: Early Prints by Forty-Six Contemporary Artists.* Exh. cat. New York: Hudson Hills Press in association with Walker Art Center, Minneapolis, 1989.

Associated American Artists. *The Development of Sculptural Form.* Exh. cat. New York: Associated American Artists, 1989.

*Balken, Debra Bricker. *Nancy Graves: Painting, Sculpture, Drawing.* Exh. cat. Poughkeepsie, N.Y.: Vassar College Art Gallery, 1986.

*Belloli, Jay. *Nancy Graves.* Exh. cat. La Jolla, Calif.: La Jolla Museum of Contemporary Art, 1973.

Bosio, Gerard, Francis Delille, and Federico Mayor. *Mémoire de la Liberté.* Exh. cat. Paris: Gefrart, 1991.

*Bourdon, David. *Nancy Graves: Paradigm and Paradox.* Exh. cat. Philadelphia: Locks Gallery, 1991.

*Carmean, E. A. Jr. et al. *The Sculpture of Nancy Graves: A Catalogue Raisonné.* Exh. cat. New York: Hudson Hills Press in association with the Fort Worth Art Museum, 1987.

*Cathcart, Linda L. *Nancy Graves: A Survey 1969/1980.* Exh. cat. Buffalo, N.Y.: Albright-Knox Art Gallery, 1980.

Corlett, Mary Lee, and Ruth E. Fine. *Graphicstudio: Contemporary Art from the Collaborative Workshop at the University of South Florida.* Exh. cat. Washington, D.C.: National Gallery of Art, 1991.

Field, Richard S., and Ruth E. Fine. *A Graphic Muse: Prints by Contemporary American Women.* Exh. cat. South Hadley, Mass.: Mount Holyoke College Art Museum, 1987.

Friedman, Martin et al. *Tyler Graphics: The Extended Image.* New York: Abbeville Press in association with Walker Art Center, Minneapolis, 1987.

Gilmour, Pat. *Ken Tyler: 25 Glorious Years.* Exh. cat. Stockholm: Heland Wetterling Gallery, 1989.

Goldman, Judith. *Art Off the Picture Press: Tyler Graphics Ltd.* Exh. cat. Hempstead, N.Y.: Emily Lowe Gallery, Hofstra University, 1977.

Hansen, Trudy Victoria, and Eleanor Heartney. *Presswork: The Art of Women Printmakers.* Exh. cat. New York: Lang Communications, 1991.

Institute of Contemporary Art. *Prints, Posters, and Catalogues.* Philadelphia: Institute of Contemporary Art, University of Pennsylvania, 1991.

Kelder, Diane. *America/Italy: A Visual Dialogue That Continues.* Exh. pamphlet. Staten Island, N.Y.: The College of Staten Island, City University of New York, 1992.

Kelder, Diane. "New Editions by Nancy Graves." *Arts Magazine* 64 (October 1988): 17–18.

Museum of Modern Art, New York. *American Prints 1960–1985 in the Collection of The Museum of Modern Art.* New York: Museum of Modern Art, 1986.

Museum of Modern Art, Toyama. *Big Prints from Rome.* Exh. cat. Tokyo: Tokyo Shimbun, 1989.

Neuberger Museum of Art. *Inspired by Nature*. Exh. pamphlet. Purchase, N.Y.: Neuberger Museum of Art, State University of New York, 1994.

O'Connor, Patrick. *Nancy Graves: Prints 1972–1988*. Exh. cat. New York: Associated American Artists, 1988.

Print Collector's Newsletter 16 (March–April 1985), 19.

Print Collector's Newsletter 16 (July–August 1985), 100.

Tyler, Kenneth E. *Tyler Graphics: Catalogue Raisonné, 1974–1985*. New York: Abbeville Press in association with Walker Art Center, Minneapolis, 1987.

University of Colorado. *Visiting Artist Program: 20th Anniversary Show*. Exh. cat. Boulder: University of Colorado Art Galleries, 1992.

Walker, Barry. *Public and Private: American Prints Today, the 24th National Print Exhibition*. Exh. cat. Brooklyn: Brooklyn Museum, 1986.

*Yager, David et al. *Nancy Graves: Recent Works*. Exh. cat. Catonsville, Md.: Fine Arts Gallery, University of Maryland, 1993.

EXHIBITIONS

The following is a complete listing of exhibitions that have included prints by Nancy Graves. Solo exhibitions are marked with an asterisk.

Baltimore. Meyerhoff Gallery, Maryland Institute, College of Art. "Artist/Printmaker." October 10–November 16, 1986

Bellevue, Wash. Bellevue Art Museum. "Women's Caucus for Art 1993 Honor Awards." January 23–March 21, 1993

Boulder. University of Colorado Art Galleries. "Visiting Artist Program: 20th Anniversary Show." January 17–February 15, 1992. Catalogue

Brooklyn. Brooklyn Museum. "Public and Private: American Prints Today, the 24th National Print Exhibition." February 7–May 5, 1986; Flint, Mich., Flint Institute of Arts, July 28–September 7, 1986; Providence, Rhode Island School of Design, September 29–November 9, 1986; Pittsburgh, Museum of Art, Carnegie Institute, November 26, 1986–January 4, 1987; Minneapolis, Walker Art Center, February 1–March 22, 1987. Catalogue

Cincinnati. Cincinnati Art Museum. "Lithographs Based on Geologic Maps of Lunar Orbiter and Apollo Landing Sites." September 15–November 28, 1993

Hempstead, N.Y. Emily Lowe Gallery, Hofstra University. "Art Off the Picture Press: Tyler Graphics Ltd." April 14–May 22, 1977. Catalogue

Hong Kong. Hong Kong Art Center. "Americana 1992." February 11–May 4, 1992

*Houston. Meredith Long and Company. "Energy Fields Transfixed: Recent Work by Nancy Graves." April 11–30, 1991

Kansas City, Mo. Nelson-Atkins Museum of Art. "Nancy Graves: Excavations in Print." Organized by The American Federation of Arts. January 26–April 7, 1996; Poughkeepsie, N.Y., Frances Lehman Loeb Art Center, Vassar College, May 3–July 14, 1996; Youngstown, Ohio, The Butler Institute of American Art, August 9–October 20, 1996; Winter Park, Fla., Cornell Fine Arts Museum, Rollins College, November 9, 1996–January 12, 1997; Memphis, Tenn., Memphis Brooks Museum of Art, February 21–May 4, 1997; Annapolis, Md., Mitchell Art Gallery, St. John's College, September 5–November 16, 1997; Middlebury, Vt., Middlebury College Museum of Art, December 12, 1997–February 22, 1998. Catalogue

*La Jolla, Calif. La Jolla Museum of Contemporary Art. "Nancy Graves." August 25–October 7, 1973; Corpus Christi, Art Museum of South Texas, October 18–November 29, 1973. Catalogue

Lancaster, Pa. Tremellen Gallery. "Master Prints: Nancy Graves, Al Held, Richard Diebenkorn, Sam Francis, Jim Dine, Howard Hodgkin." May 1–31, 1993

Minneapolis. Walker Art Center. "Prints from Tyler Graphics." Part I, September 23, 1984–January 6, 1985; Part II, January 20–March 17, 1985. Catalogue

Minneapolis. Flanders Graphics. "Fifteenth Anniversary Exhibition Past and Present." November 1987

Minneapolis. Walker Art Center. "First Impressions: Early Prints by Forty-Six Contemporary Artists." June 4–September 10, 1989; Austin, Laguna Gloria Art Museum, December 2, 1989–January 21, 1990; Baltimore, Baltimore Museum of Art, February 25–April 22, 1990; Purchase, N.Y., Neuberger Museum of Art, State University of New York, June 21–September 16, 1990. Catalogue

*Minneapolis. Flanders Graphics. "The Prints of Nancy Graves." December 4, 1993–January 8, 1994

*New York. Getler-Pall Gallery. "New Prints by Nancy Graves." August 22–September 24, 1977

*New York. Associated American Artists. "Nancy Graves: Prints 1972–1988." January 5–30, 1988. Catalogue

New York. Associated American Artists. "The Development of Sculptural Form." December 5–30, 1989. Catalogue

*New York. Betsy Senior Gallery. "Nancy Graves: Etchings." June 3–July 31, 1993

*Palm Beach, Fla. Irving Galleries. "Nancy Graves: Alchemy of Time." February 11–March 3, 1992

Paris. Musée National d'Art Moderne, Centre Georges Pompidou. "Mémoire de la Liberté." October 9–28, 1991. Catalogue

Purchase, N.Y. Neuberger Museum of Art, State University of New York. "Inspired by Nature." September 25–December 24, 1994. Pamphlet

*Santa Fe. Gerald Peters Gallery. "The Clash of Cultures: New Paintings on Paper and Sculpture." July 3–15, 1990

South Hadley, Mass. Mount Holyoke College Art Museum. "A Graphic Muse: Prints by Contemporary American Women." October 5–November 15, 1987; New Haven, Yale University Art Gallery, December 9, 1987–January 20, 1988; Santa Barbara, Calif., Santa Barbara Museum of Art, February 13–April 3, 1988; Richmond, Virginia, Museum of Fine Arts, April 26–June 12, 1988; Kansas City, Mo., Nelson-Atkins Museum of Art, June 30–August 7, 1988; Tampa, Fla., Tampa Museum of Art, September 18–November 6, 1988. Catalogue

Staten Island, N.Y., Gallery 313, The College of Staten Island, City University of New York. "America/Italy: A Visual Dialogue That Continues." October 15–November 5, 1992. Pamphlet

Stockholm. Heland Wetterling Gallery. "Ken Tyler: 25 Glorious Years." May 24–August 13, 1989. Catalogue
Toyama, Japan. The Museum of Modern Art. "Big Prints from Rome." April 8–May 21, 1989; Osaka, Japan, Navio Museum of Art, June 28–July 18, 1989; Fukuoka, Japan, Koinoura Gallery, October 7–November 19, 1989. Catalogue

Washington, D.C. The National Museum of Women in the Arts. "Presswork: The Art of Women Printmakers." Organized by Lang Communications. September 24–December 1, 1991; Minneapolis, University of Minnesota Art Museum, January 9–March 14, 1992; Madison, Wisc., Elvehjem Museum of Art, June 21–August 16, 1992; Atlanta, Woodruff Arts Center, Atlanta College of Art, December 6, 1992–January 17, 1993; Youngstown, Ohio, The Butler Institute of American Art, April 11–May 23, 1993; Colorado Springs, Gallery of Contemporary Art, University of Colorado, June 11–July 25, 1993; Kansas City, Mo., Fine Arts Gallery, Federal Reserve Bank, August 15–September 26, 1993; Wichita, Kans., Edwin A. Ulrich Museum of Art, Wichita State University, October 7–November 28, 1993; Portsmouth, Va., Arts Center, Portsmouth Museum, December 19, 1993–January 30, 1994; Mason City, Iowa, Charles H. Macnider Museum, February 20–April 3, 1994; Lexington, Ky., The Headley-Whitney Museum, April 24–June 5, 1994; Mobile, Ala., The Fine Arts Museum of the South, June 24–August 7, 1994; Joplin, Mo., Spiva Center for the Arts, August 28–October 9, 1994; Denton, University of North Texas Art Gallery, October 30–December 11, 1994. Catalogue

Washington, D.C. National Gallery of Art. "Graphicstudio: Contemporary Art from the Collaborative Workshop at the University of South Florida." September 15, 1991–January 5, 1992. Catalogue

Yokohama, Japan. Yokohama Museum of Art. "Innovation in Collaborative Printmaking: Kenneth Tyler 1963–1992." June 13–July 26, 1992; Marugame Genichiro, Japan, Inokuma Museum of Contemporary Art, August 6–September 20, 1992; Wakayama, Japan, Museum of Modern Art, October 3–October 25, 1992; Tokushima, Japan, Tokushima Modern Art Museum, October 31–December 6, 1992; Obihiro, Japan, Hokkaido Obihiro Museum of Art, January 5–February 28, 1993

G L O S S A R Y

The glossary is adapted from Donald Saff and Deli Sacilotto, *Printmaking: History and Process* (New York: Holt, Rinehart and Winston, 1978) and André Béguin, "Glossary of Technical Terms," in Richard S. Field, Michel Melot et al., *Prints* (Geneva: Editions d'Art Albert Skira; New York: Rizzoli, 1981), by permission of their respective publishers. Words or terms within definitions printed in SMALL CAPITAL LETTERS are defined in the glossary.

aquatint: INTAGLIO process in which rosin or asphaltum powder is used to produce a tonal or textural surface on a metal PLATE.

artist's proof: One of a small group of PRINTS not included in the EDITION, set aside for the artist's use. Also called épreuve d'artiste.

bath: The mixture of acid and water in which INTAGLIO PLATES are etched.

binder: Substance that holds together the particles of PIGMENT in an INK or paint.

bite: The corrosive effects of an acid on a metal PLATE.

bleeding: INK seepage around a printed image, caused by excessive use of ink, oil, or pressure.

bon à tirer proof: The "right to print" PROOF, designated by the artist as the standard against which every PRINT in the EDITION is to be judged for its aesthetic and technical merits.

burnishing: In INTAGLIO, the polishing and smoothing of the PLATE to lighten an aquatint or to flatten a burr of a drypoint or to create highlights.

burr: In INTAGLIO, the ridge of metal cast up on either or both sides of a line by the ENGRAVING or DRYPOINT tool. In engraving, the burr is usually removed, while in drypoint it remains on the PLATE, creating the characteristic fuzzy edges of the lines.

cancellation proof: PRINT taken from a PLATE, block, or STONE after the image has been defaced at the end of the EDITION. This is done to ensure that no further PRINTS can be made.

carbon tissue: Gelatin-coated paper that can be made LIGHT-SENSITIVE for use in the PHOTOGRAVURE process.

cast paper: Three-dimensional paper made from liquid paper-pulp cast in a mold.

catalogue raisonné: Classified and numbered list of all known works made by an artist in a particular medium.

chine collé: Technique for pressing a thin sheet of Japan paper to a heavier backing sheet and printing it at the same time. This can be accomplished by the printing methods of LITHOGRAPHY and INTAGLIO.

chop: Identifying mark impressed on a PRINT by the printer or workshop or, in some cases, by the artist or a collector. Also called dry stamp.

composite print: PRINT made from a number of individual PLATES, blocks, STONES, or STENCILS combining different techniques in the same work.

direct gravure etching: An INTAGLIO technique in which a drawing is transferred to LIGHT-SENSITIVE CARBON TISSUE. The tissue is affixed to a copperplate and immersed in hot water to remove the paper backing and the unexposed gelatin from the carbon tissue. The remaining gelatin adhering to the copperplate corresponds directly to the tonal gradations of the original drawing but in negative form. The PLATE is then etched, producing the tones of the original drawings.

documentation sheet: Form identifying the technique employed in making a PRINT, as well as the INKS, paper, drawing materials, the size of the EDITION, the printers, and the publisher.

drypoint: INTAGLIO technique in which a sharp needle scratches the PLATE, creating a BURR that yields a characteristically soft and velvety line in the final PRINT.

edition: Set of identical PRINTS, sometimes numbered and signed, that have been PULLED by or under the supervision of the artist and are authorized for distribution.

embossed print: INTAGLIO PRINT in which the image is raised slightly, producing a three-dimensional effect. Also called inkless intaglio or blind embossing (when printed without INK), *gauffrage* (French), *blinddruck* (German), and *karazuri* or *kimekomi* (Japanese).

engraving: INTAGLIO technique in which the image is produced by cutting a metal PLATE directly with a sharp engraving tool. The incised lines are inked and printed with heavy pressure.

etching: INTAGLIO technique in which a metal PLATE is first covered with an acid-resistant GROUND, then worked with an etching needle. The metal exposed by the needle is "eaten" or "bitten" in an acid BATH, creating depressed lines that make an impression when the plate is later inked and a paper is pushed against it in an etching press.

etching press: INTAGLIO printing press consisting of two large cylinders and a sliding bed. The bottom cylinder supports the bed, on which the inked PLATE and the paper are placed, while the top cylinder presses the paper against the plate.

ghost image: In LITHOGRAPHY, traces of the image remaining on the STONE or PLATE after the WASHOUT.

gradation: Specialized technique in which a PLATE or STONE is inked with strips of different colors or shades of the same color, which are blended at the edges and printed simultaneously.

ground: In ETCHING and AQUATINT, an acid-resistant substance used to protect areas of the PLATE from the action of the acid; protected areas will make no impression in the PRINT. Hard grounds contain asphaltum, beeswax, and rosin; soft grounds contain the same ingredients plus tallow.

hard ground: See GROUND.

impression: See PRINT.

impression number: The number of a PRINT in an EDITION. The first three prints in an edition of one hundred would be numbered 1/100, 2/100, 3/100.

ink: Coloring matter composed of PIGMENT, a BINDER, and a VEHICLE.

intaglio: Printing technique in which paper is pushed into depressed or recessed lines made in a metal PLATE and filled with INK. The lines, which form the image, can be made on the plate by acid or a sharp tool, using one or more of the following techniques: ETCHING, ENGRAVING, AQUATINT, mezzotint, or DRYPOINT.

Japan paper: General name for Oriental papers.

lift ground: See SUGAR-LIFT AQUATINT.

light-sensitivity: The ability of a substance or surface to change chemically when exposed to light.

lithographic crayon: Greasy drawing substance used for drawing images on a lithographic STONE or PLATE. The substance attracts ink, so the image drawn is the image printed.

lithography: Printing technique in which the image areas on a lithographic STONE or metal PLATE are marked with a LITHOGRAPHIC CRAYON or TUSCHE, so they will accept INK and repel water, while the nonimage areas (those that will come out white) are treated to repel ink and retain water. Because the printing surface remains flat, lithography is sometimes referred to as a planographic technique.

matrix: A matrix is the source—for instance, the block, PLATE, or STONE—in which designs are cast and from which PRINTS originate. A matrix is a surface that accepts a design, holds the INK, and, when printed, transfers the ink to paper.

monoprint: A printed drawing with some elements fixed in the MATRIX. The artist makes incised marks on a surface of metal or wood. Establishing this partial MATRIX allows the artist to go back into the PLATE between printings and draw additional marks, or to make color alterations so that it is possible to produce a series of variations on a constant image.

monotype: Technically, a PRINT PULLED in an EDITION of one, from a painting made on a sheet of metal or glass. The method has been successfully adapted in special LITHOGRAPHY techniques.

Mylar: A sheet of clear synthetic material on which crayon, TUSCHE, or other material can be applied to block out image areas in the preparation of a PHOTO SCREEN, or from which a negative can be cut in the preparation of a PHOTO PLATE.

offset lithograph: A LITHOGRAPH produced on an offset press in which the inked image is transferred from the printing MATRIX to an intermediary rubber cylinder and then to the paper, rather than directly from a lithographic STONE or PLATE.

photogravure: An INTAGLIO printing process in which the image has been placed on the PLATE by photographic means using CARBON TISSUE.

photo plate: A lithographic PLATE on which an ink-receptive image is produced by photographic means. The lithographic plate is treated with a LIGHT-SENSITIVE coating and exposed to light through a negative image on a film (or MYLAR) overlay. In the light-exposed areas the coating accepts ink, while the unexposed coating can be washed away. The plate can then be inked and printed.

photo screen: A SCREEN on which a design has been produced photographically by the action of light on LIGHT-SENSITIVE materials.

pigment: Coloring matter in INK or paint, usually in powder form.

plate: A sheet of metal, often zinc, copper, steel, aluminum, or magnesium, on which an image is prepared for printing in the LITHOGRAPHY, INTAGLIO, or RELIEF techniques.

plate mark: In an INTAGLIO PRINT, the impression left by the PLATE on the paper as it passes through the press.

pochoir: Printmaking technique using a STENCIL made of plastic, brass, copper, or oiled paper, originally for applying small areas of color.

print: Image produced on paper or another material by placing it in contact with an inked block, PLATE, collage, or STONE and applying pressure or by pressing INK onto a sheet of paper through a STENCIL. Also called an impression.

printer's proofs: PRINTS not included in the EDITION, given to the master printer(s).

proof: Trial PRINT that is PULLED to test the progress of the image.

pull: To print an image.

pulp: The basic ingredient of paper, consisting of cotton or vegetable fibers that have been chopped and beaten with water to moisten and separate the fibers.

registration: Adjustment of separate PLATES, STONES, blocks, or SCREENS in color printing to ensure correct alignment of the colors. Sometimes they are deliberately printed off register.

relief: Printmaking technique, such as woodcut, in which the image is printed from a raised surface, usually produced by cutting away nonimage areas.

relief etching: Metal RELIEF PLATE produced by INTAGLIO techniques.

run: The application of INK from a printing MATRIX to paper in a single pass through a press, or the alteration of

the IMPRESSION through EMBOSSING in a single operation.

screen: A fine mesh of silk or synthetic material stretched tightly across a frame that supports the STENCIL design for a SCREENPRINT.

screenprinting: Printing technique in which INK is forced directly onto a piece of paper or canvas through a STENCIL containing the image. The term was coined by Carl Zigrosser. The process is also called SILKSCREEN or (less frequently) mitography.

silkscreen: See SCREENPRINT.

soft ground: See GROUND.

spit biting: AQUATINT technique for achieving gradated tonal effects by applying acid to the PLATE with a brush containing saliva or water.

stencil: In SCREENPRINTING, a means of blocking the passage of INK through the nonimage, or blank, areas of the SCREEN. A stencil can be made of paper, glue, TUSCHE, shellac, or a variety of other materials. Also used in POCHOIR.

stone: The limestone MATRIX used in the creation of a lithograph. Because it accepts grease and water equally, limestone is ideally suited to LITHOGRAPHY. Lithographic stones vary in size, hardness, and porosity, each of which provides the printed image with different textures.

stop-out: Substance (such as stop-out varnish or GROUND) that prevents acid from attacking certain areas on an ETCHING PLATE.

sugar-lift aquatint: AQUATINT technique in which the image is drawn on the PLATE with a water-soluble solution (usually containing sugar). The plate is then covered with a GROUND and submerged in water, which dissolves the sugar solution, lifting the ground and exposing the image areas so the plate can be ETCHED. Also called LIFT-GROUND.

suite: Related group of original PRINTS.

trial proof: PROOF pulled from a block, PLATE, or STONE to check the appearance of the image.

tusche: Grease-based drawing material used for LITHOGRAPHY and some types of STENCILS. It contains wax, tallow, soap, shellac, and lampblack and comes in solid and liquid form.

ukiyo-e: The classic period of Japanese woodcutting, lasting from the first half of the seventeenth century to the middle of the nineteenth century.

vehicle: Liquid ingredient of an INK or paint that allows the PIGMENT to be applied easily to a surface.

washout: In LITHOGRAPHY, the process of removing the greasy drawing material from the completed image on the STONE or PLATE.

THE AMERICAN FEDERATION OF ARTS
BOARD OF TRUSTEES

Elizabeth Blake
Chairman Emerita

Robert M. Meltzer
Chairman

Jan Mayer
President

Donald M. Cox
Vice President

Stephanie French
Vice President

Tom L. Freudenheim
Vice President

Gilbert H. Kinney
Vice President

Margot Linton
Vice President

Hannelore Schulhof
Vice President

Richard S. Lane
Secretary

James S. Snyder
Treasurer

Maxwell L. Anderson
Ruth Bowman
J. Carter Brown
Robert T. Buck
Constance Caplan
George M. Cheston
Jan Cowles
Catherine G. Curran
Jane M. Davis
Philippe de Montebello
Linda Downs
David C. Driskell
Suzanne G. Elson
Arthur Emil
Donna M. Forbes
John A. Friede
Jay Gates
Marge Goldwater
John G. Hanhardt
Lee Hills
Theodore S. Hochstim
Janet Kardon
Lyndel King
William S. Lieberman
Ellen Liman
Roger Mandle
Jeanne Lang Mathews

Cheryl McClenney-Brooker
Barbara Babcock Millhouse
Charles S. Moffett
Mary Gardner Neill
George W. Neubert
Sunny Norman
Nancy M. O'Boyle
Elizabeth Petrie
Earl A. Powell III
Frieda Rosenthal
Wilbur L. Ross, Jr.
Helen H. Scheidt
Thomas K. Seligman
Lewis I. Sharp
Linda B. Shearer
Susan Weber Soros
John Straus
Myron Strober
Martin Sullivan
David J. Supino
Mary Ann Tighe
Evan H. Turner
Virginia Ullman
Nani Warren
Nancy Brown Wellin
Dave Williams

HONORARY TRUSTEES

Roy R. Neuberger
President Emeritus

John Walker

THE AMERICAN FEDERATION OF ARTS
NATIONAL PATRONS

Amy Cohen Arkin

Anne H. Bass

Mr. and Mrs. Frank B.
Bennett

Mr. and Mrs. Winslow W.
Bennett

Mrs. Edwin A. Bergman

Mrs. George F. Berlinger

Mr. and Mrs. Leonard Block

Mr. and Mrs. Donald J. Blum

Mr. and Mrs. Duncan E.
Boeckman

Mr. and Mrs. Andrew L.
Camden

Mr. and Mrs. George M.
Cheston

Mrs. Paul A. Cohen

Elaine Terner Cooper

Marina Couloucoundis

Catherine G. Curran

Dr. and Mrs. David R. Davis

Sandra Deitch

Beth Rudin DeWoody

Mr. and Mrs. C. Douglas
Dillon

Mr. and Mrs. Herbert Doan

Mr. and Mrs. Robert B.
Dootson

Mrs. Lester Eisner

Mr. and Mrs. Oscar Feldman

Mr. and Mrs. James A. Fisher

Bart Friedman and Wendy
Stein

Barbara Goldsmith

Marion E. Greene

Mr. and Mrs. Gerald Grinstein

Leo S. Guthman

Mr. and Mrs. John H. Hauberg

Mrs. Wellington S. Henderson

Elaine P. Kend

Mr. and Mrs. Robert P. Kogod

Mr. and Mrs. Anthony M.
Lamport

Natalie Ann Lansburgh

Carole Meletio Lee

Mrs. Robert H. Levi

Barbara Linhart

Richard Livingston

Mr. and Mrs. Jeffery M. Loewy

Mr. and Mrs. Lester B. Loo

Mr. and Mrs. Mark O. L.
Lynton

Richard Manoogian

Mr. and Mrs. John Marion

Mr. and Mrs. Melvin Mark, Jr.

Mr. and Mrs. Alan M. May

Mrs. Eugene McDermott

Mr. and Mrs. Paul Mellon

Mr. and Mrs. Robert Menschel

Mr. and Mrs. Eugene Mercy, Jr.

Raymond Donald Nasher

George P. O'Leary

James H. Ottaway, Jr.

Patricia M. Patterson

Mr. and Mrs. Mark Perlbinder

Mr. and Mrs. Nicholas R. Petry

Mr. and Mrs. Charles I. Petschek

Mr. and Mrs. John W. Pitts

Mr. and Mrs. Lawrence
Pollock, Jr.

Mr. and Mrs. Charles Price

Howard Rachofsky

Audrey S. Ratner

Edward R. Roberts

Mr. and Mrs. Jonathan P.
Rosen

Mr. and Mrs. Robert J.
Rosenberg

Walter S. Rosenberry, III

Mr. and Mrs. Milton F.
Rosenthal

Mr. and Mrs. Richard
Rosenthal

Felice T. Ross

Mr. and Mrs. Douglas R.
Scheumann

Marcia Schloss

Mr. and Mrs. Paul C. Schorr, III

Lowell M. Schulman and
Dianne Wallace

Mr. and Mrs. Alan Schwartz

Mr. and Mrs. Joseph Seviroli

Mr. and Mrs. George A.
Shutt

Mr. and Mrs. Gilbert
Silverman

Mr. and Mrs. Robert Sosnick

Mr. and Mrs. James G.
Stevens

Mr. and Mrs. Harry F.
Stimpson, Jr.

Rosalee Taubman

Mrs. Norman Tishman

Mr. and Mrs. William B. Troy

Mr. and Mrs. Robert C.
Warren

Mr. and Mrs. Alan Weeden

Mr. and Mrs. Guy A. Weill

Mr. and Mrs. David Welles

Mr. and Mrs. Robert E. Wise

Mr. and Mrs. T. Evans
Wyckoff

INDEX

Titles beginning with arabic or roman numerals are alphabetized as if the numeral were spelled out. Both illustration pages and catalogue numbers are shown in *italic* type; catalogue numbers are preceded by the designation *CR* and are set off from page numbers with a semicolon. Prints are referenced to their main catalogue entry by catalogue (*CR*) number. Other mentions of a work (e.g., in other catalogue entries) are referenced by page number. An asterisk (*) after the page number indicates the reference is to the catalogue introduction to the series to which the print belongs. Entries for persons and organizations who collaborated with Graves give the *CR* numbers of the prints on which they worked. Entries for techniques, materials, and motifs give the *CR* numbers of the prints in which they were employed. Entries for exhibitions cited in the catalogue are indexed by city and date (see the key on pages 196–97) and give the *CR* numbers of the prints included.

PHOTOGRAPH CREDITS

Unless otherwise indicated, all photographs are by Ken Cohen.

The Berkshire Museum: fig. 2; Cate Brigden: cat. no. 90; Timothy Green-field-Sanders: fig. 19; David Heald: cat. no. 110; from René Huyghe, ed., *Larousse Encyclopedia of Prehistoric and Ancient Art*, New York, 1957, by permission of Prometheus Press: fig. 9; Gian Tomaso Liverani: fig. 18; Lunar and Planetary Institute, Houston: fig. 6; Kelly McLain: cat. no. 89; National Gallery of Canada, Ottawa: figs. 1, 5; Courtesy Nippon Television Network Corporation: fig. 16; Paul Schraub: cat. no. 112; Jean Vertut, from André Leroi-Gourhan, *Treasures of Prehistoric Art*, New York, 1967, Harry N. Abrams, Inc.: fig. 10; Tony Walsh: cat. no. 154